# Raqs Media Collective: Casebook

**agYU** ART GALLERY OF YORK UNIVERSITY

Raqs Media Collective: Casebook

CONTENTS

### SECTION 4: RULES TO BE INVENTED

### SECTION 5: THE LIBRARIAN'S LUCID DREAM
### (FROM DECOMPOSITION)

**Previous spread**
*Premonition*
2011/ Signage on metal, emergency lights. 36 x 182 x 8 cm
*Premonition*, Experimenter Gallery, Kolkata (2011).

Sometimes, not even the insistent repetition of phenomena finds you prepared
for the uncanny tug of premonition. Premonition: the anticipatory call of things
forever about to happen. Even if nothing happens. Even if the emergency lights
flicker away a wasting sense of urgency.

**Following three pages**
*Preface to a Ghost Story*
2005/ Photographs with text. Series of 6, each 60 x 60 cm

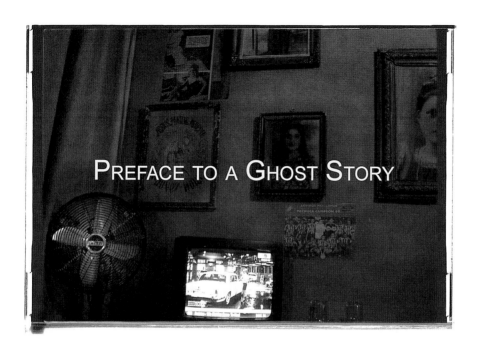

PREFACE TO A GHOST STORY

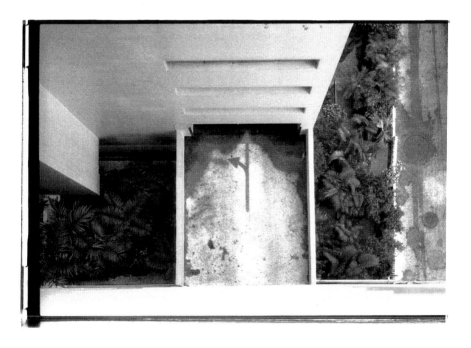

On leaving the nearest suitable abandoned building,
somewhere mid-leap,
the unknown citizen hovers briefly,
considering detours and the sour taste of regret.

Downstairs, there is a car waiting.
An old car with a new car smell, like an evergreen matinée idol.
A quick getaway is possible,
theoretically.

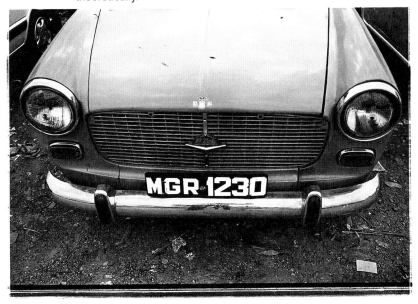

The moment that might have been is over.
None but a nearby company of superheroes has seen the descent
or gauged its impact.

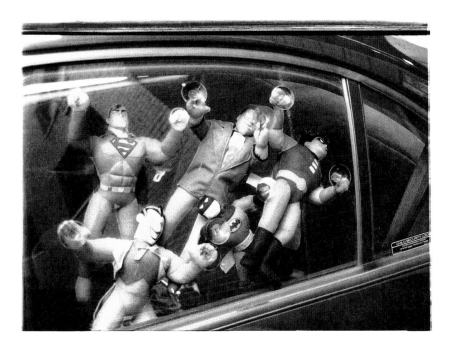

A gathering of shadows assesses the situation on the ground.

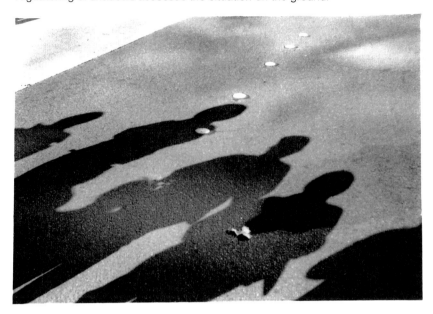

Bodies are fragile, easily broken.
A scrap of paper, an explanation, sustains impact better.

Elsewhere, the unknown citizen's personal effects,
a make-do archive,
await discovery.
In the bag there are five photographs and the preface to a ghost story.

# The Cipher and the Sieve

"Was he a person, a pseudonym, a fiction, or a persistent conspiracy?" So asked the Raqs Media Collective of KD Vyas, a character, or rather a mysterious correspondent, in their *The KD Vyas Correspondence, Vol.1* (2006).[1] We could ask the same question of Raqs. Let them answer — conspiratorially — for themselves:

> What brings us to work everyday (and has kept us together for the past seventeen years [they wrote in 2008]) is a desire for questions and a dissatisfaction with answers, even if they are of our own devising. We seek refuge from certainty in all of what we do. This means that our work often expresses our deep and enduring scepticism with narratives built out of unexamined ideas about identity, property, progress, memory, and security. We cultivate a daily and diligent garden of doubt, from which we harvest many different kinds of fruits and flowers.

They add:

> We see ourselves more as citizens of a federated republic of practices than as the subjects of nations and the objects of history. This means our commitments and fealty generally lean more towards the things that we make, see, read, listen to, and participate in — images, words, sounds, and situations — rather than to abstract and static concepts that are determined by factors and forces outside our control.[2]

To abstract a definition for the Raqs Media Collective (Jeebesh Bagchi, Monica Narula, and Shuddhabrata Sengupta) or to locate their activity in the static result of artworks would be to fail in our conspiratorial task of passing along, even if only by means of a whispering campaign, the doubts that they themselves have sown. These doubts sometimes are obscured, though, doubly so: on the one hand, in the assurance of the very existence of artworks that they produce as a collective (work that this book documents); on the other hand, through a certain tone of writing, indeed, a tone of certainty that pervades whatever they write (texts which are absent here).

Raqs Media Collective's activity is only partly its products: that is, its artworks. For a collective that developed from documentary film origins and whose name — Raqs — derives from the whirling of dervishes, the "products" are only the articulation of a

process.[3] Each is a moment in an overarching scheme — a scheme though that is transversal, not end oriented.[4] And if these products seem to suggest themselves as the last moment, as if the finalization of a design, we are mislead as to their importance. Rather, they are nodal points in a network, temporary on-off switches, whose potential branching set us off on new movements — but also to soundings of new depths.

To say that the Raqs Media Collective's production is only partly its products is not to suggest instead that it is composed of multiple activities: artworks on the one hand and social agencies such as Sarai on the other hand, not to mention curatorial endeavors and writing.[5] In that sarais (*caravanserai*) are "stable institutions of hospitality for practices of nomadism,"[6] traditional places for temporary relaxation of traders and travellers and the transmission of tales, we might locate Raqs practice in such hospitable storytelling. Inheritors as they are of a nation's "epics, stories, songs, and sagas,"[7] such as the monumental *Mahabharata*, they have adapted ancient principles to modern techniques, or rather found them one and the same, indeed anticipated in advance, such as those of open text and recension. "Recensions are hospitable, they are ever willing to accommodate textual fellow travellers in their entourage."[8]

Here is a concept that we can take to be foundational to Raqs' practice: recension. Recension is revision of a text, or a continuing series of revisions, that does not obscure the original. Raqs takes a very old case — the Sanskrit epic the *Mahabharata* — to ally the textual (but which was once oral) to the very new digital realm, finding the ancient to be as hypertextual as the contemporary: "The *Mahabharata* in that sense is an instance of a perennially new media work, because it is deeply hypertextual, every recension links to other recension, every story contains the threads of many other stories."[9] The artists have written that, "The idea of a 'recension' is a concept that we have found very useful in thinking about free and open source systems of cultural production. The idea of recensions as a category that makes it possible to think about the relationships of descent, affinity, and sharing between texts and narratives is something that emerges from the sciences of textual criticism, theological exegesis, and philology."[10] A recension links not only story to story but also storyteller to storyteller through time — to the storytellers that Raqs sometimes are, speaking from afar through the voices of the *Mahabharata*. (The *Mahabharata* often stands behind — or is it above? — Raqs' work. An open source, the *Mahabharata* is a bottomless resource for their work.)

"The KD Vyas Correspondence" is not a recension, but it talks of it and much more besides. We can take this "correspondence" as an allegory of Raqs' practice. In that "A Dossier Concerning the KD Vyas Correspondence, Vol. 1," to take this particular iteration of the purported correspondence, is a public deposition, a quasi-legal document, or the fiction of one, the artists here announce their ways of proceeding. Such *performative* fictions as these — a modal practice which includes their essays, lectures, and films — are means to link the artists' various "themes," ways to practically elaborate their concerns in an open framework that can accommodate complexity without closure. It is a method that allows them to add to their stock of concerns over time and "cut-and-paste" between media.[11]

(If I name this method "writing" in the broad sense, and find the "source" of its operations in actual written texts, which cannibalistically reappear as the spoken word of lectures and films, it is not to give priority or origin to what is published. In the absence of actual artworks here, these available texts offer an insight into the complexity and fluidity of Raqs' process. "Writing" is the network of which individual artworks are the nodes.)

In part, the performative mode accounts for a tone of writing that is, at times, frankly admonitory. Admonitory in that the text speaks with that god-like voice from above and from all time that generally pervades Raqs' writing.[12] (Sometimes this untimely voice, as is the case with "The KD Vyas Correspondence," comes from the distance and divided time of a dead letter office.) But the text/tone is also confessional; whenever the artists write of KD Vyas, they are also writing of themselves: "The material we received seemed occasionally to yield tantalizing glimpses into his complex, eccentric ideas, which were always half formed and full blooded, and which forever ran in several directions all at once." Ditto Raqs. Yet, saying so is hardly a critique. Running in all directions merely implies the networked nature of Raqs' nodal artwork.[13] Similarly, the phrase "half formed and full blooded" only conveys a sense of the "unresolved poetics" of their work, which variously maintains itself as an eccentric site for belated haunting. Recensions, too, are haunted.

Overlay underlies the concept of recension, if I might make this seemingly contradictory statement. Any superimposition may yield traces that were not previously visible. Superimposing the idea of a digital open-source network on the reality of a sprawling, unregulated, and sedimented city such as Delhi tells us something novel of the latter, but the reverse is equally true and just as productive, perhaps more so. Each is a means to think the other and has been so in many of Raqs investigations, of which Sarai is one outcome. We need to be careful, however, that any new mapping (any mapping is a schematic overlay) is not new strip mining. "How can those of us who work with information in a creative manner begin to get a handle on the enormously significant ethical questions that arise from working with information in today's world?", Raqs ask.[14] They also say, rhetorically but to allegorical ends, of any current artistic practice, "The first question we want to ask is: how can this fiction of location, this imaginary map, the one that we are all currently engaged in drawing, not reproduce the boundaries that beset all mapmaking exercises? How can we as mapmakers avoid the predicament of an expression of mastery over the landscape we intend to survey?"[15] Mapping or mining: there are always two sides to an act that make it either ethical or exploitive.

This makes all terrain contested, even that of a photograph, which we know is anything but transparent. "The surface of the photograph then has to be seen as a contested terrain. Appearing on it or disappearing from it is not a matter of visual whimsy, but an actual index of power and powerlessness."[16] Take eugenicist Francis Galton's nineteenth-century physiognomic typologies, which figure in Raqs' 2009 film installation *The Surface of Each Day is a Different Planet*, and which were nothing but series of transparent photographic overlays. Galton intended to chart, for example, the deviant "Jewish Type," through the averaging of pictorial statistics, by mapping face on photographic face —

but in the end was met by the composite gaze of a Jewish angel.[17] Arrested in a blur, appearing and disappearing at the same time, collectively these individuals exist as a palimpsest of personalities reduced to a cipher. By "cipher" I mean reduced to a code but also to a naught, in the sense that one uses the photograph to cipher deviancy but also to esteem a person of no importance.

A palimpsest is not a recension. But it is a corollary concept. Contrary to recension, any overlay of a palimpsest obscures what is beneath. For a palimpsest, the issue of legibility, therefore, is paramount. Legibility means visibility in Raqs' world, but this is not always a good thing. Visibility means an arrest of identification and examination:

> To be legible is to be readable. To be legible is to be an entry in a ledger — one with a name, place, origin, time, entry, exit, purpose, and perhaps a number. To be legible is to be coded and contained. Often, when asked an uncomfortable question, or faced with an unsettling reality, the rattled respondent ducks and dives with a stammer, a mumble, a sweat, a scrawl, or a nervous tic. The respondent may not be lying, but neither may he be interested in offering a captive legible truth either to the interrogator or in response to his own circumstances.[18]

For Raqs, the difference between recension and palimpsest really is a valency that puts them to different use. With a recension, nothing is lost; it is a positive model for ongoing creative dialogue. With a palimpsest, what is seemingly lost or obscured may only be hidden in sight. The palimpsest, thus, has a bifurcated value: "An insistence on legibility produces its own shadow: the illegible. Between the bare-faced lie and the naked truth lies the zone of illegibility — the only domain where the act of interpretation retains a certain ontological and epistemic significance."[19] Here, illegibility has the virtue of self-defense.

In the obdurate resistance of what underlies or that falls or escapes through the meshes of evidence as residue, Raqs finds a whole other dialectic of legibility and illegibility, visibility and invisibility, appearance and disappearance. But how is resistance or residue made visible against overwhelming evidential fact? The photograph is evidence, evidence of a sort. But of what sort? What is evident in the photograph is not necessarily what the photograph is evidence *of*. The photograph can be used in evidence, brought forth in criminal trial or the marshalling of historical fact: of an individual, action, or event. But a single photograph, such as Felice Beato's 1858 photograph, *Scene at Sikanderbagh*, can be shown to be both the construction of assurance and the sowing of doubt. So this photograph figured in Raqs' 2009 *The Surface of Each Day is a Different Planet* and their 2011 theatre production *Seen at Secunderabagh*. Of what does this photographic evidence, or lack of, convict?

Then we have the question of what constitutes evidence *in* the photograph? Galton sought the indices of insanity or deviancy within the photographic image itself, not in its referential association. Simply stated, the photograph is evidence of a "that has been."

But can a photograph be evidence, too, of disappearance, not only of an object or individual that we know destiny has displaced, but evidence of disappearing itself, as an event? Contrary to a documentary film ethos according the reality of the image evidence of lived experience, Raqs have turned themselves into documentarians of the *disappearance* of lived experience.[20]

Take the crowd. It might be thought itself as a photograph, and a photograph that captures it as an emblem itself of statistics. Any individual caught within it is a matter merely of ciphers and statistics.[21] A missing person might float there and disappear in the sieve of the crowd.

> Millions of people fade from history, and often the memory of their disappearance also fades with time. With the disappearance of ways of life, entire practices and the lived experiences and memories that constituted them vanish, or are forced to become something other than what they were accustomed to being. When they make the effort to embrace this transformation, typically what stands questioned is their credibility. They are never what they seem to be, or what they try to say they are. The annals of every nation are full of adjectives that accrue to displaced communities and individuals that begin to be seen as cheats, forgers, tricksters, frauds, thieves, liars, and impostors, as members of "criminal castes, tribes, and clans" or as deviant anomalies who habitually attempt to erode stable foundations with their "treacherous" ambiguities and their evasive refusal to be confined, enumerated, or identified.
>
> These "missing persons" who disappear, or appear with great reluctance, with their names, provenances, identities, and histories deliberately or accidentally obscured in the narratives of "progress" and the histories of nation states, are to the processes of governance, what the figure of the "unknown soldier" is to the reality of war. The only difference is that there are no memorials to those who fade from view in the ordinary course of "progress." The missing person is a blur against a wall, a throw-away scrap of newspaper with a fading, out-of-focus image of a face, a peeling poster announcing rewards for wanted or lost people in a police post or railway station waiting room, a decimal point in a statistic, an announcement that some people have been disowned or abandoned or evicted or deported or otherwise cast away, as residues of history. No flags flutter, no trumpets sound, nothing burns eternal in the memory of a blur.
>
> The blur is not even an image that can lay a claim to original veracity, but a hand-me-down version of a reality that is so injured by attempts at effacement that only a copy can have the energy necessary to enable its contents to circulate. The patchwork of faded fakes, interrupted signals, and unrealized possibilities, which does not read well and which does not offer substantive and meaningfully rounded-off conclusions, is sometimes the only kind of manuscript available to us.[22]

Let's not take this only as Raqs' lament for the disappeared and dispossessed. The individual may be subject to evidentiary criteria but the missing person slyly opposes any generalized surveillance that classifies or scrutinizing gaze that tries to hunt him or her down by means of an obligatory biometrics. A passive act of transforming oneself or disappearing within appearance counters any governing attempts at measurement. "The imperative of identification, and its counterpoint, the dream of disguise, are impulses we find central to the story of our times," Raqs tell us.[23] Hence, the "cheats, forgers, tricksters, frauds, thieves, liars, and impostors" that substitute for the missing person and for whom Raqs here act as spokesperson.[24] The missing person is the unnamed entity at the heart of the Raqs Media Collective's enterprise, the unstable figure around which the questions of legibility and illegibility, visibility and invisibility, evidence and identity revolve.

If the missing person is recessive and residual, the other emblematic figure in Raqs' world is the impostor, who is infiltrative and disruptive.

> The impostor is an exemplar for a kind of performative agency that renders a person capable of expressing more than one kind of truth of the self to the scrutiny of power. The figure of the impostor offers a method of survival that meets the growing intensification of scrutiny with a strategy based on the multiplication of guises and the amplification of guile. At the same time, the term impostor is also an accusation; one that power can fling at anyone it chooses to place under scrutiny. It is this double-edged state, of being a way out as well as a trap, that lends it the capacity to be a heuristic device uniquely suited for a nuanced understanding of a time in which criteria such as authenticity, veracity, and appropriateness take on intense, almost paranoiac dimensions in the conduct and governance of life's most basic functions.[25]

The missing person and the impostor are complementary, not oppositional, figures, when they are not sometimes one and the same. They are not fixed symbols, though, but emblems of fluid strategies within deteriorating situations.

> With respect to residue: it may be said it is that which never finds its way into the manifest narrative of how something (an object, a person, a state, or a state of being) is produced, or comes into existence. It is the accumulation of all that is left behind, when value is extracted. Large perforations begin to appear in chronicles, calendars, and maps, and even the minute agendas of individual lives, as stretches of time, tracts of land, ways of being and doing, and entire clusters of experience are denied substance.[26]

To disappearing residue, Raqs offers the methodological concept of "seepage." Seepage is another, now fluid, form of overlay that is infiltrative:

> By seepage we mean the action of many currents of fluid material leaching onto a stable structure, entering and spreading through it by way of pores, until it

becomes a part of the structure, both in terms of its surface, and at the same time as it continues to act on its core, to gradually disaggregate its solidity. To crumble it over time with moisture.

In a wider sense, seepage can be conceived as those acts that ooze through the pores of the outer surfaces of structures into available pores within the structure, and result in a weakening of the structure itself. Initially the process is invisible, and then it slowly starts causing mold and settles into a disfiguration — and this produces an anxiety about the strength and durability of the structure.

By itself seepage is not an alternative form; it even needs the structure to become what it is — but it creates new conditions in which structures become fragile and are rendered difficult to sustain. It enables the play of an alternative imagination, and so we begin seeing faces and patterns on the wall that change as the seepage ebbs and flows.[27]

Seepage is an infiltrative act that adheres to a dominant structure while surreptitiously undermining it to produce its own counter-residue.[28] Whatever play of "alternative imagination" is figured within this dissolution, we are not left only lamenting a loss but have residual hope.

Falling through the sieve or off the map, where do we go from here? Let's leave the last word to the Raqs Media Collective:

What happens to the people in the places that fall off the map? Where do they go? They are forced, of course, to go in search of the map that has abandoned them. But when they leave everything behind and venture into a new life they do not do so entirely alone. They go with the networked histories of other voyages and transgressions, and are able at any point to deploy the insistent, ubiquitous insider knowledge of today's networked world.[29]

# NOTES

1. "Every witness is also an actor. All actors are also witnesses. All witnesses are redactors. Reading the *KD Vyas Correspondence, Vol.1*," a talk delivered 24 September 2008 in Damascus for the Reloading Images workshop. "The KD Vyas Correspondence" exists as this lecture, an "essay" ("A Dossier Concerning the KD Vyas Correspondence, Vol. 1") and a video installation (*The KD Vyas Correspondence, Vol. 1*, 2006). "A Dossier Concerning the KD Vyas Correspondence, Vol. 1" was published in *The KD Vyas Correspondence: Vol. 1*, ed. Monique Behr (Frankfurt am Main: Revolver – Archive für Aktuelle Kunst, 2006).

2. "Heartbeats. 20 Artists: First Person," in *International Gallerie* 24 (July 2009).

3. "Raqs is a word in Arabic, Turkish, Persian and our own Urdu that denotes a whirling, a dancing, a practice and cultivation of ecstatic contemplation founded on kinesis. So our name, our artistic signature, comes from the whirling — the Raqs — of whirling dervishes …." "Learning from the Horizon: Practicing Art. Imagining Politics," a talk delivered by Shuddhabrata Sengupta for the *Second Former West Research Congress*, Istanbul, 5 November 2010. Raqs is also an acronym for "rarely asked questions."

4. "The epics, stories, songs, and sagas that represent in some ways the collective heritage of humanity have survived only because their custodians took care not to lock them into a system of 'end usage,' but instead embellished them, which added to their health and vitality, before passing them on to others." "Pacific Parables" (2006), in Raqs Media Collective, *Seepage* (Berlin and New York: Sternberg Press, 2010), 12.

5. In 2000 Raqs co-founded the Sarai Programme at the Centre for the Study of Developing Societies in New Delhi. http://www.sarai.net

6. "Learning from the Horizon."

7. "Pacific Parables," 12. Cf. "We grew up hearing many kinds of stories. Stories of wise animals and stupid gods, arrogant kings and generous subjects, magical machines and speaking trees." "New Maps and Old Territories: A Dialogue between Yagnavalkya and Gargi in Cyberia," in *Seepage*, 159.

8. "Reading the KD Vyas Correspondence, Vol.1."

9. Ibid. "Each story demands the telling of another story, and the telling of that other story demands the re-telling of another story, and so on. Hypertext is an ancient device. New Media is very old media." "A Dossier Concerning the KD Vyas Correspondence, Vol. 1." Needless to say, the stories of the *Mahabharata* take many trans-cultural forms and are not limited to their actual telling in the epic: from ancient sculptures to puppet shows to contemporary films, not to mention Raqs' work itself. See "Digressions from the Memory of a Minor Encounter" (2006), *Seepage*, 46–55, which recounts Raqs twentieth-century encounter of a circa 967 CE Cambodian temple frieze of a minor story from the *Mahabharata* in a nineteenth-century Paris museum, where they "felt the sharp edge of estrangement in something that also felt downright familiar" (46), for an apt discussion on contemporaneity: "An increased intensity of communication creates a new kind of experiential contagion. It leads to all kind of illegitimate liaisons between things that were meant to be unfamiliar. The first thing that dissolves under the pressure of this promiscuous density of contact across space is the assumption that different degrees of 'now' can be better obtained in different places; that Delhi, or Dar-es-Salaam are somehow less 'now' than Detroit. The 'now' of different places leach into each other with increasing force" (47).

10. "Reading the KD Vyas Correspondence, Vol.1." Raqs' usage of "recension" is not the same as "the process of reconstructing the most reliable readings from variant versions of a text." Chris Baldick, *The Concise Oxford Dictionary of Literary Terms* (Oxford: Oxford University Press, 1990), 185. In "The Concise Lexicon: of/for the Digital Commons," Raqs define "recension" as: "A re-telling, a word taken to signify the simultaneous existence of different versions of a narrative within oral, and from now onwards, digital cultures. Thus one can speak of a 'southern' or a 'northern' recension of a myth, or of a 'female' or 'male' recension of a story, or the possibility (to begin with) of Delhi/Frankfurt/Tehran 'recensions' of a digital work. The concept of recension is contraindicative of the notion of hierarchy. A recension cannot be an improvement, nor can it connote a diminishing of value. A recension is that version which does not act as a replacement for any other configuration of its constitutive materials. The existence of multiple recensions is a guarantor of an idea or a work's ubiquity. This ensures that the constellation of narrative, signs, and images that a work embodies is present, and waiting for iteration at more than one site at any given time. Recensions are portable and are carried within orbiting kernels within a space. Recensions, taken together, constitute ensembles that may form an interconnected web of ideas, images, and signs." *Sarai Reader* 03 (Delhi: The Sarai Programme, 2003), 363. OPUS (Open Platform for Unlimited Signification) was a public platform Raqs created for such activity. It was launched as an online adjunct to their installation *Co-ordinates 28.8N 77.15E* at *documenta 11* in 2002.

11  The same can be said of the video installation *The KD Vyas Correspondence, Vol. 1*: "The installation invites its viewer to reflect on this insistence by entering a matrix of eighteen video loops and nine layered soundscapes that function as a select set of indices to our continuing investigations on the theme of 'declining time,' on the protocols of the production and transmission of narratives, on the vexed questions of the verification and authenticity of being, and on some methods for remaining sane in the early years of the twenty-first century." "Reading the KD Vyas Correspondence, Vol.1."

12  In part, the "Dossier Concerning…" is a fictional device used to deliver KD Vyas's "Selected Admonitions," such as: "Disguise the contents of your dreams but reveal the structure of your thoughts and be open with the materials of your research."

13  One might initially think that a work like *Revoltage* (2010), whose electrical illumination alternates between the words "revolt" and "voltage," is merely binary in its opposition but its streams of electrical cords implicate that decision in a host of connections. See the entry "Node" in "A Concise Lexicon "

14  "Pacific Parables," 11.

15  Ibid., 7.

16  "In the Theatre of Memory: The Work of Contemporary Art in the Photographic Archive," *Lalit Kala Contemporary* 52 (January 2012), 86.

17  "But the 'ghost' image of a composite of madmen from Bedlam has strangely gentle eyes. Galton's wager, that if you were to stick the faces of eighty-six inmates of the Bedlam asylum on top of each other you would end up looking into the eyes of madness, has gone oddly awry. Criminal composites produce a saintly icon. A quest for the precise index of what Galton thinks is ugliness in a row of sullen East London Jewish schoolboys yields amazing grace." Ibid. 85. Raqs long-standing interest and investigation of biometrics finds a coincidence in the fact that in 1858 William Herschel sent Galton the hand print of a man called Raj Konai, a villager from lower Bengal. This hand print appears in Raqs' work *The Untold Intimacy of Digits* (2011).

18  "Stammer, Mumble, Sweat, Scrawl, and Tic," (2008) in *Seepage*, 31.

19  Ibid.

20  In their 30 April, 2009, lecture for the Prefix Urban Field Speaker series, "Photographs and Phantoms," Raqs quote Ackbar Abbas: "Disappearance, too, is a matter of presence rather than absence, of super-imposition rather than erasure. Hence an elective affinity between the photograph and disappearance." See Abbas, *Hong Kong: Culture and the Politics of Disappearance.* (Minneapolis: University of Minnesota Press, 1997), 106.

21  "Because the crowd erases distinctions and gains numbers because a crowd is nothing if it is not an accumulation." Scenario to *The Surface of Each Day is a Different Planet*. In part, this work is a complex meditation on the relation of individual and crowd, and crowds and photographs.

22  "Dreams and Disguises, as Usual," (2004) in *Seepage*, 81.

23  Ibid., 74.

24  The impostor and missing person are Benjaminian types much like those allegorical figures Raqs employ to "speak to the predicament of the contemporary practitioner": "In a networked world, there are many acts of seepage…. They destabilize the structure, without making any claims. So the encroacher redefines the city, even as she needs the city to survive. The trespasser alters the border by crossing it, rendering it meaningless and yet making it present everywhere—even in the heart of the capital city—so that every citizen becomes a suspect alien and the compact of citizenship that sustains the state is quietly eroded. The pirate renders impossible the difference between the authorized and the unauthorized copy, spreading information and culture, and devaluing intellectual property at the same time. Seepage complicates the norm by inducing invisible structural changes that accumulate over time." "X Notes on Practice: Stubborn Structures and Insistent Seepage in a Networked World" (2002), in *Seepage*, 107, 112.

25  "Dreams and Disguises, as Usual," 76. The quotation continues: "As concepts, the 'impostor,' like the 'waiting room,' can signify both thresholds meant for quick, sportive, and easy crossing, portals into unpredictable futures, that come laden with the thrill that only unintended consequences can bring, and, for some, a bleak and eternal purgatory tinged with its own peculiar anxiety, distrust, and fear." Raqs' notion of the waiting room is also a situation that applied until very recently to non-Western artists. "The figure of a person biding time in a waiting room helps us to imagine the predicament of people living in societies often considered to be inhabiting an antechamber to modernity. In such spaces, one waits to be called upon to step onto the stage of history. Most of the world lives in spaces that could

be designated as 'waiting rooms,' biding its time. These 'waiting rooms' exist in transmetropolitan cities, and in the small enclaves that subsist in the shadow of the edifices of legality. There are waiting rooms in New York just as there are waiting rooms in New Delhi, and there are trapdoors and hidden passages connecting a waiting room in one space with a waiting room in another." Ibid., 75–76. The impostor in the waiting room figures in the video *They Called it the XXth Century* (2005).

26    "Photographs and Phantoms." Cf. "The first thing to consider is the fact that most of these acts of transgression are inscribed into the very heart of established structures by people located at the extreme margins. The marginality of some of these figures is a function of their status as the 'residue' of the global capitalist juggernaut. By 'residue,' we mean those elements of the world that are engulfed by the processes of Capital, turned into 'waste' or 'leftovers,' left behind, even thrown away." "X Notes on Practice," 111.

27    "X Notes on Practice," 112. Cf. Raqs' comment on their work *Erosion by Whispers* (2005): "Things can come undone because of a whispered rumour. Cities may be built in steel and concrete but they are eroded by whisper. *Erosion by Whispers* reflects on the way in which rumours render cities ephemeral."

28    If we qualify Raqs' work as a semiotics of recension (with its three aspects of the textual [recension and palimpsest], the diagrammatic or schematic [mapping], and the indexical (the superimpositions of photography]), we have to remember this concept of seepage that makes it all active and effective.

29    "X Notes on Practice," 112.

## Mistakes

Some works never complete themselves. Mistakes in an art work make our understanding of it porous. This understanding may not have been available to us otherwise. They are mistakes, and not necessarily failures. Sometimes, the feeling that a mistake is being made could be present during the making of the work itself. A mistake could be a wrong balance of form, amplitude, intensity, and even in the balance of placements. Mistakes do not translate into "lessons learned"— they are practice itself.

# 1

CO-ORDINATES OF
EVERYDAY LIFE

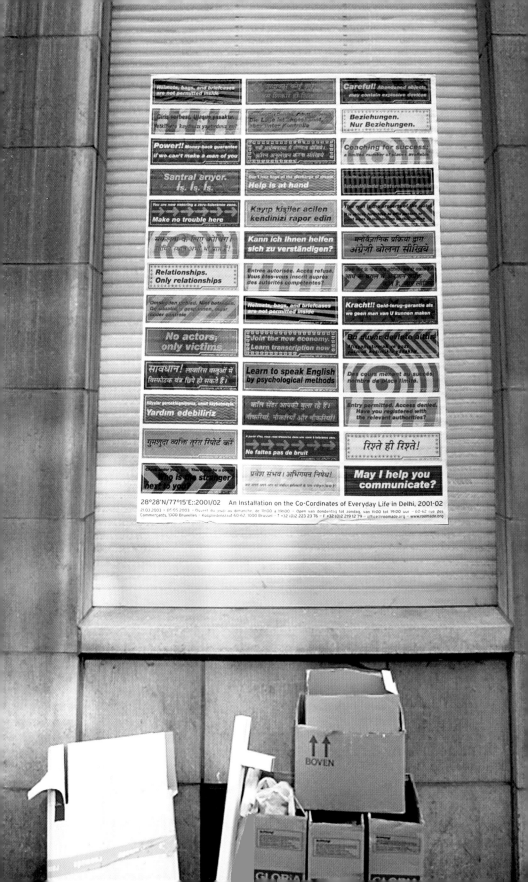

# CO-ORDINATES 28.8N 77.15E

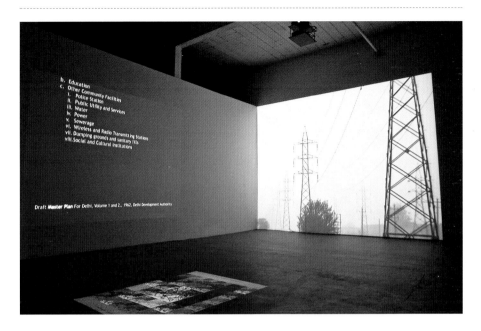

2002/ Installation with video, audio, prints, stickers

Documenta 11, Kassel, Germany (2002). *City One conference*, Sarai/CSDS, Delhi (2003). *Co-Ordinates*, Roomade Office for Contemporary Art, Brussels (2003). *Image Asia*, Copenhagen (2003). *Adaptations* (curated by Craig Buckley), Apexart, New York (2004); Kunsthalle Fridericianum, Kassel (2004). *Digital Discourse*, Malta (2005-06).

In listing a set of latitude and longitude measurements, bracketed by two calendar years, this installation names a city called Delhi and a time that feels like the first two years of the twenty-first century. In doing so, the syntax of space-time coordinates also connects the city as a location to the abstractions of other spaces and times.

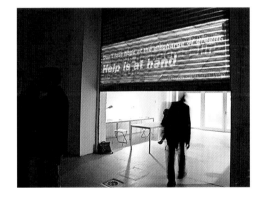

These co-ordinates become a frame within which the work witnesses the experience of living in Delhi in terms of the constant conflict over control of space and over the different meanings that accrue to space. The installation presents each unit of space — public or residential — as being open to a variety of conflicting claims made by inhabitants, transients, users, owners, and planners.

It witnesses the city as the battleground of a daily civil war between the master plan and the moment.

# 5 PIECES OF EVIDENCE

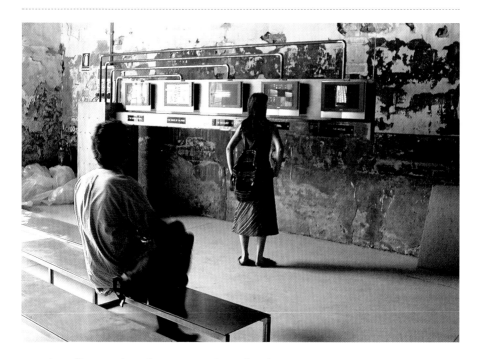

2003 / Installation with 5 video screens, audio, and steel armature

*The Structure of Survival*, Venice Biennale (2003). *Janken: The Power of Chance*, Ogaki Biennale (2006). Awarded Honorary Mention at Prix Ars Electronica, Linz

*5 Pieces of Evidence* reflects on missing persons, urban myths, transitoriness, maps, and global networks. The five screens are narratively organized along the lines of a "whodunit."

Missing persons notices, street maps, demographic statistics, and images of pipelines, rail tracks, harbours, and cityscapes evoke a multi-layered set of speculations on the way urban spaces stage everyday "disappearances."

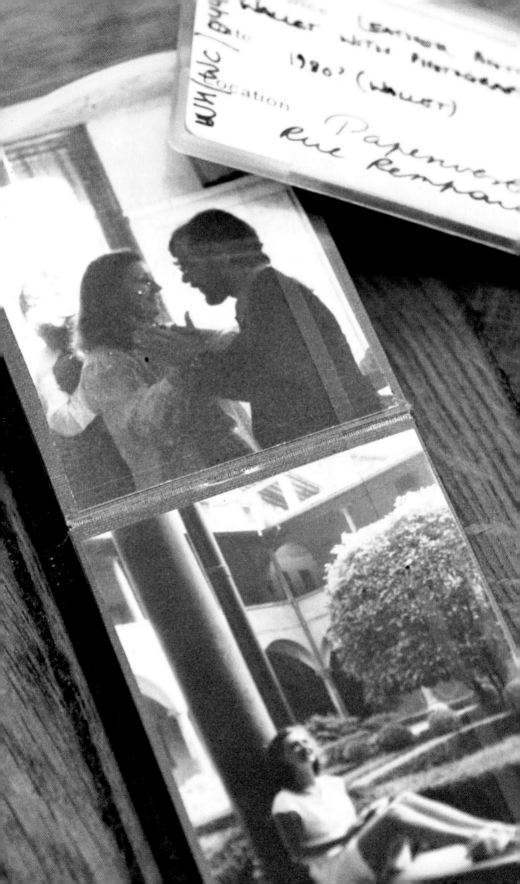

# THE WHEREHOUSE

2004 / Installation with video, found objects, altered books, text panels, audio, spoken performance, photographs, and web page

*Revolution/Restoration II*, Palais des Beaux-Arts, Brussels (2004). Taipei Biennial, Taipei (2004-05).

*The Wherehouse* is a constellation of images, objects, and annotational possibilities designed to posit a speculative archaeology of/for the present moment.

It constitutes an assemblage of reflections on time, memory, movement, stasis, and location in a world where some people are forced to abandon home, while others are imprisoned by their assumptions about the stability of their present location.

The constellation gestures to the fragility of the moorings we have in the materiality of the world we inhabit, and to our brittle certitudes about our destinies. It essays this through a sustained interaction with abandoned objects on the streets of Brussels and a series of annotations that engage with the experiences and reflections of immigrants to Europe, many of whom live under conditions of detention.

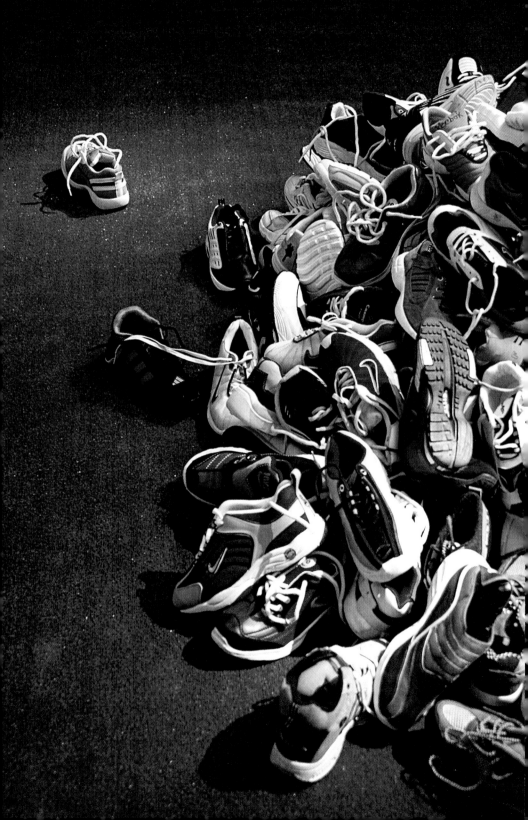

# LOST NEW SHOES

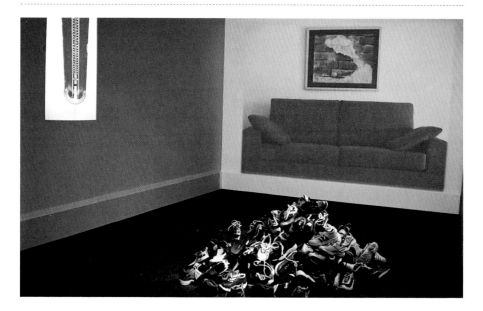

2005/ Installation with shoes, astroturf, and video projections

*Citizens*, Pitzhanger Manor House, London (2005); The City Gallery, Leicester (2005); Oriel Davies Gallery, Powys, Wales (2005); Ormeau Baths Gallery, Belfast (2005).

*Lost New Shoes* confronts the notion of the "citizen" by looking at the absence or void where a person may be. One way of looking at a pair of shoes (just shoes) is to regard them as hollow objects from which someone has withdrawn themself. Used and thrown away shoes, like used-up people, are hollowed out by the absence of meaningful usage. One is shod with citizenship as with shoes. As is often the case, the fit can be too tight for comfort.

Measurements index the effort involved in making bodies count. Bodies, like shoes, are examined if they measure up to the claims that can be made about them and they are often found wanting. Sometimes, as people disappear, shoes are the only things left standing. Shoes leave bodies. Bodies leave shoes.

*Lost New Shoes* looks at shoe that went astray in search of places that were considered safe to walk in. Shoes that confronted new terrain that approached rest but didn't quite get there, that stopped where maps and walls made them stand still. We are looking at the emptiness in them that asks to be filled with a claim to just be. The images that make up this installation are only a record of an itinerary in search of somewhere to stand.

# U
## Ubiquity

Everywhere-ness. The capacity to be in more than one of heterogeneous situation, a feature of the

Read, Modify, Rearrange

# T
## Tools

Read, Modify, Rearrange

# S
## Site

Read, Modify, Rearrange

# TAS (TEMPORARY AUTONOMOUS SARAI) with Atelier BowWow (Tokyo)

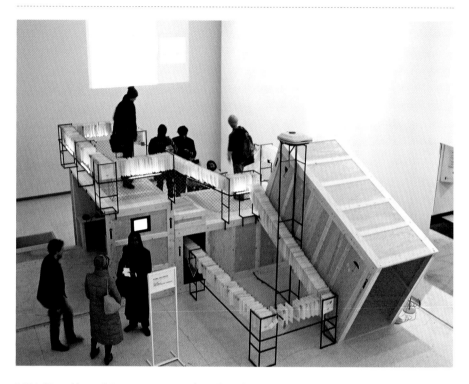

2003 / Portable, multi-use structure made with packing crates for computers, projectors, paper, sound, and people

*How Latitudes Become Forms: Art in a Global Age*, Walker Art Center, Minneapolis (2003).

The *TAS (Temporary Autonomous Sarai)* is an attempt to give form to an ethic of improvisation, conversation, and hospitality through an impermanent structure that can contain itself as it moves from place to place.

The structure, made of crates used to pack art objects in museums, snow fencing, plastic hangers, clips, A4 sized heavy transparency paper, and post-it notes, unpacks to form a refuge for people, computers, texts, signs made with pen and paper, and software that privileges itinerancy, flexibility of usage, and the possibility of role-shifts between users and producers, players and viewers, guests and hosts.

In this spatial configuration, all visitors are encouraged to be playful with the presences and traces of others.

# JUST PASSED HARMONY

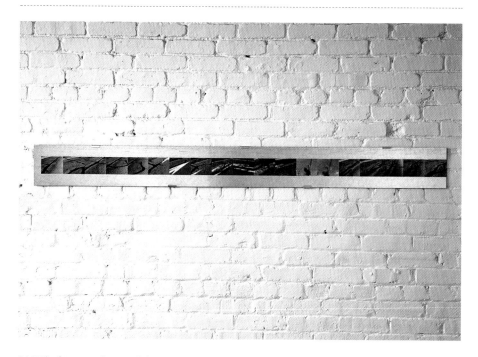

2007/ Inkjet on galvanized aluminum. 18 x 182 cm

*India: New Installations, Part II*, Mattress Factory, Pittsburgh (2007-08).

A long strip of galvanized steel bears the emboss of the high road, just past the town called Harmony. On the way, possibly, to Industry.

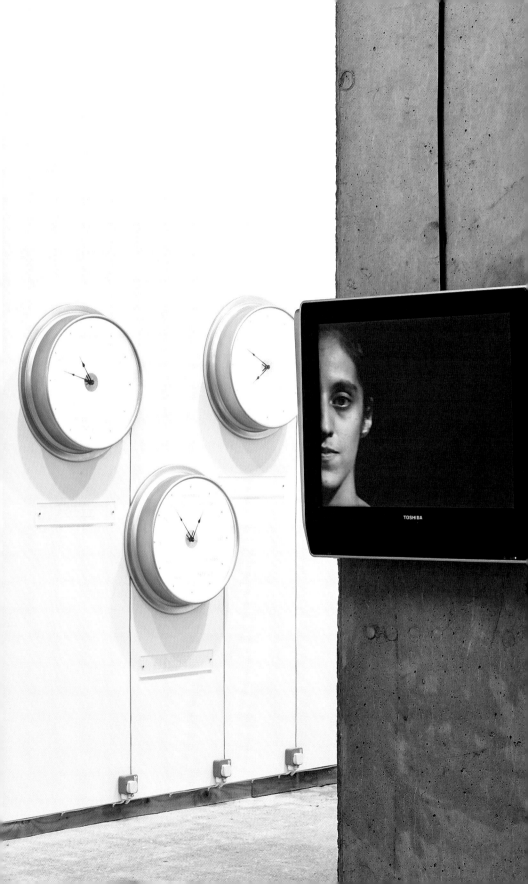

# ESCAPEMENT

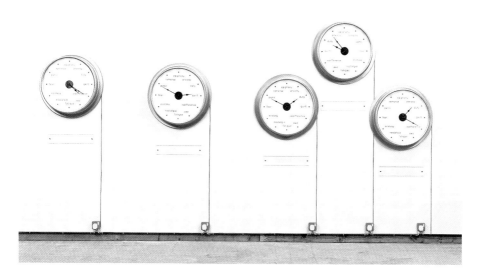

2009/ Installation with 27 clocks with LED lights, 4 video monitors, and looped audio

*Escapement*, Frith Street Gallery, London (2009).

*Escapement* invokes clockwork, emotions, geography, fantasy, and time zones to ask what is contemporaneity—what does it mean to be living in these times, in these quickening hours, these accumulating minutes, these multiplying seconds, here, now?

*Escapement* denotes the mechanism in mechanical watches and clocks that governs the regular motion of the hands through a "catch and release" device that releases and restrains the levers that move the hands for hours, minutes, and seconds. Like the catch and release of the valves of the heart, allowing for the flow of blood between the chambers which sets up the basic rhythm of life, the escapement of a watch regulates our sense of the flow of time. The continued pulsation of our hearts, and the ticking of a clock, denote our liberty from an eternal present.

With each heartbeat, with each passing second, they mark here and now, promise the future and remember the resonance of the heartbeat that just ended. It is our heart that tells us that we live in time.

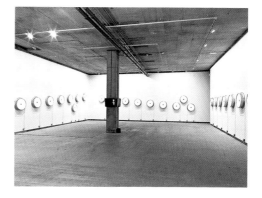

Time girds the earth tight. Day after day, the hours, astride minutes and seconds, ride as they must, relentlessly. In the struggle to keep pace with clocks we are now everywhere and always in a state of jet lag, catching up with ourselves and with others, slightly short of breath, slightly short of time. Escape, when possible, is up a hatch and down a corridor between, and occasionally beyond, longitudes, to places where the hours chime epiphanies.

# Global Village Health Manual

## Ver 1.0

### A work by
### Raqs & Mrityunjoy

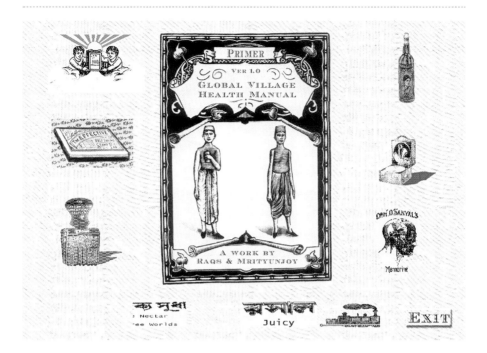

2000/ Web-based work using re-purposed material found in web searches

*Kingdom of Piracy* (curated by Shu Lea Chang, Yukiko Shikata, and Armin Medosch), Ars Electronica, Linz (2002).
*Edge of Desire* (a travelling exhibition co-organised by the Art Gallery of Western Australia and the Asia Society,
curated by Chaitanya Sambrani), Art Gallery of Western Australia, Perth (2004); Asia Society of Museum of Art,
New York (2005); Museo Tamayo, Mexico City (2005); MARCO, Monterrey (2006); Berkeley Art Museum,
Berkeley (2006); National Gallery of Modern Art, New Delhi (2006); National Gallery of Modern Art, Mumbai (2007).

*Global Village Health Manual, Ver 1.0* is an eccentric assemblage of material found in web searches that suggests the fragility of the body, especially the labouring body, in cyberspace. It signposts the exhilaration as well as the exhaustion that characterized early forays into virtuality. Links to cloning, repetitive strain injury, cyborgs, data bodies, virtual prostheses, idorus, anthropometry, and innovative methods of torture are presented through an interface that invokes nineteenth-century print culture.

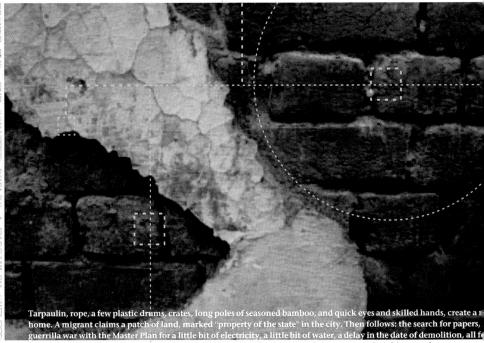

A boat changes course at sea, dipping temporarily out of the radar of a nearby coastguard vessel. A cargo of contraband people in the hold, fleeing war, or the aftermath of war, or the fifth bad harvest in a row, or a dam that flooded the valley, or moving in search of employment, or a government that suddenly took offence at the way they spelt their names. The map of the world is now contoured with safe havens and dangerous border posts, places for landing, transit and refuge, encircled and annotated in blue ink. A geography lesson learnt in the International University of Exile.

Tarpaulin, rope, a few plastic drums, crates, long poles of seasoned bamboo, and quick eyes and skilled hands, create a new home. A migrant claims a patch of land, marked "property of the state" in the city. Then follows: the search for papers, guerrilla war with the Master Plan for a little bit of electricity, a little bit of water, a delay in the date of demolition, all few scraps of legality and a few loose threads of citizenship. The learning of a new accent, the taking on of a new name, invention of one or several new histories that might procure a ration card or a postponed eviction notice. The squat grows incrementally, in Rio de Janeiro, in Delhi, in Baghdad, creating a shadow global republic of not-quite citizens, with not-there passports, and not-there addresses.

# SIGHTINGS

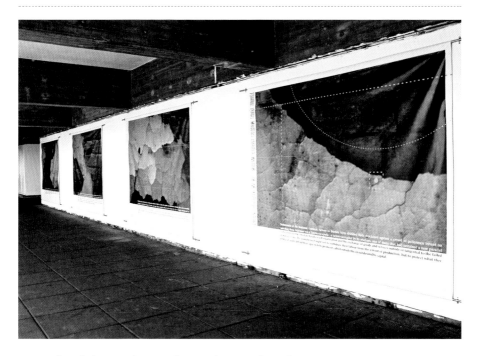

2007/ Altered photographs printed on vinyl. Series of 4, each 130 x 275 cm

*World Factory: Active Witness*, San Francisco Art Institute, San Francisco (2007). 10th Istanbul Biennial (2007).

*Sightings* is a photographic foray in decaying architecture with cartographic resonances. The images, taken together, seem to indicate the possibility that an entire map of the world can be deciphered from close observation of walls in need of repair. The images are annotated by a set of texts that invoke a quartet of figures who constitute a whimsical but carefully constructed navigation aid for the contemporary world.

geographies do not congea[l]
in a **work** of art.

la geografia **non** si fossilizza
in **un'opera** d'arte.

la **curiosità si esaurisce**
in una mostra d'arte?

can **curiosity** end
with an *art* exhibition?

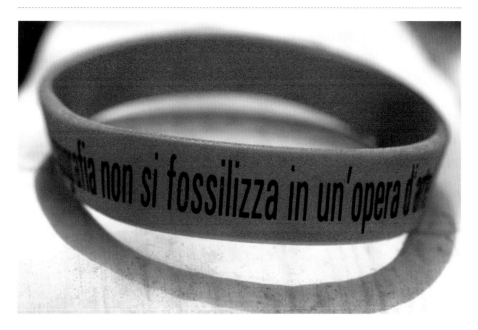

2006/ Installation of bilingual wall texts and wrist band inscriptions

*Sub-contingent*, Fondazione Sandretto Re Rebaudengo, Turin (2006).

*3 Caveats...* are a set of inscriptions designed to be read on a bare wall or worn as wristbands that ask questions about viewership, curation, exhibition, and distance.

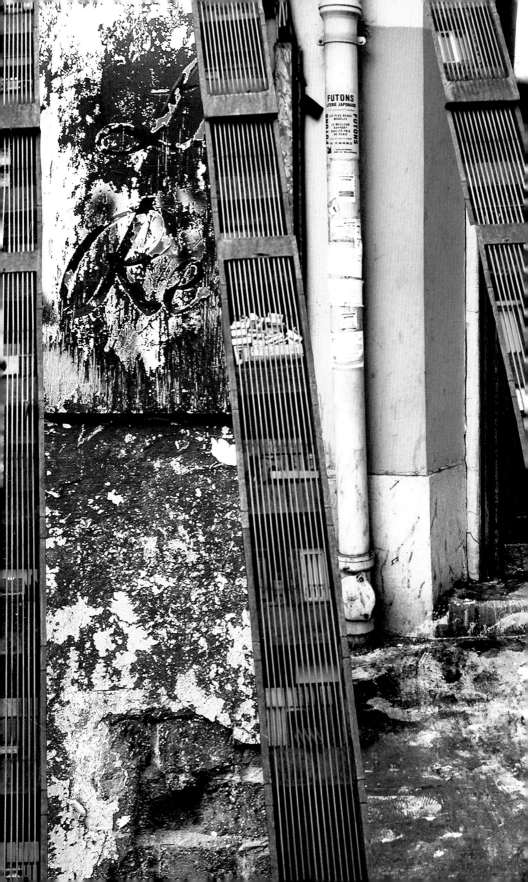

# EROSION BY WHISPERS

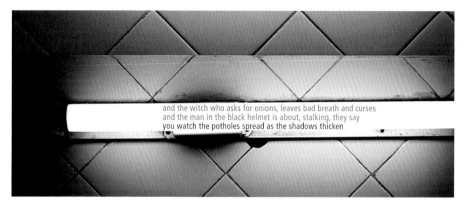

and the witch who asks for onions, leaves bad breath and curses
and the man in the black helmet is about, stalking, they say
you watch the potholes spread as the shadows thicken

2005/ 2 lightboxes, galvanized wire, printed broadsheets. 66 x 76 x 13 cm

*Ephemeral Cities: A Project Space*, Deptford X, London (2005).

*Erosion by Whispers* is an intangible presence of words, whispers, and rumours across our dense urban infrastructure suggesting that fragility is as much part of the experience of cities as the claim to endurance built into their design.

The extraction of value from any material, place, thing or person, involves a process of refinement. During this process, the object in question will undergo a change in state, separating into at least two substances: an extract and a residue.

A packet of smokes and a scatter of cigarette butts. Cigarette butts and ash, ash and the debris of thoughts in the aftermath of a deal closed by lunch. The hot expulsion of a smoke ring floats through a transaction like a fragment of history, a fragment of history and a

tobacco cartel. A tobacco cartel and a packet of smokes, a packet of smokes and a scatter of butts, a scatter of butts and ash, and so on.

With respect to residue: it may be said it is that which never finds its way into the manifest narrative of how something (an object, a person, a state, or a state of being) is produced, or comes into existence. It is the accumulation of all that is left behind, when value is extracted.

Large perforations begin to appear in chronicles, calendars and maps, and even the minute agendas of individual lives, as stretches of time, tracts of land, ways of being and doing, and entire clusters of experience are denied substance.

There are no histories of residue, no atlases of abandonment, no memoirs of what a person was but could not be.

Everything is valuable, yet all things can be laid waste.

The sediments that precipitate at the base of our experience of the world can, however, decompose to ignite strange sources of light, like will o' the wisps in marshlands by night. Sometimes, this is all the illumination there can be in vast stretches of uncertain terrain.

ALL THAT CAN BE VALUABLE IS ACCOUNTED FOR. RESIDUES REMAIN, AWAITING ESTIMATION; OCCASIONALLY GLOWING.

The extraction of value from any material, place, thing or person, involves a process of refinement. During this process, the object in question will undergo a change in state, separating into at least two substances: an extract and a residue.

A plate of baked fish and fish bones picked clean, fish bones picked clean and a jaded palate, a jaded palate and a moment of indulgence, an indulgent moment and a re-drawn map, a re-drawn map and a fragment of history, a fragment of history and a sea without fish, an empty sea and container ships, container ships and a box full of ice, a box

full of ice and a plate of baked fish, a plate of baked fish and fish bones picked clean, and so on.

With respect to residue: it may be said it is that which never finds its way into the manifest narrative of how something (an object, a person, a state, or a state of being) is produced, or comes into existence. It is the accumulation of all that is left behind, when value is extracted.

Large perforations begin to appear in chronicles, calendars and maps, and even the minute agendas of

individual lives, as stretches of time, tracts of land, ways of being and doing, and entire clusters of experience are denied substance.

There are no histories of residue, no atlases of abandonment, no memoirs of what a person was but could not be.

Everything is valuable, yet all things can be laid waste.

The sediments that precipitate at the base of our

experience of the world can, however, decompose to ignite strange sources of light, like will o' the wisps in marshlands by night. Sometimes, this is all the illumination there can be in vast stretches of uncertain terrain.

ALL THAT CAN BE VALUABLE IS ACCOUNTED FOR. RESIDUES REMAIN, AWAITING ESTIMATION; OCCASIONALLY GLOWING.

# WITH RESPECT TO RESIDUE

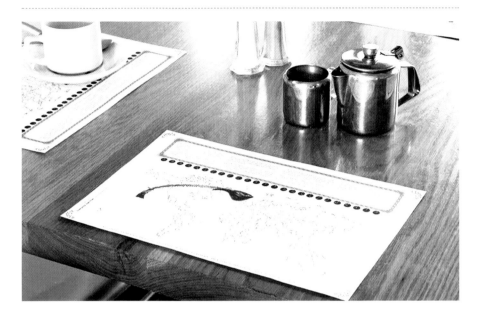

With Respect to Residue: Table Maps for Liverpool
2004/ Site-specific installation with printed paper placemats

Liverpool Biennial (2004).

With Respect to Residue: 4 Illuminated Maps for the Pearl River Delta
2005/ Installation with lightbox table, chair, ashtray, printed paper placemats

Second Guangzhou Triennial, China (2005-06).

*With Respect to Residue* is a project designed to provoke reflection about the things, states of being, and histories that end up abandoned as waste, as the detritus of the routine processes that constitute and maintain the world. The maps are placemats meant to be used in restaurants destined to be thrown away after a meal, embellished with the traces of peanut shells, fish bones, used teabags, and tobacco ash.

matic Call Distributor (ACD)

nail Management

tbound Call Management

agement Information Syst

Web Chat                           Call / M

                    Web Integra

Interfaces for Integration

**Soft Phone**                  Interactiv

                    Contact Monit

mputer Telephony Integratic

nferencing          All Media L

# A/S/L (AGE/SEX/LOCATION)

2003/ Installation with 3 video monitors, audio

*Geography and the Politics of Mobility*, Generali Foundation, Vienna (2003). *Globalia*, Frauenmuseum, Bonn, (2004). *World-Information City*, Bangalore (2005). *Linked: connectivity and exchange*, Govett-Brewster Art Gallery, New Plymouth, New Zealand (2005-06).

In this installation (which also doubles as a piece of text-based one-act electronic theatre), transcripts of chat sessions constitute an electronic patchwork that also includes real and simulated audio recordings of conversations between call centre workers and their clients, images of a female larynx, the text of a reworked Upanishadic dialogue, and video recordings of a spoken English class in Delhi.

The work presents the map of the world as a grid of reflecting surfaces marked by shifting inequalities, and the call centre worker as a figure in this mirrored world, demanding a new understanding of the world and of what it means to labour in a place and across space.

I collect my boarding pass, like all the other times. There will be a delay, as it happens sometimes. But this time I am to spend a night on the chairs in the transit lounge.

2002 / Image and text

*soDA magazine* 19, Zurich (2002).

## Event Shaped Holes

A photograph is an image of an event-shaped-hole, and as witnesses to such perforations we could begin to act like protagonists in a Scandinavian crime thriller, building up layers of forensic interpretation onto the cavity of the event in order to transform the event-shaped-hole into a rich account of making and unmaking of ways and forms of living. Usually we find a propositional cavity inside a document or a photograph or a report, an event-shaped-hole, that needed filling in.

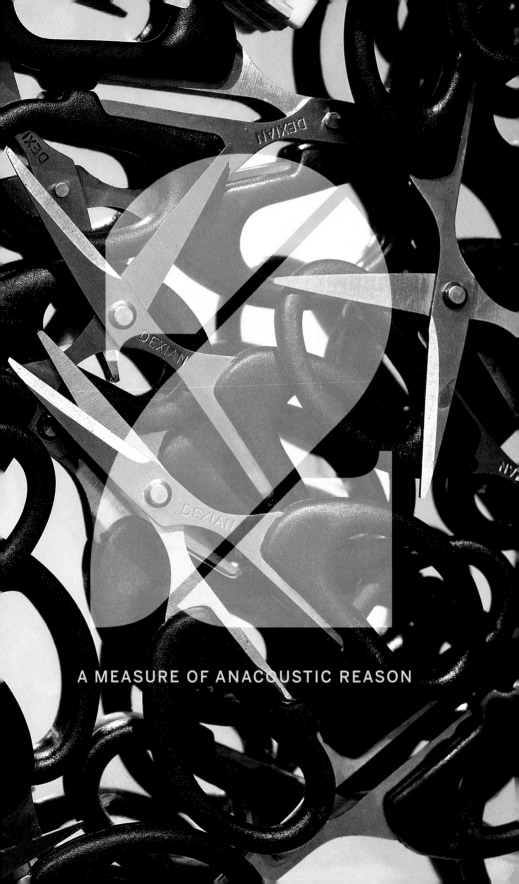

A MEASURE OF ANACOUSTIC REASON

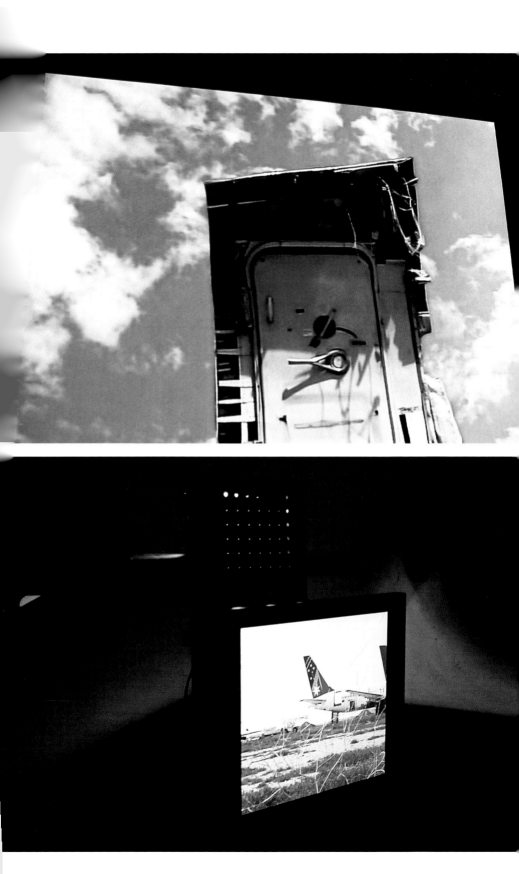

# A MEASURE OF ANACOUSTIC REASON

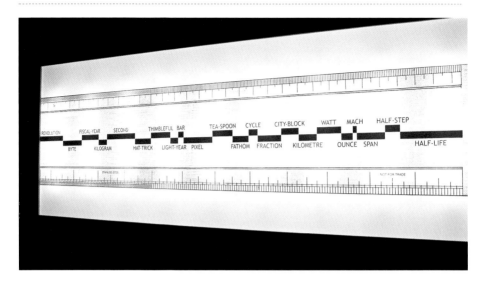

2005/ Installation with 1 projection, 4 screens, 4 dialogues, 4 lecterns, 4 benches with embedded speakers, lightbox

*iCon: India Contemporary*, Venice Biennale (2005). *Thermocline of Art*, Zentrum für Kunst und Medientechnologie, Karlsruhe (2007). *There has Been a Change of Plan*, Nature Morte, New Delhi (2006).

As the world turns, so does the deaf ear of power. Watching, not listening, the marksman locates a target. Bang Bang.

*A Measure of Anacoustic Reason* registers our thinking about forms of reasoning that insulate themselves from listening. The word anacoustic refers to a zone in the atmosphere where air particles are too distant from each other to allow for the conduction of sound. It also denotes any environment, device, or condition that effectively blocks out sound.

The term "measure" suggests the deployment or operation of such forms of reason (as in "measures taken") as well as an account or audit of the acts of reason that are realized in the form of measurements. It is, in that sense, a measure of measuring.

The installation sees the act of "turning a deaf ear" as the unwillingness or inability to listen to the voices that refuse to be accommodated into the master narratives of progress, of instrumental reason, and the domestication of space through the geomancy of corporations and nation-states.

In this turning away lies an aggressive disavowal of the possibility of the humanity of other forms of expressions and speaking about the world, that privilege realities and experiences that cannot, or need not, be counted.

# SUPER-DUPER HELTER-SKELTER LEGO WORLD

2010/ Digital print on Hahnemühle FineArt paper. 89 x 41 cm

*Super-Duper Helter-Skelter Lego World* is a map of the world in building blocks. Each block, repeated across the map, stands in for some superlative claim or the other on the planet and its resources. Perhaps this is a completed puzzle waiting for an appropriately earth-shattering kick.

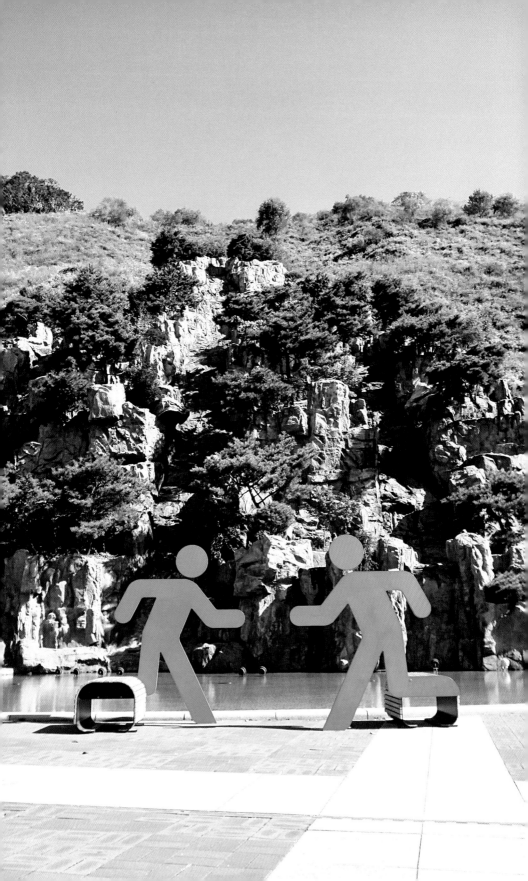

# CAN YOU SAY THAT AGAIN? (5 UNEASY PIECES)

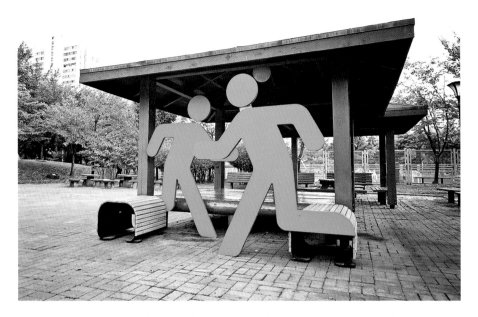

2010/ Temporary public sculpture with 5 audio tracks (4:36, 4:43, 6:03, 4:59, 5:19)

Anyang Public Art Project, Anyang, Korea (2010).

*Can You Say That Again? (5 Uneasy Pieces)* features an intimate portable outdoor audio theater framed by the "Exit" glyph of the walking man and the narration of five episodes of anchorage and dislocation. Part public furniture, part listening station.

Raqs references real estate, urban folklore and architecture—combining notions of utility and fantasy — to create uncanny resonances across private experience and public memory for Anyang.

The work incorporates two aspects. The first is a set of public sculptures attached to park furniture. The second is a set of five soundtracks of scripted audio-dramas, written by Raqs, translated into Korean, and performed by a team of actors from Anyang experienced in radio drama.

METRE

# ON THE QUESTION OF STANDARDS WHILE CONSIDERING
# THE FREEDOM OF SPEECH, AFTER DUCHAMP

2006/ Printed postcard. 10 x 15 cm

*Utopia Station*, Davis Center for Historical Studies, Princeton University (2006).

A piece in response to the invitation from Molly Nesbit, Hans Ulrich Obrist, and Rirkrit Tiravanija on the occasion of Utopia Station at the Shelby Cullom Davis Center for Historical Studies, Princeton University.

# OVER TIME

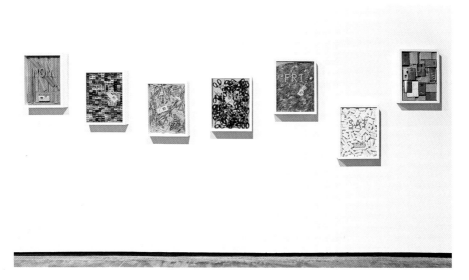

2010/ Assembled and framed found objects. Series of 7, each 48 x 38 x 8 cm

*The Capital of Accumulation*, Project 88, Mumbai (2010).

Seven frames stand in for the seven days of the week. Each one contains an assemblage of suspended objects.

Sharpeners, erasers, notebooks, dividers, rulers, pencils, and diaries are caught between sheets of acrylic glass like insects in amber.

Every calendrical marking is an index of endurance.

Days are shaved, sharpened, and divided in service to the accumulation of everything that can be accumulated.

The score of the week is inscribed and erased — between time given over and time taken away, between time that gets counted and time that runs out.

Overtime gets longer over time.

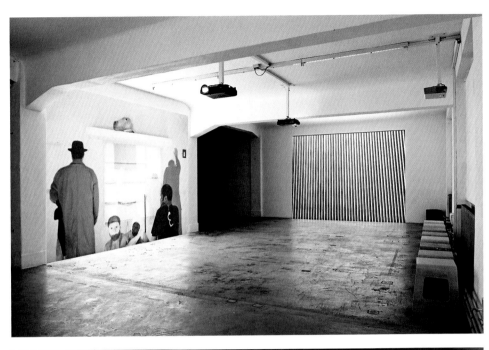

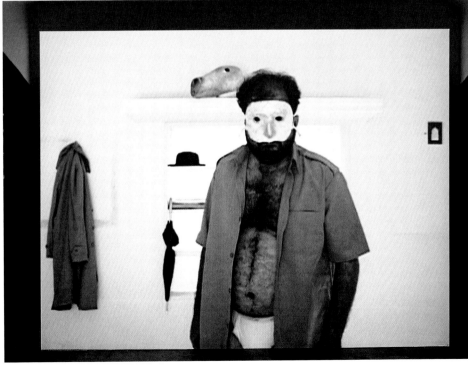

# THE IMPOSTOR IN THE WAITING ROOM &
# THEY CALLED IT THE XXTH CENTURY

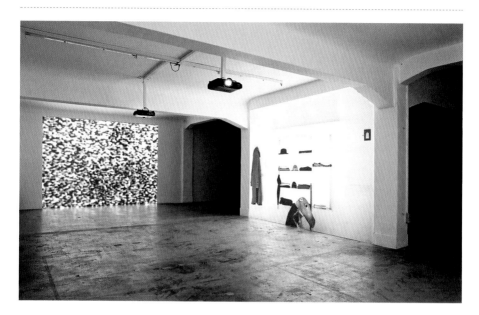

The Impostor in the Waiting Room
2004/ Installation with video, photography, performance, text, audio, and print

*The Imposter in the Waiting Room*, Bose Pacia Gallery, New York (2004).

They Called it the XXth Century
2005/ Installation with video, audio, and printed ticket

Theater der Welt, Künstlerhaus, Stuttgart (2005). *Indian Summer*, Ecole nationale supérieure des Beaux-Arts, Paris (2005).

A consideration on what happens when modernity encounters its shadow. As a group of practitioners who navigate routes in and out of modernity, its past, present, and future, on a daily basis in Delhi, the city where we live, and in the course of our travels elsewhere we have come to realize that the world is densely encrusted with "waiting rooms," spaces for transients to catch their breath as they prepare for the arduous ascent to the high promontory of modernity.

The image of the "waiting room" gestures towards the sense of incompleteness and elsewhereness that fills these spaces of the world about which the overriding judgment is that they are insufficiently modern — that they are merely patchy, inadequate copies of "somewhere else." Such waiting rooms exist in the very heart of that "somewhere else" — in New York and Los Angeles, in London and Singapore — but it is outside these islands that they have their truest extent. Most of the world, in fact, inhabits such antechambers of modernity. We know such antechambers well; we are at home in them, everywhere.

Waiting Rooms everywhere are full of Impostors waiting to be auditioned; waiting to be verified; waiting to know and to see whether or not their "act" passes muster, whether they can cross the threshold and arrive onto the plane where "history is truly made."

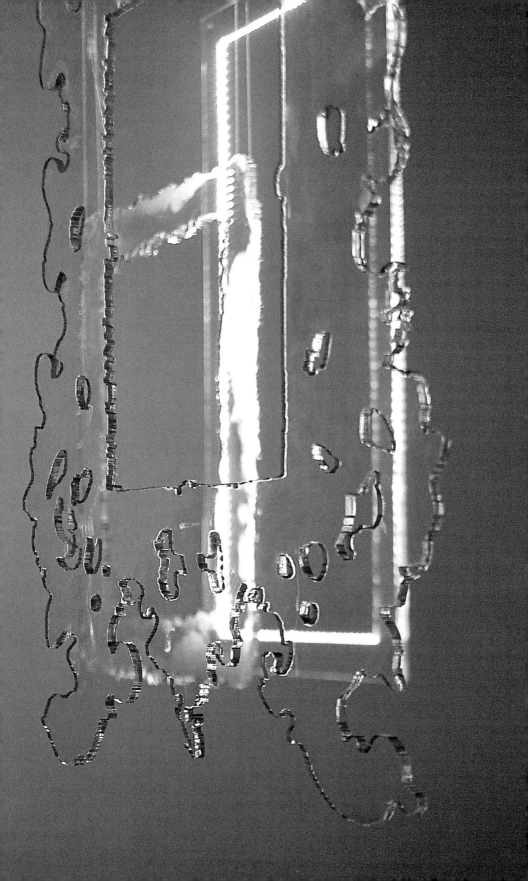

# DÉJÀ VU AND DISTANCE & HAVE YOU FACTORED IN?

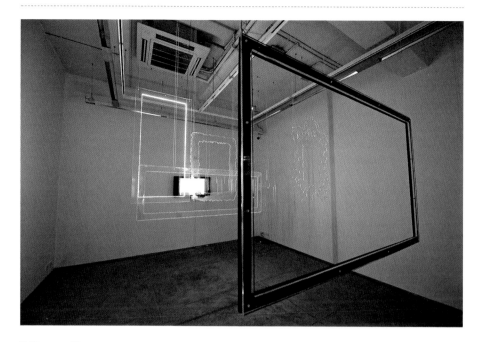

Déjà vu and Distance
2011 / Installation with 9 acrylic frames, LED lights

Have You Factored In?
2011 / Video loop

*Premonition*, Experimenter Gallery, Kolkata (2011).

The picture is a mirage in the desert of the now. A thing made of vapour and thirst that hangs over the horizon. A loop caught repeating itself endlessly, like a premonition that is also a memory that is also a warning that is also a moment of reflection. Like a mirror that is also smoke. Empty frames that show you nothing but déjà vu. Have you factored for déjà vu and distance at Baranagar?

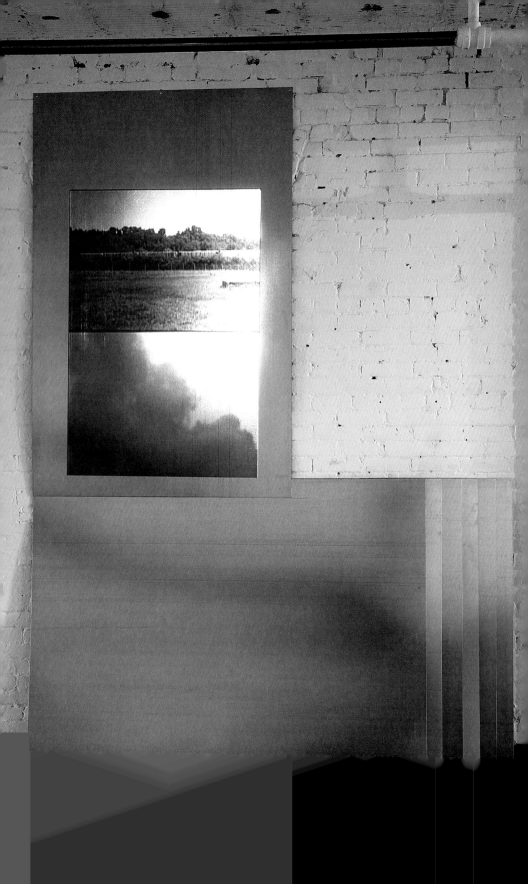

# CEASURAL VARIATIONS I & II

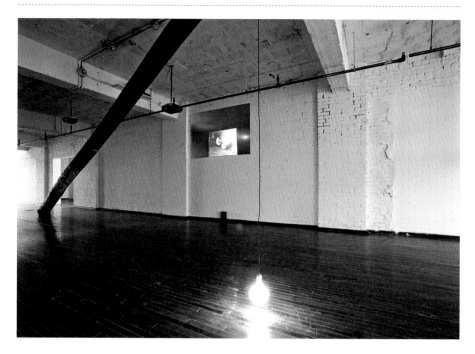

2007/ 2 videos: *Ceasural I*, 3:18; *Ceasural II*, 3:53

*India: New Installations, Part II*, Mattress Factory, Pittsburgh (2007-08). *Re:Frame*, Lowave, Paris (2009).

Two short video meditations set in the post-industrial landscape of the steel-town of Pittsburgh.

Memory, the permanence of steel, the impermanence of industry, and an invocation of the silent aftermath of decades of labour mark a steady measure of the flow of time.

Within these brackets, an instance of machinic immobility; a caesural, a brief interval between shifts.

A time to stand, wait, observe, and remember. Awaiting premonitions.

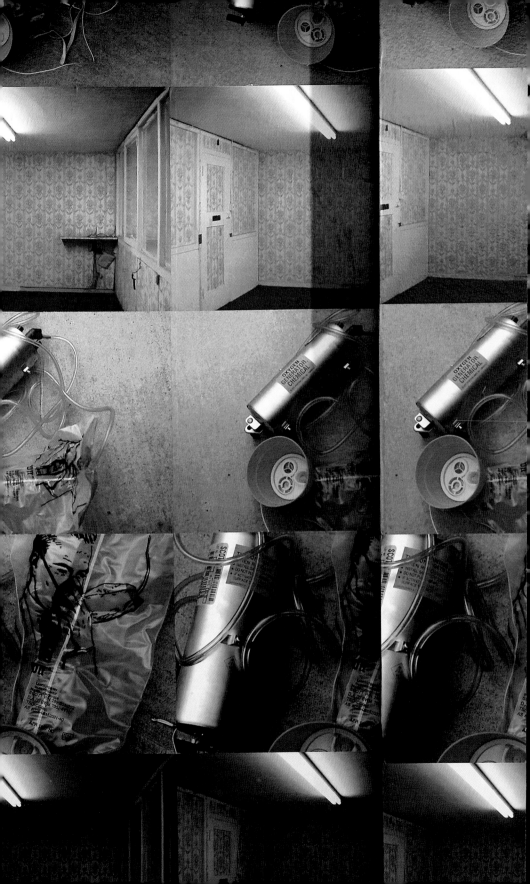

# INSURANCE % INVESTMENT

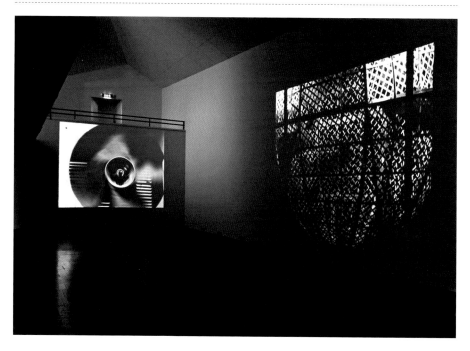

2007/ Installation with 3 videos, audio, wallpaper, photographs

*Art of the Possible*, Lunds Konsthall, Lund (2007).

*Insurance % Investment* illustrates the mental arithmetic of investment and insurance, two mechanisms designed to administer, anticipate, and forestall risk, speculation, and the possibility of failure.

Whirling motorcyclists in a fairground "well of death," giant rotating fan blades, oxygen masks, empty rooms with ornate wall paper, and a soundtrack that suggests the respiration of strange machines constitute a constellation of uncanny effects that poise the visitor in a space full of ambivalences.

The proliferation of cautionary motifs only emphasizes the latency of danger. Everything is anticipated, yet anything is possible.

The subtraction of the infinite disquiet of the multitude from the reverberation of the voice of authority by the accumulation of i
own echoes, especially when those echoes are heard raised to an exponential power, is equal to anacoustic reason.

The net effect of the disquiet of the multitude can be arrived at by considering the difference between the frequency of the voice c
authority and the accumulated voices of the multitude.

Randomness can be taken to imply anything from a sudden and inexplicable outbreak of joy in generally sullen populations to th
occasional exhaustion of the mighty; or even the consequences of wear and tear, maintenance and accidental malfunctions in the
apparatus of power. In the end, it all adds up to something that has the potential to change the rules of the game. The equation
necessarily fragile.

A careful observation of the fluctuating index of anacoustic reason can yield a precise measure of who and what gets a hearing
the world.

# The Mathematics of Anacoustic Reasor

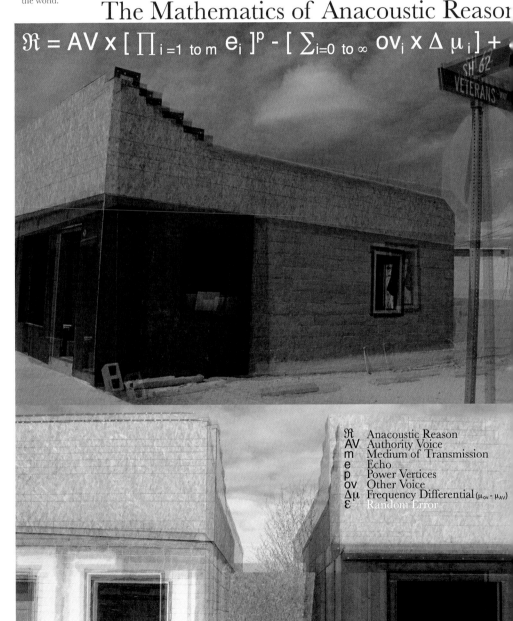

$$\mathfrak{R} = AV \times \left[\prod_{i=1 \text{ to } m} e_i\right]^p - \left[\sum_{i=0 \text{ to } \infty} ov_i \times \Delta\mu_i\right] + $$

| | |
|---|---|
| $\mathfrak{R}$ | Anacoustic Reason |
| AV | Authority Voice |
| m | Medium of Transmission |
| e | Echo |
| p | Power Vertices |
| ov | Other Voice |
| $\Delta\mu$ | Frequency Differential $(\mu_{ov} - \mu_{AV})$ |
| $\varepsilon$ | Random Error |

# THE MATHEMATICS OF ANACOUSTIC REASON

$\mathfrak{R}$    Anacoustic Reason
AV    Authority Voice
m    Medium of Transmission
e    Echo
p    Power Vertices
ov    Other Voice
$\Delta\mu$    Frequency Differential $(\mu_{ov} - \mu_{AV})$
$\epsilon$    Random Error

2006/ Inkjet print. 182 x 120 cm

*Out of the Equation: Roads to Reality* (a project curated by Hans Ulrich Obrist). *NOW WHAT: Democracy and Contemporary Art*, Space Hamilton and Insa Art Space, Seoul (2006).

*The Mathematics of Anacoustic Reason* is an aphoristic image-text work in response to an invitation to respond to the concept: *Out of the Equation: Roads to Reality*.

The project responds to this invitation by expressing an equation written primarily in the formal language of mathematics and by elaborating on this expression with images and a brief accompanying text. The equation attempts to condense an articulation of the relationships between silence, disquiet, power, and the actions of the multitude with a view to yielding a measure of understanding about who or what gets a hearing in the world.

## Unarrest

Documentation of a work is part of the journey of the work itself. We unpack the work, take the unfinished road, activate it, and "unarrest" it. This could take the form of a lecture performance through which newer connections are drawn, different forms of telling are explored, and further ways of punctuating words, concepts, and the work's inter-connectedness with other works is dwelled upon. This keeps an artist's archive from becoming a repository. The archive stays mobile, is constantly reinvented.

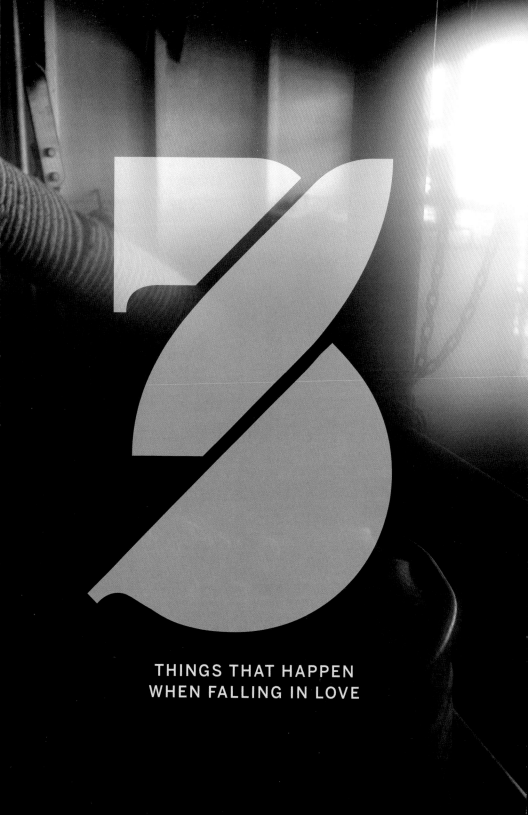

THINGS THAT HAPPEN
WHEN FALLING IN LOVE

# THE THINGS THAT HAPPEN WHEN FALLING IN LOVE

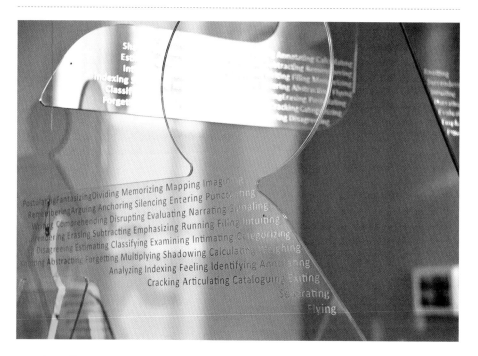

2010/ Installation with 18 coloured and clear acrylic figures with printed mirrored letters, wire cables, 7 video screens, 13 photographs

*The Things That Happen When Falling in Love*, Baltic Centre for Contemporary Art, Gateshead, Newcastle (2010).

*The Things That Happen When Falling in Love* brings together suggestions of words, ships, and people on the move to create an image of a world where the fortunes of both love and labour are framed and dismantled by global forces.

Ways of life and labouring die and are reborn elsewhere, as industries such as shipbuilding relocate from the North of England to the West Coast of India. Like onshore sweethearts bidding farewell to men in sailing ships, the world watches its own histories float away.

Sometimes, only the words for knowing loss and longing remain.

Part sculptural installation, part concrete poetry, part meditation with found footage, *The Things That Happen When Falling in Love* is, above all, an elegy to the global web of wills and longings that sustain life and love in the face of loss.

In this work, it is this mesh of dispositions that is seen as girding our world, generating strange intimacies across vast distances.

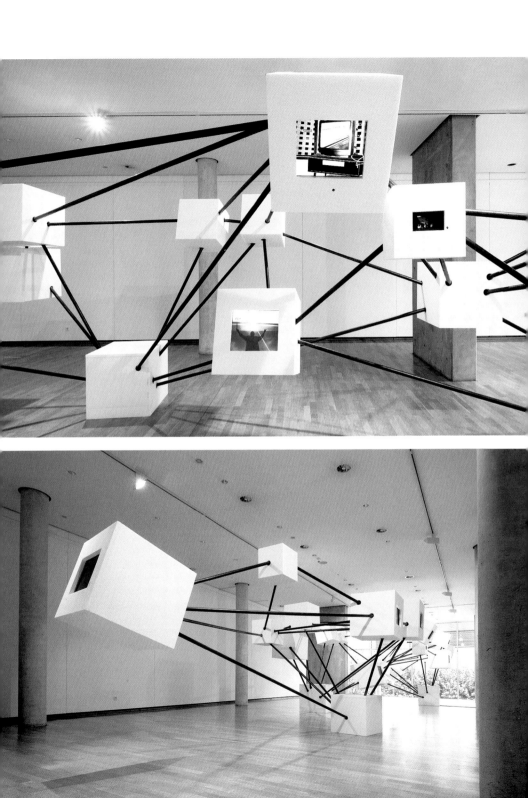

# THE KD VYAS CORRESPONDENCE, VOL.1

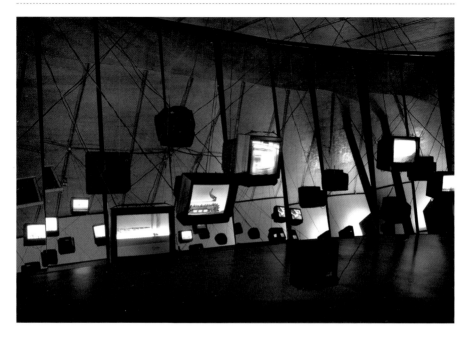

2006/ Installation with 18 video screens and DVD players, steel frame structure, audio

*The KD Vyas Correspondence, Vol.1*, Museum of Communication, Frankfurt (2006). *Shooting Back*, Thyssen-Bornemisza Art Contemporary, Vienna (2007). *Horn Please*, Kunstmuseum Bern, Bern (2007-08).

*The KD Vyas Correspondence, Vol. 1* is an installation that embodies an epistolary enigma. The basis of this work are a set of eighteen "letters" between Raqs and a person or entity who is identified as KD Vyas, sometime redactor of the *Mahabharata*.

The installation manifesting this "correspondence" brings together eighteen video enigmas that could be an abbreviated contemporary concordance to the eighteen cantos of the *Mahabharata*: densely encrypted messages, annotations to the letters themselves, or memories of places and times where they may have been read — once, twice, or an infinite number of times.

The work involves video, sound, a dossier, and a dialogue with the architects Nikolaus Hirsch and Michel Müller that results in a structure, "The Node House," which holds the images and sounds, hovering like the disembodied memory of an instance of the epic's hyperlinked incantation.

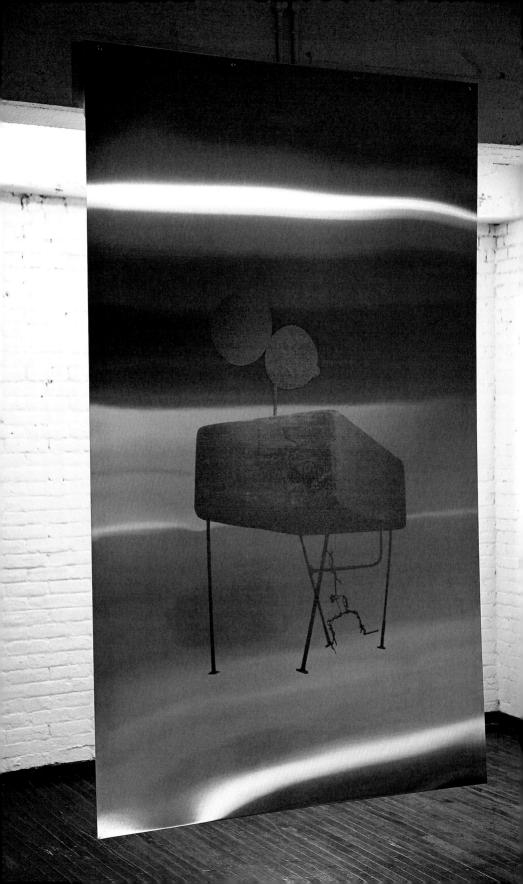

# ANONYMOUS STEEL WORKER

2007/ Silkscreen on stainless steel. 244 x 148 cm

*India: New Installations, Part II*, Mattress Factory, Pittsburgh (2007-08). *New Wave*, Aicon Gallery, London (2007).

Every factory has a time-book. The time-book is an index of the value of a worker's time. It records hours, minutes, and money, and acts as the memory machine of the factory. But time also leaks out of the factory, reclaimed for purposes other than those dictated by the inventory. The accounts of these nameless moments "occupied" by anonymous workers never enter the factory's time-book.

In Pittsburgh, once the world centre of steel production, there is an archive of labour in the steel industry called "Rivers of Steel." In that archive, along with time-books, union leaflets, photographs, and newspaper clippings are a few eccentric objects. One such object is a quirky dog made of machine parts, odds and ends, made between shifts in a steel factory by an unknown worker. This dog, the pet and companion of reclaimed time, is emblazoned in brilliant orange on a stainless steel sheet as a heraldic tribute to the hours that an anonymous steel worker rescued from the pages of the time-book.

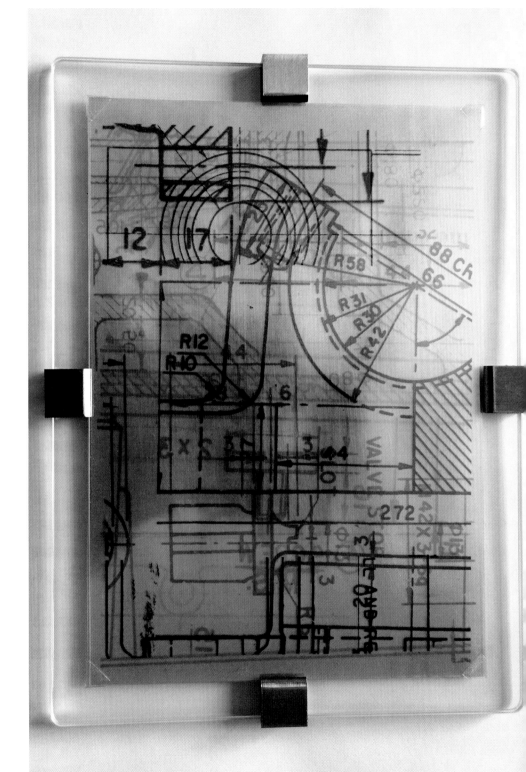

# LOVE IS ENGINEERING

2009/ Printed transparencies, acrylic glass, steel fixtures. 24 x 36 cm

*Signs Taken for Wonders: Recent Art from India and Pakistan*, Aicon Gallery, London (2009).

Fused transparencies of mechanical drawing encased in acrylic glass sheets, the clouded light of dawn and the rudimentary text of the screenplay of an imaginary film sequence to speak of the quotidian battle between love and time, fought over the delicate terms of the silent departure of a man from his lover's bed.

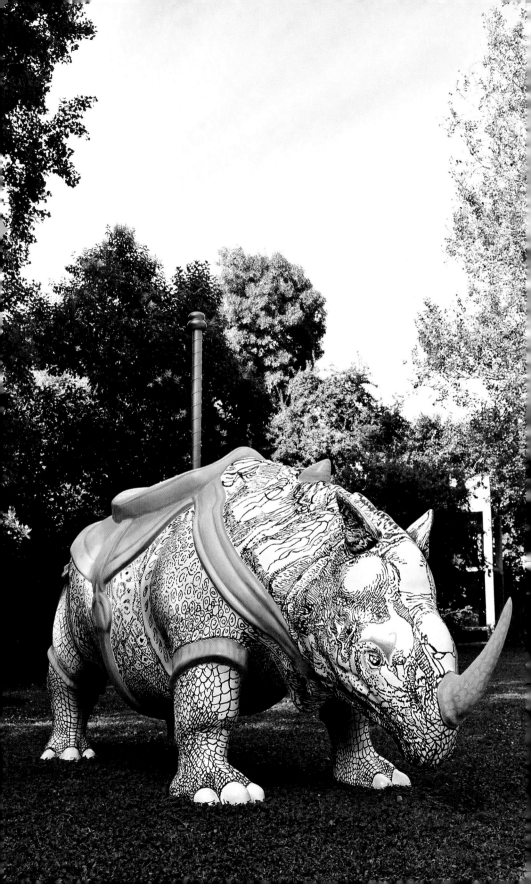

# HOWEVER INCONGRUOUS

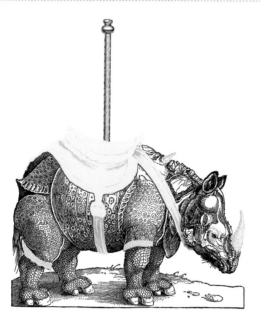

2011 / Fibreglass. 160 x 92 x 320 cm

Site-specific work for the Gulbenkian Gardens, Lisbon (2011).

Albrecht Dürer came across rumors of the Indian rhinoceros named Gainda sometime in 1515 that he would immortalize in his woodcut, *Rhinoceros*. Gainda the rhinoceros, far from his native habitat in the grasslands of Gujarat (where no rhinoceroses remains today), was sadly lost at sea while being transported, in time, from Lisbon to the Vatican.

The Gulbenkian Gardens stand on a piece of land that was once used for a fun-fair. What is now a quiet and serene garden, an organic machine designed for leisurely contemplation, would once have been a busy, bustling, noisy site for the carnivalesque, for flirtation, and for the pursuit of thrills. The sudden reappearance of Gainda the lost rhinoceros in the Gulbenkian Gardens allows the space to be haunted by its own past.

The sailor walks up to
the sky deck and looks
down below him.

The city, in waves, is
frozen in rising. Her
wish is amongst them.
So many desires have
stood up to be count-
ed that he finds him-
self wanting.

He has no name for
their number and his
ship is waiting and the
shore leave has ended.

# SKIRMISH & SHORE LEAVE (TWO LOVE STORIES)

Skirmish
2010/ Laser-cut acrylic over inkjet on Hahnemühle FineArt Baryta paper. Series of 8, each 40 x 60 cm

*This is Unreal*, Experimenter Gallery, Kolkata (2010).

Shore Leave
2010-11 / Single channel projected digital slide show, gilded frame. 90 x 120 cm

*Slipping Through the Cracks*, Latitude 28 Gallery, New Delhi (2012).

*Skirmish* is a brief, unhappy, love story with pictures and text, another of Raqs' ongoing forays into the photo-roman form.

*Skirmish* tells the story of an imagined estranged couple fighting a coded war of messages against themselves. Their bitter and desiccated passion, halfway between seduction and aversion, is played out on the surface of dreams and the walls of an unknown city.

A sailor, a prostitute, a city, the search for warmth, and a slice of snatched time; *Shore Leave* is a short story in words and images about words and the unsaid, about desire and the incalculability of longing.

# THE KNOTS THAT BIND ARE THE KNOTS THAT FRAY

2010/ 7 channel video installation, varying lengths

*The Things That Happen When Falling in Love*, Baltic Centre for Contemporary Art, Gateshead, Newcastle (2010).
*Cynical Love: Life in the Everyday*, Kiran Nadar Museum of Modern and Contemporary Art, Noida, U.P (2012).

In early April 2009, the last of the distinctive Titan cranes from the Tyneside Swan Hunter shipyard in northern England were loaded onto a heavy load vessel and sailed out of the River Tyne. These vast iconic forms were dismantled and shipped to a new life at the Bharati shipyard on the west coast of India. This narrative forms the background to the seven screen video work, *The Knots that Bind are the Knots that Fray*.

Raqs treats found footage of this last voyage of the ship-building cranes (shot by an engineer and amateur shipyard enthusiast) to create a world of passages, transitions, and departures. The ghostly forms within the images allude to floating worlds, to the enchantment of industrial machinery and the life of ships. They remain indefinite and suggestive of place, evoking an archive built by acts of lay remembering. The video enthusiast's footage of a piece of local history is transformed into vignettes from a fantastical voyage. The work is both about drifting away and coming ashore. The "knots" of the title can refer both to nautical speed as well as to the complex ties that bind people to histories — ties hold things together and speed frays them apart. The knots that bind are the knots that fray.

*The Knots that Bind are the Knots that Fray* evokes this history of attachment *and* distance, *and* brings together ships and people on the move to create an image of a world where the fortunes of both life and labour are framed and dismantled by global forces. It is an attempt to come to terms with the fact that we finally learn to value a history only when consider its departure, its passage away from our lives.

Like on-shore sweethearts bidding farewell to men in sailing ships, the world watches its own histories float away. Sometimes, as when finally falling in love, only the silences of loss and longing remain.

# SURFACE TENSION STUDIES

2010/ Giclée prints on Hahnemühle FineArt Baryta paper. Series of 13, each 25 x 40 cm

*The Things That Happen When Falling in Love*, Baltic Centre for Contemporary Art, Gateshead, Newcastle (2010).

*Surface Tension Studies* is a suite of photographs which considers making choices between unfathomable depth and a distant horizon, encountering the strong pull of submerged currents, the attractions of beaching on unnamed islands, and the modest comfort of anchorage.

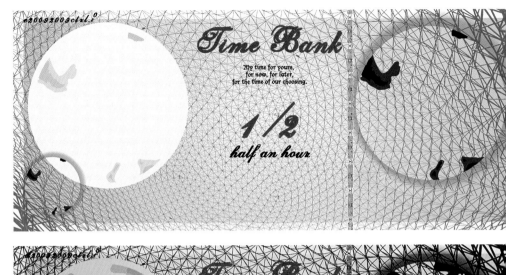

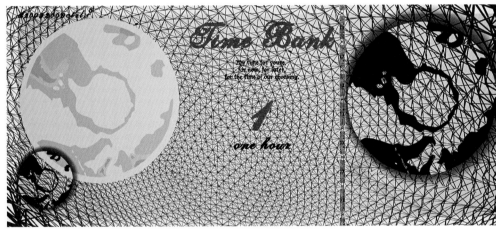

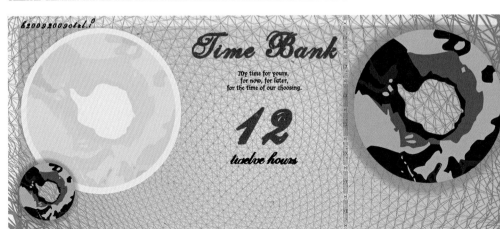

# TIME IS MONEY

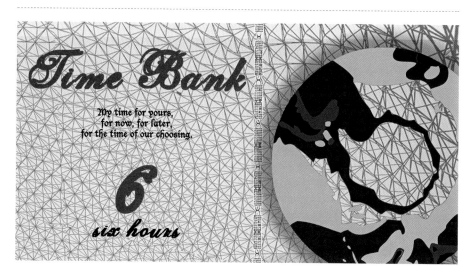

2010/ Prints. Series of 5, each 12 x 28 cm

*Impossible Exchange*, Frieze Fair (2010). *Time Currency*, Liverpool Biennial (2010).

Currency prototype for the Time Bank, a project by Anton Vidokle and Julieta Aranda.

## How the Most Terrible Solitude was Overcome

Once a small piece of sky (a Bodhisattva unknown to itself) landed on the earth. It rested, bewildered by the hardness of the surface. Everything everywhere was gritty. The sky-patch-Buddha-to-be felt very alone. It had lost its playmates, the clouds. Many years passed. The sky child, of itself unconscious yet boundless compassion, decided to be dead to the earth. The skylet, after considerable melting, became liquid and substantial: at the same time, con verted itself into a pool of deep cool water. Grasses began to grow around its shoulders. The wind played ripples on its ridged skin. The pool invited rest. It quenched the thirst of passing strangers, pro ... ... ... Its task about in sunless days, its lost playmates the clouds would show reflected themselves. Sometimes it was ... ... ... ... it found itself discovered in the empti ... its still waters ... of sky that had strayed so far from home. ... this piece of displaced, fallen sky was united again with ... ... ... by pools reflecting ... to sustain the earth below ... ... to slake with beauty and the quenching of thirst, ... ... ... the mysterious relationship of interdepen ... ... ... ... with the active presence of eve ... ... ... ... the most terrible solitude was over ... ... ... ... ... loneliness was cured.

# UNFAMILIAR TALES

2008/ Lenticular photographs, etched acrylic sheets. 2 Sets of 2, each 90 x 120 cm

*A Question of Evidence*, Thyssen-Bornemisza Art Contemporary, Vienna (2008-09).

*Unfamiliar Tales* is a pair of image-text diptychs entitled "How The Most Terrible Solitude Was Overcome" and "How the Long Wait for the Thaw was Endured." The work features three-dimensional lenticular reproductions of photographic images accompanied by short fables cut into acrylic. The fables are very short stories, two new Jataka tales, of equal length.

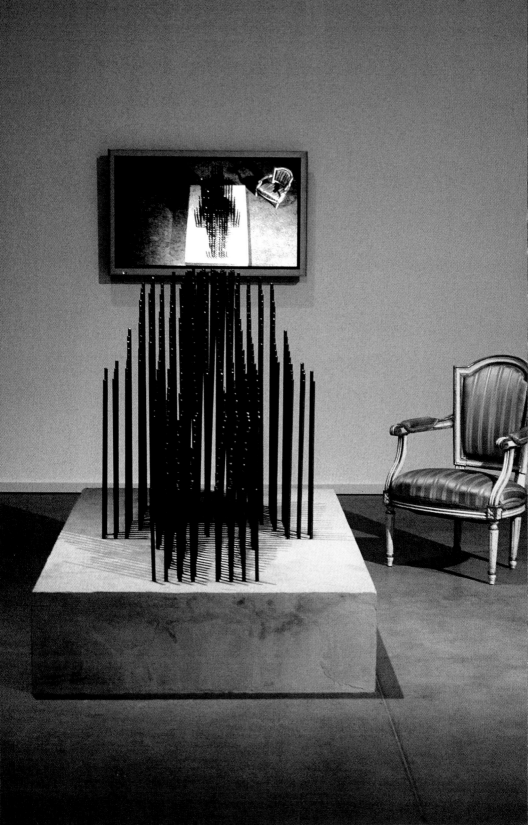

# A DYING MAN SINGS OF THAT WHICH FELLED HIM

2006/ Installation with rebar, concrete, furniture, closed circuit video

*Sub-contingent*, Fondazione Sandretto Re Rebaudengo, Turin (2006). *Bombaysers de Lille*, Maison Folie Moulins, Lille (2006-07).

*A Dying Man Sings of That Which Felled Him* presents its viewer with a silent song of a thousand words, a bier of iron rods for the repose of a fallen man, a setting sun, and an empty chair awaiting a visitor. Here, in this long twilight, a story from the *Bhishma Canto* of the *Mahabharata*, realized with construction materials, is configured to form a meditation on contemporary global capitalism.

The list of a thousand words (reminiscent of Bhishma's death-bed incantation of the thousand names of Vishnu) may be thought of as a "dying declaration," or as a eulogy chanted by a dying man to the power that felled him. The installation involves us all as witnesses to this terminal state. At a time when the rhetoric of impending "super-powerdom" resounds in the metropolises of South Asia with an exhausting monotony, this installation is a reminder of the whimsical contingencies of the operation of power which spare no one, not even those who imagine themselves at the helm of affairs.

The iron rods — a notational trope that recalls both the building and destruction of cities as well as Bhishma's deathbed of arrows made during the *Mahabharata* battle by Arjun — act as a reminder of the fragility and tenuousness of our hold on the world.

The visitor is invited to contemplate their own recorded image within the matrix of this installation, and to reflect on the caveats that this work offers to the discourse of triumph that surrounds us today.

## Concept Intruder

The figures of the "missing person" and "impostor" elide territorial formations. They are mobile, contingent categories that vary according to the field of forces they find themselves in. They are not subjects and make no claim to stability. Their mobility keeps them from being attached to any specific subjectivities. The "missing person," "impostor," and "crowd" are all different. These gures are not territorial; the figure is everywhere, dispersed—in time, in space. We have never actually worked with clear subjects in mind. They come and stand in, like specters or phantoms, more as intruders into our conceptual worlds, messing up neat partitions and legibility.

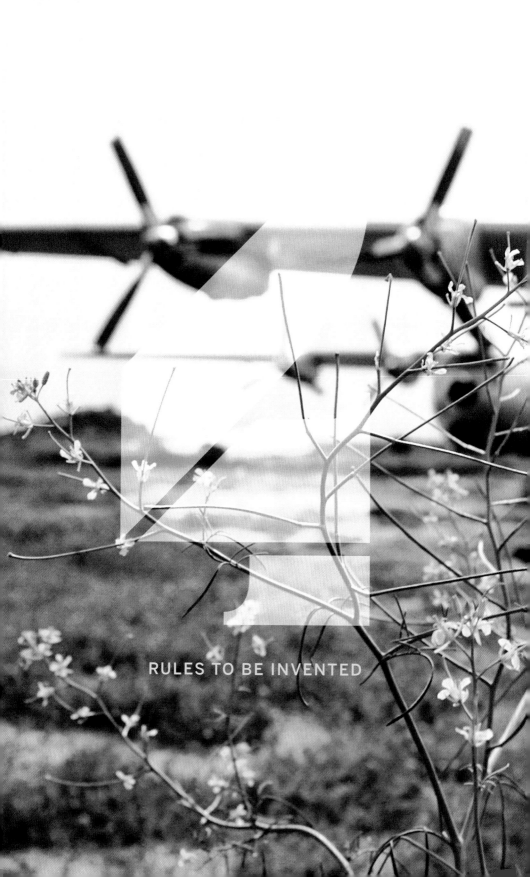

RULES TO BE INVENTED

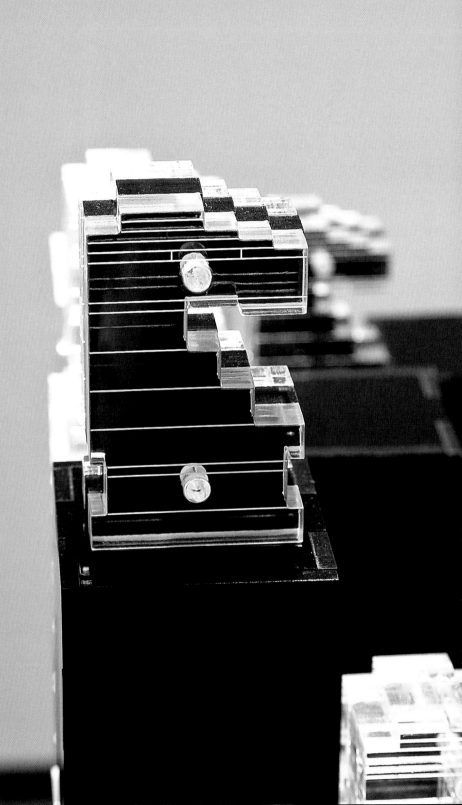

# RULES TO BE INVENTED

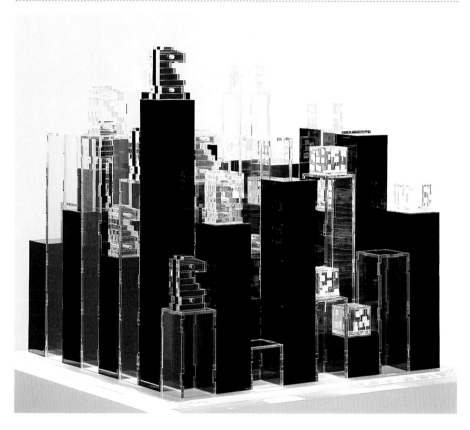

2010/ Acrylic. 60 x 60 x 60 cm

*The Capital of Accumulation*, Project 88, Mumbai (2010).

A chessboard that scales peaks. The pieces climb up and down a terrain as uneven as history. All chess pieces save the knight have been eliminated. Because there is no king left to checkmate, no queen to trap, nor pawn to crawl across the board, the knights have mated and multiplied to take over one whole side of the game. Facing this band of knights is a line of six-sided die, waiting to be thrown. The knights' calculated moves must try their luck against the winds of chance, but no one quite knows what is left to win or lose.

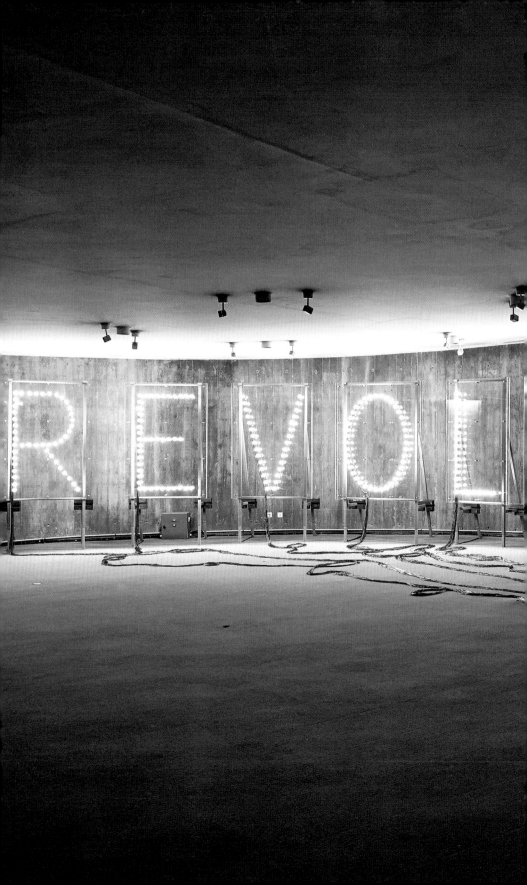

# REVOLTAGE

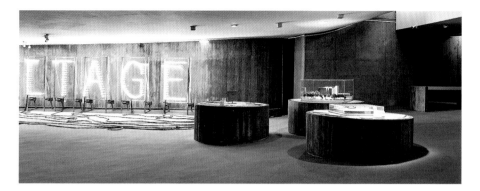

2010/ Lightbulbs, fixtures, acrylic sheets, wiring. Version 1 (3 pieces): 90 x 64 x 10 cm, 183 x 64 x 10 cm, 90 x 64 x 10 cm; Version 2 (9 pieces): 200 x 133 x 60 cm each

*The Capital of Accumulation*, Project 88, Mumbai (2010) [Version 1]. *Reading Light*, Festival d'Automne, Espace Oscar Niemeyer, Paris (2011) [Version 2].

*Revoltage* is a large sculpture made up of light bulbs, electricity, electrical wire, and a new word. It fills the space it occupies with warmth, light, and the charge of an idea that embraces both celebration and rage. It suggests the energy, or "voltage," of what it means to revolt, to commit oneself to humanity.

An array of light bulbs spells out a series of nine larger-than-human-size letters, like the elements of a festive marquee. Formed by inserting light bulbs onto vertical transparent acrylic sheets, the letters join to suggest an incandescent hybrid between electricity and uprising — alternately illuminating the words "Revolt" and "Voltage" through a fluctuating electrical current in order to coin a new thought, "Revoltage."

The electric aura of this new word creates a generous, expansive illuminated space for thought. Viewers stand either sharply silhouetted against the word or bathed in its glow, becoming a part of its rhetoric, entering the stage of the "age of revolt" as actors. Their bodies write their own stories on the surface of the ground with an alphabet of shadows. Every time a body moves, the story written with shadow changes.

A cascade of black and red wiring (anarchy's traditional colours) makes its way down from the multitude of light bulbs that make up the word, and flows along its length on the ground. The bunched wires merge and divide like a map of the tributaries of a mighty, turbulent river before disappearing into the shadowy darkness behind the work. By representing the transport of the electrical energy that fuels the work, the wires evoke the way in which ordinary people all over the world have flooded their cities in recent times (in Cairo, New York, Athens, Madrid, Moscow, Tel Aviv, and elsewhere), like rivers in spate, electrifying global consciousness with the actualization of a new politics, carrying with them the charge of a new mode of being human and citizen.

At a time when the demos unmakes the polis on a daily basis in squares and streets across cities through contagious, festive occupations fueled by a strange new energy, *Revoltage* registers first as an after-image (the kind we see when we shut our eyes after looking at a strong source of light) and then as a subliminal suggestion within our consciousness to brighten our days with the brilliance of a form of truant, rebel power that refuses to either name itself or be named into domesticity.

*Revoltage* is an instance of Raqs' evolving practice of word play. From graffiti, from street names and signs, posters, notices, from fragments of text blown along with pieces of paper in the wind, the refrains of songs, snatches of conversation, the neon signage of dreams: words make their way into their work. With *Revoltage*, Raqs have begun writing a new glossary for these times.

DO NOT TOUCH
DO NOT PLEAS
O NOT PLEASE
THE ART OF TOUCH
HE ART OF WORK.
WORK NOT. DO TOU
ART OF TOUCH PLE
TOUCH THE ART OF
DO WORK. TOUCH N

# PLEASE DO NOT TOUCH THE WORK OF ART

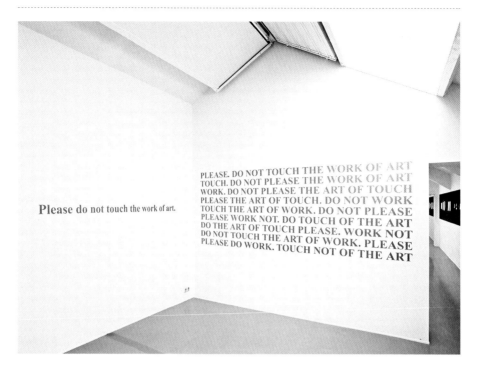

2000 & 2006/ Version 1 (takeaway postcard): Gold ink on 300 gsm gold paper. 10 x 15 cm; Version 2: Gold vinyl lettering on wall. Dimensions variable; Version 3: Etched carrera marble. 90 x 120 cm

*Art of the Possible*, Lunds Konsthall, Lund (2007) [Version 2]. *The Art of Participation: From 1950 till now*, San Francisco Museum of Modern Art (2008-09) [Version 1]. *Whose Exhibition is This?*, Taipei Fine Arts Museum (2009) [Version 1]. *Reverse Engineering*, Gallery Nature Morte, Berlin (2012) [Version 3].

A textual interpretation of instructions usually designed to separate art works from their publics.

Please do not touch the work of art.

PLEASE. DO NOT TOUCH THE WORK OF ART
TOUCH. DO NOT PLEASE THE WORK OF ART
WORK. DO NOT PLEASE THE ART OF TOUCH
PLEASE THE ART OF TOUCH. DO NOT WORK
TOUCH THE ART OF WORK. DO NOT  PLEASE
PLEASE WORK NOT. DO TOUCH OF THE ART
DO THE ART OF TOUCH PLEASE. WORK NOT
DO NOT TOUCH THE ART OF WORK. PLEASE
PLEASE DO WORK. TOUCH NOT OF THE ART

II

It is not desirable that the future be captive to the present,
just as it is unthinkable that the present be held hostage by the future.
Neither the arrow, nor the boomerang of time!

# FRAGMENTS FROM A COMMUNIST LATENTO

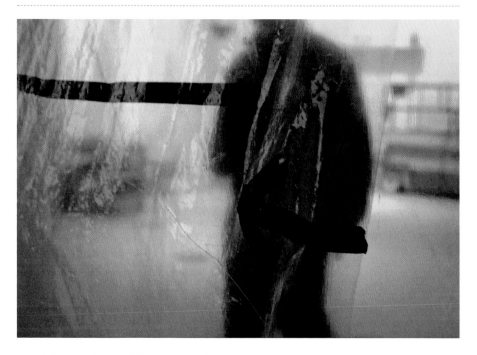

2010/ Photographs in lightboxes. Series of 8, each 71 x 51 x 13 cm

*Critical Fetishes: Residues of general economy*, Centro de Arte Dos de Mayo, Madrid (2010). *Rehearsal*, Shanghai Biennale (2010).

*Fragments from A Communist Latento* is an image/text series that features photographs of found minimalist hand-drawn signage on transparent surfaces (mainly arrows and direction markers) annotated by a set of terse statements by Raqs Media Collective. The work takes the form of a *Latento*, a term coined by Raqs to suggest the converse of a Manifesto. It follows that this work can be read as a shadow-gloss of the more familiar *Communist Manifesto* of Marx and Engels.

# Vidya Nalini Chillimeril

# FORTHCOMING TITLES

2010 & 2012 / Custom book covers: *Luxme Sorabgur, The Capital of Accumulation* (2010); *Granita Moscino, The Parole Notebooks* (2012); *Vidya Nalini Chillimeril, What is to be Undone?* (2012).

*A Phrase, Not A Word*, Gallery Nature Morte, New Delhi (2012).

Book jacket designs for three unwritten books. Each book is an imagined classic in a wished-for canon of anagrammed Marxism.

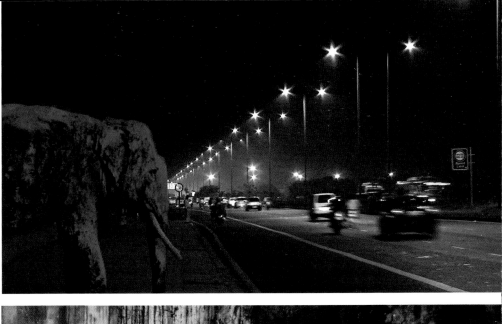

# STRIKES AT TIME

इतवार

42 रुपये फ्राइंगपैन, 8 रुपये सिगरेट, 20 रुपये शराब में
20 रुपये दूध, लंच 50 रुपये
आज परस के साथ पहाड़ी पर गया।
इस संसार की सरहदों के आगे भी दुनिया है।
बाकी सब साधारण है।

2011 / Installation with 2 channel video projection and audio. 18:32

*Paris – Delhi – Bombay*, Centre Pompidou (2011).

*Strikes at Time* is a lucid dream, readings from an occasional anonymous journal, and a long walk at the edge of the city of the night.

In that no man's land annexed by the awakening mind from the fatigue of the labouring day, the work weaves together a disquisition on time in the form of a discreet annotation of philosopher Jacques Rancière's *The Nights of Labor*, together with renditions of the found text of a worker's diary by the *CyberMohalla Ensemble*, a group of unorthodox proletarian urbanists that Raqs has been in dialogue with over a decade.

The shadowy presence of a Yaksha and Yakshi — guardians of wealth in Indic mythologies — stands watching over the work, marking time with questions.

# THE CAPITAL OF ACCUMULATION

2010/ Installation with 2 channel video projection and audio, 2 books in glass-fronted bookcase. 50:00

*The Promised City*, Hebbel Am Ufer, Berlin (2010); Museum of Modern Art, Warsaw (2010). *The Capital of Accumulation*, Project 88, Mumbai (2010). Manifesta 9, Genk, Belgium (2012).

*The Capital of Accumulation* is a video installation that writes an oblique narrative of the relationship between metropolises and the world in counterpoint to Rosa Luxemburg's exceptional critique of global political economy, *The Accumulation of Capital*.

The work, a 50 minute video diptych, trawls through a haunting, dream-like landscape straddling Warsaw, Berlin, and Bombay/Mumbai to produce a riff on cities, capitalism, and the twentieth century's turbulent history.

Part natural history, part detective journal ... part forensic analysis, part cosmopolitan urban investigation ... and part philosophical dialogue ... *Capital of Accumulation* offers a considered and personal reflection on the remaining possibilities for radical renewal in our times.

# THERE HAS BEEN A CHANGE OF PLAN

2006/ Photographs on Hahnemühle FineArt paper. Series of 4, each 96 x 137 cm

*There Has Been a Change of Plan*, Gallery Nature Morte, New Delhi (2006).

*There Has Been A Change of Plan* features enigmatic images of aircraft abandoned in a desert blossoming after a rare shower. The images are poised in a delicate balance between accumulating debris and fragile possibilities.

Sometimes, adjustments have to be made. Schedules need calibration. There are contingencies, questions, obstinate demands, weak excuses, strong desires. Journeys are abandoned midway. Aeroplanes sit on wooden platforms in a wilderness like widows on a funeral pyre. Flights are grounded, engines rust, propellers turn idly. The debris of the unrealizable accumulates on the surface of the eagerly expected. Time to pause, to take stock. Sit still and let a conversation begin. There has been a change of plan.

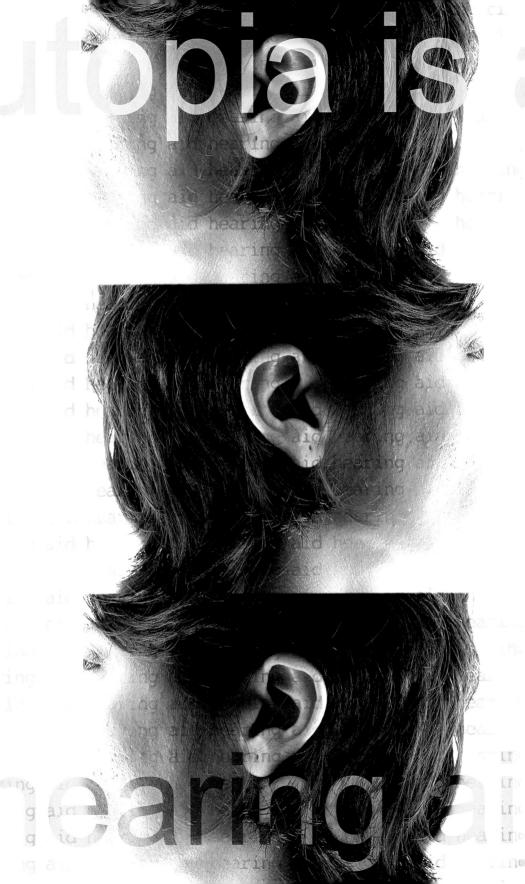

# UTOPIA IS A HEARING AID

2003 / Posters installed in situ in Venice, Italy. 90 x 60 cm

*Utopia Station*, Venice Biennale (2003).

*Utopia is a Hearing Aid* features images of the ear superscribed repeatedly with the statement "Utopia is a Hearing Aid." This image-text emerges from our understanding that the possibility of another world is actually always latent within the materiality of this one; one has only to listen to the sounds of it stirring to make it manifest. This requires the cultivation of a hermeneutics of listening, of listening very carefully. Of paying attention to the things that are being said, not only aloud but also in whispers, not only in proclamations and manifestos but also in forms of disguised and coded speech, and not only in reasonable discursive forms but also in acts of parrhesiastic, fearless speech. It calls for fearless and attentive listening.

*The Library's Lucid Dreams (From Decomposition)*
2010/ Wallpaper. Variable dimensions

THE LIBRARIAN'S LUCID DREAM
(FROM DECOMPOSITION)

*The following section is a collection of essays and writers chosen by Raqs Media Collective.*

ELENA BERNARDINI

# Impostors and Waiting Rooms:
# Figures and *Loci* of Modernity

In *The Impostor in the Waiting Room* (2004) Raqs critically rethink the spaces of the contemporary in light of a history and map of modernity, which envisioned the West and the model of the bourgeois citizen at its centre while consigning most places and people to the "waiting rooms" of the "not-yet-modern." Concentrating on these unaccounted antechambers and their inhabitants Raqs identify the impostor and the waiting room respectively as a crucial political site and figure of our times sketching a more complex picture of what modernity has meant and means for many people.

The image of the waiting room has been used by Dipesh Chakrabarty to underline how colonialism and its civilizational project were justified through a historicist argument.[1] According to this, the colonisers and the colonised shared the same historical trajectory leading towards modernity and sovereignty. The colonisers, however, were positioned ahead as already fully modern subjects while the non-modern colonised lagged behind in "need" of colonial rule to modernise. The waiting room defined, therefore, a non-dialogical space where the people in there were at the mercy of a source of authority that had absolute power and set the terms of their exclusion or inclusion in the political community. In Raqs' installation the letter of Bengali reformer Rammohan Roy (1784–1833) reminds us that this temporal displacement reserved, however, a further catch. Even a modernizer like Roy could still be denied a visa to go to Paris. Indeed being a modern man but not from Europe could not eliminate the suspicion that one was not authentically modern.

The idea that one may be disguising oneself as modern is further stressed in the installation by the recurrent image of a man in a bowler hat which Raqs have cunningly modelled on Magritte's painting *Le Barbare* (1928). In *Le Barbare* the man in the bowler hat is a foreigner and a delinquent, Fantômas, who is pretending to be a Parisian, a rightful citizen, but in truth is not. Reinforced with notions of authentic identity the historicist argument indeterminately confined individuals, peoples, or nations to the waiting rooms of modernity. If modernity could truly be achieved only by Europeans, there was no chance for the colonised to exit the waiting rooms. The question of authenticity denied in practice sovereignty and the universality of human rights and equality, which the

colonisers' vision of modernity nonetheless promised. As such, an essentialist notion of identity played a crucial part not only in controlling but also in maintaining the difference between inside and outside, the waiting rooms and the spaces of modernity, colonisers and colonised.

As the notice boards and light boxes in the installation suggest, the image of the waiting room keeps haunting us in postcolonial times beyond a question of recognition of postcolonial political agents vis-à-vis the West. On one of the notice boards Raqs consider how airports have become spaces of precarious hospitality, prolonged wait, and captivity in-between states for people who do not have the right papers. On the other, a map highlights the presence of waiting rooms in city spaces within national borders. Marked among a variety of urban areas fully recognised and recognisable by their function, the waiting rooms remind us of what has been left behind and unrecognised in official visions of cities and city life. Whether one thinks of the precarious position of refugees in detention areas at airports or the experience of impoverished urban residents in cities like Delhi, it appears evident that lack of clear political status or governmental accountability can seriously undermine basic rights. The type of extreme exclusion at stake in the image of the waiting room, therefore, is found again at the core of modern democracies and interrogates not only the universality of human rights but its very foundations. If it is the inscription within the political that defines the rights of the person rather than nativity itself, it is no surprise to find out that the border between the inside and outside of the political community has been object of great political contestation.

Philosopher Giorgio Agamben has eloquently talked about this through the figure of the *homo sacer* and the notion of exception highlighting how controlling the definition of the political community has been a prime task of sovereign power.[2] Coming from a philosophical perspective, Agamben pushes the issue raised by the difference between what he calls "bare life," a life with no juridical or political ascription, and "political life" to its limit. For Agamben the challenge is whether it is possible to think a politics which does not imply the sovereign ban, in other words, the structure of exclusion at the core of the inscription of life in the political.

The figure of the impostor in the installation, however, suggests also a different strand of reflection. In one of the projections a man is seen while impersonating a series of different characters such as the peasant, the factory worker, and the man in a bowler hat. The man in the bowler hat, however, is just a persona among others. Unlike in the historicist argument, it does not crown the man's various transformations, suggesting that there may be many ways of entering or exiting modernity, and one hopes that one of these figures would be of his own choice. Like in the painting *Le Barbare*, the man never shows his face giving the impression that although we may identify him as such and such character, his identity is never fully known. The unintelligibility of his face seems to hint at the man's inexhaustible capacity for self-transformation. The ability to re-fashion oneself has certainly been crucial for those who wanted to exit the waiting rooms and had to comply with the requests of the authority guarding the border between

inside and outside. However, it may also hint at the necessity of questioning notions of authentic identity and the role these play in maintaining the distinction between inside and outside. As seen earlier with reference to colonialism, the authenticity argument defined a border that could not be overcome unless one problematised its very assumption, namely that only some people by virtue of their nativity are to be considered full political subjects.

Keeping this in mind, one could recognise in the faceless impostor with his/her many personifications the embodiment of what Chantal Mouffe and Ernesto Laclau would call the moment of the political itself: when a given order, truth, or assumption is put into question, made object of political struggle, and new political subjectivities are negotiated in public space.[3]

---

Portions of this essay were published in "Everyday Border Surveillance and Trespassing: Cities in Contemporary Indian Art," in *Experiences of Freedom in Postcolonial Literatures and Cultures*, eds. Annalisa Oboe and Shaul Bassi, (Abingdon: Routledge, 2011) and "Raqs Media Collective: Nomadism in Art Practice," in *Global and Local Art Histories*, eds. Celina Jeffrey and Gregory Minissale, (Newcastle: Cambridge Scholars Publishing, 2007).

---

## NOTES

1   See Dipesh Chakrabarty, *Provincializing Europe: Postcolonial Thought and Historical Difference* (Princeton: Princeton University Press, 2000).
2   See Giorgio Agamben, *Stato di Eccezione* (Torino: Bollati Boringhieri, 2003) [trans. Kevin Attell, *State of Exception* (Chicago: University of Chicago Press, 2005)] and *Homo Sacer: Il Potere Sovrano e la Nuda Vita* (Torino: Einaudi Editore, 1995) [trans. Daniel Heller-Roazen, *Homo Sacer: Sovereign Power and Bare Life* (Stanford: Stanford University Press, 1998)].
3   See Chantal Mouffe, *On the Political* (Abingden and New York: Routledge, 2005) and Mouffe and Laclau, *Hegemony and Socialist Strategy: Towards a Radical Democracy* (London: Verso, 1985).

UNTOUCHABLE
FACTORY

E

W

DISCREPANT
ABSTRACTION

UNCOMMON

POSITION

MANUAL

# Puzzling Time

Raqs Media Collective defines itself as "an ensemble; everything it does is an ensemble of existing or anticipated practices."[1] "Ensemble" here refers not to any group homogeneity but rather alludes to the egalitarian rapport existing between intellectual peers united by elective affinities. When the question of the definition of collective arises, they refer naturally to mathematicians' groups, specifically to Nicolas Bourbaki, the collective identity of a group of several highly talented, young (mainly) French mathematicians.[2] Raqs' training and early projects produced unconventional documentaries but, beginning in 2000, they have expanded into other forms of research. This collegial structure cultivates for Raqs a certain ubiquity, which allows it to multiply its points of intervention, and which is supplemented by the versatility of its members who combine the roles of curator, film-maker, writer, media theorist, artist, social scientist, and cultural producer.

The main task of their project is to elaborate a new derivation of the project of modernity, which the three members of Raqs agree to call "off-modern," a term introduced by media-theorist Svetlana Boym. Being "off-modern" is inhabiting the trajectory of the "lateral move of the knight in a game of chess. A detour into some unexplored potentialities of the modern project."[3] Off-modernism offers a critique of both the modern fascination with newness and the no-less-modern reinvention of tradition. The adverb "off" confuses our sense of direction. It makes us explore side shadows and back alleys rather than the straight road of progress; it allows us to take a detour from the deterministic narratives of history. And it seems it is on this terrain Raqs expands its agenda into an experimental set of questioning about time, obsolescence, and alternative histories. In their performance work, *With Respect to Residue,* at the Liverpool Biennial in 2004, the group issued a call for an alternative historiography, recognizing that there are "no histories of residue, no atlases of abandonment, no memoirs of what a person was but could not be." (The issue of "residue" would be further developed in *The Rest of Now* (2008), the Manifesta 7 section that Raqs curated.)

Modernity has unleashed fiction on a grand scale — as colonial projection, commodity-driven economy, and desire. It has ghettoized fiction in institutions and disciplines

(such as "art"), but out there in the really-real world it has waged a holy war on fiction, a holy war on beliefs, superstitions, and whatever is suspected of non-compatibility with rationality and the reality principle, in the attempt to replace these things once and for all with modernity's knowledge, its hard facts.

In this context, their work could be understood as investigations in which images, texts, and installations are the supports, rather than the final results, of their attempts to rethink links to modernities as well as to address the modern trauma of attempting to live in a linear time. Their method is characterised by the theme of irreducible mystery which also originates, no doubt, in the will to disrupt the presuppositions of modernity. The mode most favoured by Raqs is a kind of *encrypting*: "There are a lot of games of semantic hide-and-seek going on in the work" because "the intensification of scrutiny must be met with the amplification of guile."[4] Very often, the images with which Raqs works take the form of rebuses, of puzzles encoding a process of thought.

This liking for the enigma becomes explicit in the Collective's use of the rhetoric of detective fiction in its early works. *5 Pieces of Evidence* (2003) evokes missing persons, urban myths, and cartographies of global network. The installation is organized in five screens, each bearing a title drawn from a convention of detective fiction, namely: "The Missing Person," "The Scene of the Crime," "The Assailant," "The Trail," and "The Motive." Consider also the title of the multi-media installation from 2004, *The Impostor in the Waiting Room,* which might easily be that of a whodunnit. On one of the screens, we follow the evolution of a bowler-hatted character out of a Magritte painting, a familiar figure whose origins have been traced by some commentators to the influence of detective fiction on the surrealist painter.[5] But in all these cases, any hope that intrigue will find a resolution goes unfulfilled. Such is, perhaps, the paradox of this aspect of Raqs' work. It creates a surface over which one can wander, but which cannot necessarily be penetrated. Raqs' work does not seek to render situations explicit but prefers rather to stay at a more indefinable level where there does not appear to be any possible narrative. In the same way, the work's spatial organisation — notably the use of multiple screens — breaks the constraints of linear narrative by separating and de-synchronizing the various elements that make up the mystery. This is also a way of disrupting a teleological rhetoric in favour of what Raqs calls an "unresolved poetics."

Particularly revealing in this respect are the texts which often accompany their installations.[6] They are never explanations or translations of the work, nor are they instructions for its interpretation. They are, rather, a second voice in which the work speaks allusively, not directly, to the extent that we are forced to consider the problems inherent in the very idea of the textual. One of these strategies for the transformation of theory into an image or figure is the recourse to "conceptual personages" (who are also "activating characters" in the sense of philosopher Gilles Deleuze). This strategy allows the establishment of specifically individual categories to index and translate the symptoms of the contemporary world. The text "X Notes on Practice" details a number of such personages.[7] Particularly striking are the figures of the Artisan,[8] the Pirate, the Illegal Migrant, and the Call Centre

Worker. From the work's description of them, these figures seem to evolve in the interstices, caught up in ambivalence: at once actors and witnesses, vulnerable but at the same time vigilant over their own capacity for action. However, these characters seem not so much to *inhabit* Raqs's works as to *haunt* them, as we see in the pile of abandoned footwear in *Lost New Shoes* (2005).

Ghost (hi)stories… stories of spectre, not of spirit nor ontology but "hauntology."[9] Hauntology supplants its near-homonym ontology, replacing the priority of being and presence with the figure of the ghost as that which is neither present nor absent, neither dead nor alive. The ghost has its being between the palpable and the impalpable, the visible and the invisible, appearing distinctly to some but not to others, silent to one person, eloquent to the next. It warns or punishes. The ghost does not remain withdrawn at the margins. It is rather an *affirmation* that the virtual is real, the paranormal normal. The ghost occupies the blind spot of different historical rationales. It is a fictional representation and symptomatic expression of that which notoriously escapes human reasoning and historical accounts. It explores the need for collective horizons that withstand both the clichés of modernist development and the logic of division that haunts nationalist and identity politics in the long shadow of colonialism, imperialism, modernity. The diptych video *Ceasural Variations I & II* (2007), first presented in an installation at the Mattress Factory, is another case. The work tries to encapsulate through different points of view the vestiges of memory, the surviving elements of Pittsburgh's golden age which was linked to the industrial revolution.

The list of these ghostly figures which have their being in the "in-between" is not complete without the impostor. For Raqs, "the impostor [and] the secret agent are therapists, they help you come to terms with the impossibility of solitary claims to truth, and the simultaneous difficulty of dealing with the conflicts and the pleasures born out of the collision of different claims to truth." Also in this category is the strange KD Vyas, Raqs' "partner in conversation" in *The KD Vyas Correspondence, Vol. 1* (2006). *The KD Vyas Correspondence,* shown at the Museum of Communication in Frankfurt, invited architecture from architects Nikolaus Hirsch and Michel Müller. The piece, consisting of eighteen white cubes housing small video monitors attached to a network of steel tubes, resembles an oversized version of the molecular models used by chemistry students. The monitors display images of sites and scenes from forty places in the world that Raqs had visited in the previous years, and they are each accompanied by a "reading" of eighteen "letters," of which only titles are made available, a correspondence between Raqs and a person or entity identified as KD Vyas, occasional editor of the *Mahabharata*. In reality, however, KD Vyas (Krishna="dark," Dwaipayan="island-born," Vyas indicates eloquence) is no proper name but an ordinary noun which might be translated as "compiler," even though, literally, the term designates less one who collects than one who disseminates. For Raqs, "he is like a spectre invoked in a seance who refuses to go away because he is bored in the spirit world, and likes the mess here. We invoked him (or he invoked us) and now we are stuck with him, at least for a long time." He represents the "impostor incarnate." Like those impostors and forgers of the most extreme type, KD Vyas creates

history in order to become its protagonist. In the context of India, where readings of the *Mahabharata* and other sacred Hindu texts are fiercely contested by Hindu fundamentalists, Raqs' credo carries an important political valence.

There's another way to think through this, however. In the *Correspondence*, KD Vyas writes: "There is nothing new. Whatever is there is there in the *Mahabharata*, and whatever is not there in the *Mahabharata* is not worth the effort." Raqs, meanwhile, describe the *Mahabharata* as "an instance of a perennially new media work, because it is deeply hypertextual, every recension links to another recension, every story contains the threads of many other stories." In this way, the connection between internet technology and ancient literature emphasizes a critique of origins as found in historical analysis, looking for alternative ways of understanding how we came to our current situation. This point echoes that of Laura U. Marks in her book, *Enfoldment and Infinity: An Islamic Genealogy of New Media Art*.[10] After demonstrating how Islamic aesthetics historically traveled into Western art, she draws explicit parallels between works of classical Islamic art and new media art, describing texts that burst into image, lines that multiply to form fractal spaces, "nonorganic life" in carpets and algorithms, and other shared concepts and images. Islamic philosophy, she suggests, can offer fruitful ways of understanding what is called "new media."

That is why I would also describe this work of Raqs as a contribution to media archeology.[11] Media archaeology sees media culture as sedimented and layered, a fold of time and materiality where the past might suddenly be discovered anew; where new technologies become obsolete. This includes research into non-mainstream technological and mediatic apparatuses, and opening contemporary technologies through new kinds of genealogies. In this sense, *The KD Vyas Correspondence, Vol. 1*, exemplifies a part of their off-modern project — a thought-strategy of *déclassement* as a means of challenging the certitudes of modernity (the "nation-state," "progress," "development," "identity"...). There are different ways of being modern that have emerged at different times and places, and are still emerging, everywhere.

---

A version of this essay was published as "Puzzling the World," in *The KD Vyas Correspondence: Vol. 1*, ed. Monique Behr (Frankfurt: Revolver, 2006).

---

# NOTES

1. Raqs Media Collective, "The Concise Lexicon: of/for the Digital Commons," *Sarai Reader* 03 (Delhi: The Sarai Programme, 2003), 359.

2. It would have been equally possible to begin so: "At the Mass Communication Research Center at Jamia Millia Islamia University in New Delhi, there encountered one another three young people equally stricken with the same malady: they were all gifted with an energy sufficient to fidelity, a mutual probity recalcitrant to all betrayal etc., etc." Raqs Media Collective took shape in 1991 under the impulse of a wish to preserve and prolong these promises made to oneself and to others as a student and to secure some protection against the blandishments of that "media business" which was already at this period on the rise. The most immediate reason for forming the Collective, however, was the wish "to work on a film (which is still unrealized) which took us on a long sea voyage, to archives, and to thinking about the anthropometry of the soul. Aspects of that project still continue to surprise us by their presence in much of what we do today." Raqs will nonetheless go on to realize several documentary films and will also be involved in the founding of the *Public Service Broadcasting Trust*, the principal motor behind documentary film production in India. The opening of Sarai (www.sarai.net) in 2000 can be considered as the outcome of that phase in Raqs' history which consisted in the conquering, for itself, of a space which would guarantee its autonomy of action ...

3. See Svetlana Boym, "Nostalgic Technology: Notes for an Off-Modern Manifesto," (http://artefact.mi2.hr/_a03/lang_en/theory_boym_en.htm) as well as Boym, *The Future of Nostalgia* (New York: Basic Books, 2001) and *Architecture of the Off-Modern* (New York: Princeton Architectural Press, 2008).

4. Except where otherwise indicated, the remarks cited are drawn from e-mail exchanges with Raqs Media Collective in July 2006.

5. Robin Walz, *Pulp Surrealism* (Berkeley: University of California Press, 2000).

6. Many of these texts have been gathered in Raqs Media Collective, *Seepage* (Berlin and New York: Sternberg Press, 2010).

7. Raqs Media Collective, "X Notes on Practice," in ibid., 100–116.

8. About the Artisan, we read the following statement, exhibited on a panel during the Bénin Biennale (2012): "The artisan stands at the outer threshold of early modernity, fashioning a new age, ushering in a new spirit with movable type, plumb line, chisel, paper, new inks, dyes and lenses, and a sensibility that has room for curiosity, exploration, cooperation, elegance, economy, utility and a respect for the labor of the hand, the eye, and the mind. The artisan is the typesetter."

9. The word itself, in its French form *hantologie*, was coined by Jacques Derrida in his *Spectres de Marx* (Paris: Éditions Galilée, 1993), which has rapidly become one of the most controversial and influential works of his later period. Nevertheless, my use is based on the Avery Gordon's work: "Haunting is a part of our social world, and understanding it is essential to grasping the nature of our society and for changing it". Avery F. Gordon, *Ghostly Matters: Haunting and the Sociological Imagination* (Minneapolis: University of Minnesota Press, 1997), 27.

10. Laura U. Marks, *Enfoldment and Infinity : An Islamic Genealogy of New Media Art* (Cambridge: MIT Press, 2010).

11. Erkki Huhtamo and Jussi Parikka, eds., *Media Archaeology: Approaches, Applications, and Implications* (Berkeley: University of California Press, 2011).

ENTERTAIN-

WAYWARD ECONOMY

CONFIDENTIAL

INTRUSION

SANGUINE SHAPE OF TIM

# Hans Ulrich Obrist in conversation with Raqs Media Collective

**Hans Ulrich Obrist** How was Raqs born? Can you tell me about the name and how it all started?

**Shuddhabrata Sengupta** The name was first spoken in a Chinese restaurant!

**Monica Narula** We had spent a lot of time in film school together realizing that we disliked working with anyone else but each other. After school there was an open call to make a film and we went to apply.

**Jeebesh Bagchi** We needed an image for ourselves that would give us something to move towards. Not something that would define us. Earlier film collectives were named with proactive definitions so we wanted to move away from that.

**SS** It was this figure actually [shows name card] which became a kind of logo. It's a symbol for the whirling dervish. It is the moment of ecstasy in that whorl that we now call kinetic contemplation. Raqs is also a Persian and Urdu word for dance.

**JB** If you do a google search it is just dance.

So it's a kinetic notion!

**SS** Well, yes. At that time we were interested in a lot of that kind of stuff, and we still are. So, kinetic contemplation is a way of thinking the world while being on the move.

**MN** Thought through practice.

**JB** Also it captures the multiplicity. Many people can be in raqs together.

**SS** Yes, that is also very important. There is another thing. In a lot of nerd/geek-speak there is a term called FAQs, or Frequently Asked Questions. There is also something called RAQs, Rarely Asked Questions. We thought of this much later.

**JB** We also needed a name that could incorporate three people, since we are three. The name suggested to us that many people could be together in raqs or that state of ecstasy. That was one of the reasons we chose the name. There were many other reasons, which got shuffled around to create Raqs...

Did you have a master plan at the beginning or was it self-organized?

**MN** No. No plans, no manifestos, and no intentions. It was always a point of departure and the idea of movement. It was about being kinetic and never static in thoughts and ideas.

**JB** It emerged in the context of the massive industrialization of culture production in the nineties, with an enormous expansion of television and journalism, and the whole

entertainment industry. It was a move for us to consciously step away and self-organize, self-navigate and self-sustain in this world.

MN For years it was nothing but self-organized conversation, reflections, and research on our own. We didn't have any official work.

SS We had no institutional backing.

What was the economy in the beginning?

SS The economy of the group?

Yes. How did you make a living in the beginning?

JB We were assistants to different productions, such as to film-makers. Monica became a cinematographer after some time.

MN I was a camera assistant for many film and video projects first.

JB We did this for about four to five years. We did two big research projects — one was funded by Channel Four. At the time, the exchange rate for the pound was very good!

Which one was that?

JB "Black Waters." It is still one of our big unfinished and unrealized projects. We will send it to you.

You anticipated my question.

JB (Laughs) Yes, it is still unfinished. We couldn't make the film because the person who had given us the development grant from Channel Four left the company. He was interested in long-term documentaries but the new people weren't.

SS That was a film that looked at the histories of anthropometry — the study of the measurements of the body — and photography.

JB Basically, it was an interest in the history of an island.

SS The Andaman Islands. It was the history of their incarceration and measurement, bombings, photography as weapon, and architecture.

MN It was a history of the twentieth century told through this island over the span of five years. You literally had independence, separation, incarceration, torture, native inhabitants, anthropology. Lots of things. We could spend a long time talking about that.

When you started with this self-organized structure, who were your inspirations?

JB I think we didn't have heroes but we had encounters, like when Harun Farocki came to Delhi in 1993 and we had an extensive viewing of all his films that he had ever made, starting from the first. That was a great encounter to have when we were trying to figure things out and his whole argument about the industrialization of the mind was enlightening. It was interesting as an event as it made us open to diverse ways of thinking and image making. A lot of German film-makers did a lot of things on the side to keep themselves afloat. I think that helped us realize that we should also try and keep ourselves afloat by doing many things and that eventually we would find something that we could anchor ourselves into within the field that we chose. I think that was an encounter that was significant. Most of the time we were quarreling with people in our head and trying

to get out of the legacy of nationalism, institution-based validation, and the idea that you have to travel out of the country or have a foreign educational background to become something. It was a constant quarrel to get out of specific ways of looking at culture and the ways in which life is branded in India — and at the same time not suffer from post-colonial resentment.

So Raqs was optimistic from the beginning?
**MN** Yes, but as I was saying we didn't have to have heroes, which is an interesting thing to think at this point — and as one can see, it is limited, in a way. But what we were doing was constructing most of our thinking in opposition. It is productive for a while but it can't define you. When we were young and had just joined film school our fundamental goal was not to emulate anyone or be directly inspired by them but to disagree with them and to oppose every situation and idea.
**SS** We also had a lot of time in those days of long fallow unemployment, which meant we could read a lot and often read things together or shared things between each other. The economy of reading in India in the early nineties was interesting because not a lot was available and accessible so you had to go to specific libraries to borrow books and get them photocopied. There was a whole process of how material got into circulation, a lot of note taking, a lot of arguments about what you read. You lived a kind of intellectual life based on the premise of shared time and minds. It is an interesting premise and sometimes when we talk to people from Eastern Europe there is a similarity of that experience. You think that "this" (whatever this is) is not going to happen here so you live somewhat vicariously in time and space. You live with what might have been in your cultural space in the sixteenth century or you live with what you might read of — say, Argentina or Switzerland. You create a world within your consciousness. In this case we were creating a world within three consciousnesses. So a post-institutional education, a self-education, was pretty important for us.
**JB** For five years we didn't do much work except for research and occasional assistant-ship. We were also connected to the documentary movement and to various forms of political activity happening in the city. There was a world around us that we were contributing to and drawing from.
**SS** Not so self consciously though . . .
**JB** It was just a normal part of living for us. We were aware of the industrial conflicts around us.

Did you meet someone like Amar Kanwar early on or what's the connection to documentary film-makers?
**MN** We first met him many years ago.
**JB** Amar Kanwar and our trajectories are similar. We did the first film workshop in Delhi together.
**MN** He was some years our senior in film school. We kept meeting at different points. Raqs and Amar each made a film for the same documentary series in the late nineties. We were also together in documenta 11. Intriguingly, till documenta we had similar trajectories. . .

**SS** There was a burgeoning interest around documentaries and independent film-making. There were many other people who were part of that scene like Sanjay Kak, Pankaj Butalia, Ruchir Joshi, Saba Dewan, and Rahul Roy. There were a lot of people who were thinking about different ways of creating platforms to circulate and to view documentary films.

**MN** This platform question has always been of interest to us. In those days we were thinking of means of showing and sharing films. The world around (independent) cinema wasn't highly institutionalised. We were interested in figuring out how we could create contexts and platforms for interesting things to happen in as many ways as possible.

**JB** In the nineties, creating a context and making work was something that we had to think of together. If we made a film we had to also think about how it could be viewed, who would view it, where they could view it, etc. Our first book, which we edited together, was on documentary film-making.

Which book was that?

**JB** *Double Take* (1998).

**MN** It was from the perspective of the people who make the films. It was not about film studies but revolved around the idea that the people who make films are as much theorists and capable of reflecting on the process as the people who watch films to write about them. This was unexpected for people in those days as they thought film studies meant that there would be theorists who would watch films and analyze and decipher them for the public.

**JB** We also have a long essay on researching the documentary and making the documentary. The researchers' practice. How research itself is a practice.

**SS** We were trying to make a case through that book for seeing film practice as a form of knowledge.

**JB** That was just at the beginning of Sarai, or you could say the immediate pre-Sarai period.

How did Sarai come into the picture? You invented Sarai?

**MN** Yes, the three of us and two other people (Ravi Sundaram and Ravi Vasudevan at the Centre for the Study of Developing Societies) invented it. All of us had been thinking about how to create broader contexts and how to create situations in which people could think with each other as opposed to separate ways of looking at the world. Also the whole thing we just talked about, about making theory through practice. This is how the idea of Sarai found its seeds. Then we met Ravi and Ravi and we started talking about actually creating a place which could be active and that could activate others.

**JB** We started talking to Ravi Vasudevan who is a film historian and whom we had worked with before. We had put together (with him) a selection of sequences from films and taken them to schools as materials for discussion. This was in the aftermath of the first big communal violence of the nineties. It was an exercise in using discussions based on film screenings in high schools as a resource with which to think about violence. Ravi Vasudevan then invited Ravi Sundaram, who was interested in new media and

urbanism, to start a dialogue with us. We took about 20 months and we met twice every month.

That's how the structure was born, a parallel reality to Raqs.
**JB** In the early days of Sarai it used to be like this — in the daytime we were Sarai and during the night we were Raqs. Now we have Sarai days and Raqs days.

Any other parallel realities besides Raqs and Sarai?
**JB** Cybermohalla. The Cybermohalla Project, with Sarai and Ankur, is an NGO active in alternative pedagogy. Nikolaus Hirsch is designing a house or hub for the project.
**MN** Which you saw in Manifesta, that building, that prototype.
**JB** The Cybermohalla Project is a long-term situation in which seventy to a hundred people are involved.
**MN** It involves experimental media labs in different parts of the city, which are working with people much younger than us, now in their early- to mid-twenties. When we began they (the young people) were in their teens. They are reflecting on both theory and practice, but again, also reflecting theory through practice. They are looking and working with urban life in Delhi, but not the urban life you would see when you come.

We could call it the invisible city.
**MN** Yes, it's exactly about that.
**JB** The book that is coming out now from the Cybermohalla Project is called *Trickster City*. "Trickster," in the sense that the city morphs and changes its personality.
**MN** There is a book, and then there is the hoped for building which is being designed in collaboration with Hirsch and Michel Mueller for the outskirts of the city. There are lots of things that go on in there. It's a big parallel reality. There are so many young people who are involved in the labs.
**SS** There is also hope for other parallel realities. There is an idea or a vision for flexible studios in the city. We've been thinking about that for a while now. We call it the "City as Studio" scenario.
**JB** There are lots of imaginary realities that we produce for ourselves.

You've also curated a special project in the exhibition *The Indian Highway* and curated Manifesta. Is curating a parallel reality? When did this start?
**MN** We were just talking downstairs to the journalists from *The Telegraph*. They began to describe our curation as not only being about "curating" but also a renewed starting point. This is because for *Steps Away from Oblivion,* as the curated section for *Indian Highway* was called, we invited film-makers to work with our memories of their work. I think we find the role of creating contexts interesting. In Sarai the whole idea is that you create a situation and you propel the idea or the practice to become something different from its starting point. We did another curation [*Building Sight*] where we worked with all the people in the show, who were not necessarily artists at all, to create their work and, in a sense, a "connected work." Even in Manifesta, some of the artists wanted to put Raqs' name along with theirs as authors but we said no because it's not about

authorship for us, it's about creating a context where people can produce new work. I don't see the curatorial context very differently from, say, making Sarai or doing a Sarai Reader. It's constantly a way of thinking about how to create situations for people and propel situations to happen …

**JB** … to allow collision and entropy to emerge. Though it looks very calm and well designed, there is a big diversity of ideas colliding — like the Sarai Reader always has. All kinds of opinions are allowed to enter and flow in. That's the kind of context that we continuously produce. Curation eventually becomes that context.

**MN** That's what we take from it.

You call the project at the Serpentine *Steps Away from Oblivion*. Is this your contribution to Eric Hobsbawm's protest against forgetting?

**MN** I think the idea of making is itself a protest against forgetting. That is very much a part of the way we look at what we make as work. It is constantly stopping to look at something, again. Even the first book we made was called *Double Take*. It is really important to look again, to constantly having the sense to not let things slide by. I think that is an integral part to what we look upon as making.

If you look at one artistic contribution we made to the Manifesta companion book, it's a little text and image performance on the printed page called "Ave Oblivio." The work speaks in the voice of the ghost of a provincial prefect during the Salo republic, that ghost which still haunts Bolzano, and still wants us to forget. Our work, by "performing" that voice through a quiet artwork, actually makes it impossible to forget.

**JB** By remembering in a certain way. By telling the story in a certain way you are compelled to not forget, or to forget too if that is what is needed.

**MN** Its important to find ways of telling which are against forgetting. The "Ave Oblivio" is an ironic arrest of the process of simple forgetting.

**JB** Do a test. For example, take a glass. You will realize that you have a lot of voices embedded in your head telling you about that glass — scientific voices or otherwise. I think these are very powerful voices as they are always there, talking to you. Multiple retelling and multiple sidesteps are ways of not-forgetting.

**SS** There has always been an interest in rhetoric or protocol or the accompaniments of speech and hearing in a lot of the work that we have done. Listening itself or anacoustic conditions of not being able to listen or not even knowing that you are not able to listen. There is a whole work called *The Mathematics of Anacoustic Reason* (2006) which is about not knowing that you are unable to listen. That is a disability of power in some senses.

Yesterday, I had a conversation with Mr. Husain and he was talking a lot about the *Mahabharata* story, which plays a central role in his paintings. He connects the Mumbai terrorism attacks with the war in the *Mahabharata*. You did a very different work on the *Mahabharata*, which are a series of fictional letters between Raqs and KD Vyas. So I wanted to ask you about what role the *Mahabharata* plays in relation to memory and then last but not least my last question for today is, can one connect the *Mahabharata* to the kind of terrorism in Mumbai? Would you agree with that?

**SS** OK we'll answer this in two parts. The *Mahabharata* has a very interesting kind of eschatological profile. The eschatology that most people are familiar with is within a Judaeo-Christian context. This places the apocalypse ahead of you, so you look to the day of judgement, the apocalypse. It is Imminent.

So there is fear.
**SS** Yes there is fear. The *Mahabharata* places the apocalypse behind you.

So it's post-apocalyptic.
**JB** Yes, according to the *Mahabharata*, we're all living in a sort of post-apocalyptic time.
**MN** We call it "declining time."
**SS** The interesting thing to do is to find ways of turning your head around this question of how you live in a time like this. On the one hand you could say there is an element of resignation, on the other hand there is an optimism because it can't get worse, can it? It's already been the worst it could have been. We're always already reeling from the aftershock. That makes you ask different questions about the task of remembering and forgetting. A whole range of different possibilities occur when you have to remember the fact that it's already been, that you're living in the aftermath. The *Mahabharata* has a set of eight characters that it presents as notional immortals. They will travel with us till the end of time. One of them is KD Vyas, the writer or the teller of the tale. Another such character is called Ashwatthama who is quite a shadowy person in the epic but figures as someone who tries to rob the future by aborting foetuses in the enemy camp and is then condemned to be a warrior forever. We worked a bit with this Ashwatthama character and recently we discovered that there are other textual sources which play upon the idea that Ashwatthama and Vyas could be the same person in the future. So the character and the author begin to blur into each other. The rememberer and the remembered coalesce.
**JB** When you are a child, the most critical thing in the *Mahabharata* you are told is that if its told in public it gives rise to wisdom, passion, and generosity and if it is told in private it gives rise to intrigue, violence, and discord. So there is a powerful idea of the public recounting of a narrative to keep a contemplative relationship to the world alive. For us, the letters that KD Vyas (apparently, in our work *The KD Vyas Correspondence, Vol.1* [2006]) "writes" have a dual life: they could be very private letters or they could be very public. Its quite moving to think of an inversion: a public life building compassion and contemplation whereas a private life generating a small insular world full of discord and intrigue. This was definitely one of the starting points which determined the life of what a KD Vyas letter was, who read it, who we write to, and who writes to us.
**SS** Its important to realize that the *Mahabharata* doesn't have any scriptural place. It's not a holy book. It provides a variety of contradictory templates due to the sheer range of material it contains.

Its non-linear.
**SS** Completely.
**MN** The stories finish but they continue and they flow back.

**JB**  Sometimes you are not very sure if it is the beginning of the story or the ending.

**MN**  They also intersect. KD Vyas is both the writer as well as a character in the story and he can tell you what is going to happen as well as make you unaware of what is going to happen. I think it is interesting for us because we are making our world and at the same time we don't know what is going to come of it. You can say that at a very banal level.

**JB**  No it's true. You are the curator of your own world but you don't know what you are curating.

(Laughs)

**JB**  It's true; we do try to create environments around us. Look at the Mumbai attacks. You wake up one morning and for you the world has changed fundamentally. You know the world has changed because the arithmetic you were thinking of before has to now have new valences and equations.

**SS**  But at the same time one should be careful as to not think of episodes of terrorism as episodes of cosmic battle. They have a banality to themselves as well.

**MN**  A harsh banality.

**SS**  In the aftermath of the apocalypse of the terrorism incident, sometimes we do forget the banality of terrorism. If one looks at the *Mahabharata* as a resource with which to think about banality — like the banality of violence today — then there are many possibilities of thinking through those strands. But if one then extrapolates from the *Mahabharata*, a certain kind of cosmic grandeur or even something as big as the scale of national pride and honour onto incidences like we saw in Mumbai, we risk an optic that could be disabling in the long run.

**JB**  That can be hijacked very easily. *The Guardian* did this beautiful story about the guy who was caught as one of the Mumbai terrorists; in the paper there was a photograph of a cart, which belonged to him, with the small things that he sold on it. This guy who was just a guy in his village selling stuff is now on global news. To understand this junction we need a completely different political framework.

**SS**  There is one reading in the *Mahabharata*, which makes it possible for us to think of the conflict in terms of the holy war kind of rhetoric. There is nothing either holy or unholy about these conflicts. On the other hand, there is a lot of material in the *Mahabharata* which contradicts the idea of the holy war. Embedded into the *Mahabharata* is the *Bhagvad Geeta*, which is a very philosophical rumination of self and not-self-ness, based on the battlefield. The protagonists or the people who speak the dialogue of the *Bhagvad Geeta*, and in several instances later in the *Mahabharata*, ask what it was that they told him on the battlefield. In mythology, Arjuna was perhaps the world's first conscientious objector who is then made to fight a battle. Arjuna asks Krishna what it was that he told him at that moment in the battlefield and Krishna says to forget it and he doesn't remember. So, if one stays true to the enormously beautiful contradictions of the *Mahabharata* then it's a useful way of thinking about the present.

**JB**  There is one thing that is very tricky and troubling now, and that is the idea of historical injustice that gets connected to remembering. If you look at any of the groups

that are fighting now, remembering has become remembering the idea of historical injustice. Remembering is instrumental to the idea of action.

So nothing else is remembered.

**JB** In this mode of thinking — everybody is a victim and the only thing that is worthy of remembering is remembering the historical injustice. You don't have to remember all the carnivals of life or the idiosyncrasies of it.

I couldn't agree more.

**JB** This becomes worrying when the remembering becomes something of value. There are a lot of artistic practices that give way to commemoration, memory, collaboration, and the idea of historical memory. What is increasingly troubling is that the act of remembering is increasingly attached to the idea of keeping alive a sense of historical injustice, which is then made into a springboard for acting in certain violent ways in the present.

That could be the topic of our next interview.

TI-ART
R  FARE

MY BEAUTIFUL MUSE
TRIANGLE

SIMPLE STONE
LIKE   SKIN

FREEHOLD

S

WAR  FEVER

# On Appreciation: The Case of Raqs

I have known the Raqs Media Collective and their work for some time — it will soon be ten years since we first met in Delhi — and have had several occasions to work with them. It has always been stimulating and enjoyable, so when I was asked to contribute to this publication I accepted with pleasure.

I knew from the beginning that it wouldn't be easy to write about artists who use language so efficiently and subversively and who are so at home in the field that I, as a curator, am expected to roam with professional confidence. So I began by going through the file that summarises the collective's work of the last ten years or so. Expertly composed and presented, the Raqs digital *catalogue raisonné* allows us to sit back and comfortably judge the treatment to which they have subjected their chosen topics. The three artists account for their own textual, visual, and spatial achievements, offering answers to the questions "what?" and "how?" and usually also "why?" Very convenient and useful as material for an essay, we might think.

But such elaborate packaging can also be a mixed blessing. The recipient of the gift is pleased by the effort and attention, but also becomes self-conscious about breaking the seal. Indeed, what was there left for me to do once I had absorbed the information in the long PDF? How could I enter the Raqs universe at the right level of inquisitiveness? How could I go beyond describing the already scripted? How could I judge an oeuvre that incorporates the very same language — both "critical" and "poetic," with or without the scare quotes — that curators doubling as writers usually rely on to simultaneously reveal and cloak their opinions?

More to the point, how could I peer behind the screen of self-presentation to assess the inner workings of the Raqs' oeuvre? How could I analyse what I see without appearing to decry what I in fact appreciate in it? I'm thinking of its literary and literal qualities (its use of the object as text and text as object, to begin with), its credibility (as a voice audible above the art world murmur) and credentials (as an indispensable ingredient of the same murmur), its coherence (enhanced and enlivened by heterogeneity), and its tone (to which I will return). How could I arrange a working meeting between my

own subjectivity and that of Jeebesh, Monica, and Shuddha as I know them through their art?

I decided to begin by formulating my own appreciation of Raqs, and this is what I'll try to do here. One characteristic feature of their work is precisely that they're not afraid of revealing what they want to say and how and why. This is true not only of the texts that precede and succeed the "actual work"— Raqs have always been attentive to the linguistic potential of the project description — but also of the message itself, offered as audiovisual digital files or printed matter or three-dimensional objects or installations, inside or outside the art gallery. The key comes with the lock, as it were, but it usually fits in more ways than one.

Raqs don't fear contamination by explication or exemplifying. Information and opinion won't put them on the defensive. Quite the opposite, such things inspire them. They don't fret about the danger of over-determining the work by letting us know their own version of what it means. I suppose their shared background in documentary film-making has conditioned them to see meaning, and the words chosen to convey it properly, as a material that can be used to make art.

I think it should be argued as often as possible that art only really makes sense if it is experienced and judged as aesthetic practice. Of course I don't mean that art shouldn't want to be socially engaged or talk about other important things, only that it must do so in ways that make it interesting as art. This old truth has become even more important today, when art is once again yearning to show solidarity with politics and both must take a new digital reality on board. There is new simultaneity and accessibility and openness to participation, but also a new imperative to get your message across aesthetically, and as a result a new performative formalism, which is also reflected in mainstream news media and cultural events.[1] How can you be radical and sophisticated at the same time? In 2014 it's not enough to choose only one of these options.

I just used the words "literary" and "literal" to describe the Raqs Media Collective's work, but without any intention to downplay its visual aesthetic value. Art is often synonymous with "visual art" but was never restricted to using unaccompanied visuals. There is a very long history of annotated images, of embellished writing that doubles as a pattern or picture, of images that can't be isolated from tone and melody, rhythm and movement, and indeed of objects and images that become strong signs precisely because they make an honest attempt to exist outside of verbal communication.

All these approaches can be observed in the Raqs digital catalogue.[2] Yet the more an artwork aspires to mute thingliness (or its paradoxically similar opposite, aloof immateriality) and the more disdain it shows for theatrics or storytelling or critical reasoning, the more vulnerable it makes itself to accusations of corruption by content and context. Or so it seems when we review the recent history of "high art" in its Western, predominantly American guises: abstract expressionist paintings doubling as poster images of

first-world individualism and freedom of expression, minimal art immediately being accused of theatrical inclinations, conceptual art becoming indistinguishable, at its very moment of birth, from the "concepts" of the advertising industry.[3]

*   *   *

Perhaps I digress when I speak in such general terms of contemporary politics and late modernist art. But I do so to properly introduce my take on the notion of "illustration," which I believe is applicable to significant parts of the Raqs' oeuvre. Illustration may be used a term of ostensibly polite abuse. Works by this or that artist are described as technically accomplished, perhaps visually attractive, but "a bit illustrative." This hints at unforgivable artistic failure. The implication is that illustration is too obviously based on some statement already made in another, non-visual medium (typically a literary text) and therefore second-hand and second-rate.

Illustration is often regarded as a minor practice and a thing of the past: an earnest applied art that is losing its relevance and justification in the age of the audiovisual, first symbolised by television and now by the internet. But what if this understanding of the term is in itself derivative and outdated? Is illustration ready to be salvaged as a term of appreciation for the digital age, with its new proximity between image and word? Does it touch on the relation of the visual to the verbal, in a way that is fundamentally relevant to art as a sophisticated *and* radical aesthetic practice?

Let us turn for a while to etymology, the intriguing but treacherously unsystematic study of how words travel through time. If we consult the Oxford English Dictionary we learn of the English word "illustration" that "the sense-history is parallel to that of *illumination* (n.), the meaning 'spiritual enlightenment' being the first to appear."[4] Since nouns of this kind are usually derived from a verb, we are well advised to also check "illustrate," and then we find that its first listed meaning, now obsolete (but therefore no less pertinent), is "to shed light upon, light up, illumine."[5] The fifth listed meaning is also interesting: "to throw the light of intelligence upon; to make clear; elucidate; clear up; explain."[6]

Rather than signalling a lack of accomplishment illustration speaks about light, and may therefore inspire appreciation. To appreciate, in turn, means "to make or form an estimate of worth, quality, or amount" as well as "to esteem adequately or highly; to recognise as valuable or excellent, to find worth or excellence in."[7] Might there still be some importance, even some truth, in the historical link between light, spirit, intelligence, and estimation? Might illustration, as a nexus of notions for articulating positive judgment, be a force to reckon with in today's aestheticised and communication-driven public life? I don't see why not, and in fact I have repeatedly tried to explore this possibility in my work as a curator.

My first opportunity to work with the Raqs Media Collective was the group exhibition *Art of the Possible* at Lunds Konsthall in Sweden in early 2007. I had planned it around

two quotes, from Marcel Duchamp and Henri Bergson, about the possible as a retroactive principle and physical presence.[8] My invitation to Raqs was phrased as an explicit request to illustrate the exhibition concept with a new work.

The result was the decidedly non-verbal installation *Insurance % Investment* (2007), centred on three videos conveying sensations of movement. On the walls of the darkened high-ceilinged space two motorcyclists were silently racing against each other inside the metal mesh "bowl of death" of an Indian circus, while two heavy fans were blowing imaginary air into the gallery and sucking it out again, accompanied by a "three-dimensional" cranky and metallic sound that made the whole room feel like a stage without performance. There was also photographic wallpaper with repeated images suggesting airlessness: a dingy office-like interior that signalled "suffocation" and the promise of literal relief in the form of oxygen tubes and masks.[9]

This might be described as a translation of concept into image, and a work of art might also translate an image into words or bodily action. Yet what I find interesting is the capacity to *speak in images* that illustration throws light upon. This is different from direct acts of translation, but also from withdrawing from speech into an elusive beyond, represented by a high-status art image (a painting, perhaps) that decorously refuses to answer when it is spoken to.

For me Raqs represent the will to speak and to make every possible use of the image by continuously forging and breaking links with the word. Yet it would be naive to imagine that illustration could be resurrected as a positive term by an act of good will alone, or in isolation from other operations that contemporary artists perform to make their work resound with society at large. In *Art of the Possible*, for instance, illustration was associated with three other notions — articulation, self-reflection, and speculation — to form a one-off system for thinking about "the possible" in art, through art. Although Raqs were specifically entrusted with illustrating illustration, they would just as plausibly have articulated articulation, reflected on self-reflection, or speculated on speculation.

\* \* \*

My appreciation of the Raqs Media Collective's simultaneously relaxed and controlling approach to images and meaning was the main reason for starting a working relationship with them. This relationship continued with an invitation in the opposite direction: extended from them to me. In the spring of 2007 the three members were appointed curators of a main exhibition in the European biennial Manifesta 7, which was to take place in the summer of 2008 in the two autonomous northern Italian provinces of Alto Adige (the mostly German-speaking former Austrian South Tirol) and Trentino (which also used to belong to Austria but is almost entirely Italian-speaking).

Together with English artist Graham Harwood and German architect Nikolaus Hirsch I was asked to advise and assist Raqs in their preparation of *The Rest of Now*, an attempt

at interpreting — or illustrating, in the sense just outlined — the idea of "residue" in relation to contemporary aesthetic practice and to the chosen venue. Alumix, the gigantic remainder of a once even more enormous aluminum-smelting complex, was a metonym for metallurgical hubris and a quite literal demonstration of how "residue" looks and feels.

Alumix was built in 1932–1936, under Fascism, outside the city of Bolzano (which is called Bozen in German). The original ideological-industrial argumentation for it might be reconstructed as follows: Aluminum is a modern material, and suitable for future-orientated and identifiably Italian objects such as coffee percolators. Italy has, within its own territory, some important deposits of bauxite. There is hydroelectric power in the Alpine region. So let's build a factory for making the aluminum Italy needs for its self-sufficiency in this newly conquered Austrian territory and bring in Italian-speaking workers from provinces further south to run it. Moreover, Abyssinia, which we'll soon have conquered, is not just the original home of the coffee bean but probably also sits on huge mineral resources. But we can always bring bauxite from Sicily if we don't find any in Abyssinia.[10]

Said and done. But the autarchic Italian aluminum industry was not as sustainable as the Fascist planners had wished, and by the mid-eighties Alumix was closed and partly demolished. For Manifesta, the authorities in Bolzano invested in a temporary upgrade of the crumbling building, and the scene was set for bringing together the work of more than 50 artists and artists' collectives. Just like the building that housed them, their contributions to the exhibition doubled as metaphors of residue as trace, while also thematising various forms of resistance to oblivion.[11] Spatial articulation was visibly a priority for the Raqs as curators, given all the cubic metres at their command, but this approach was enriched by individualist and idiosyncratic forays into the archival.[12]

Raqs exhibited no work of their own at Alumix; they took their role as curators too seriously for that. Yet the exhibition as a whole, for which I had recommended some participants, was a composition of attitudes and forms, stories and images that had a distinctly Raqs feel to it, almost as if they had created the whole display in their own image. The concerns of content and context, the strategies of inclusion and exclusion, the aesthetic and logistical details, all was dealt with very responsibly and consistently, but the "style of curating" was quite distinct from that of career curators. Among the most memorable works in *The Rest of Now* were direct interventions in the factory building by relative newcomers to the art circuit, among them the architect couple Siv Helene Stangeland and Reinhard Kropf from Stavanger, Norway, who focus on recycled materials, or the New York-based Spanish architect and experimental building preservation specialist Jorge Otero-Pailos.

The exhibition didn't include very many internationally well-known artists' names; it had relatively little of the recognition factor to which the curatorial profession is addicted. This was a strength that some observers chose to regard as a weakness. The mainstream

art world, not least that of *Mitteleuropa*, likes to play hard to please. In fact Raqs have enough contextual traction to do almost entirely as they please, which I guess was the very reason why they were invited to curate Manifesta. A possible weakness, which might have looked like a strength, was that some of the invited artists felt more like individual elements in a Raqs *Gesamtkunstwerk* than as participants in a collective event. But such accusations, of originality and a strong individual vision, are only all too predictable when artists are asked to function as curators.

Other issues interest me more: Can their most ambitious curatorial venture to date teach us anything about how Raqs conceive and compose their own work? Exactly what balance between planning and improvisation constitutes their style? What is the secret — if there is one — behind their distinctive tone? Let's not forget that tone is to do with the body, with the tension that it produces and sustains, whereas style is in principle prosthetic, an extension of the physical Self.[13] To understand the Raqs style we must therefore look beyond the tone of voice of the members, usually Monica and Shuddha, who read the scripts to the moving or still images of their films, even if Raqs use linguistic tools such as accent and diction very actively and consciously.

As with any other artists, we must look for the defining features of the Raqs' oeuvre in more than one place at a time. We must always analyse the content and composition of an actual piece of work without overlooking the things that have been consciously left out. In the case of Raqs there is a tension, usually productive, between those qualities of their work that immediately appeal to consumers of contemporary art in general (i.e. the qualities thought of as "quality" without being sufficiently analysed in terms of power politics) and those that indicate a more specific point of departure (i.e., what is thought of as "context" without being sufficiently analysed in terms of aesthetics).

Raqs make statements about the contemporary world that can be understood and appreciated by any member of the interested public, but their activities also very much reflect "where they come from." As a large-scale event that only indirectly represented the Raqs Media Collective's own creative practice, *The Rest of Now* helped us identify three such "belongings" or "origins." The exhibition's approach to subject matter and how to present it was more than accidentally related to that of documentary cinema. I have already indicated this as important for situating the Raqs' oeuvre. As curators, Raqs also continued to refine their take on the "new media" ambitions of many artists in the nineties. This segment of the art world, which has narrowed to a niche in recent years, was significant for their early development. Finally, the Subcontinent was a visible and strategically significant presence in *The Rest of Now*, and some "new names" from India were successfully launched.[14]

\* \* \*

As we see, understanding context is important for our judgment of the Raqs Media Collective, but so are other aspects of their work. They take great care, in all their activi-

ties and roles, to weave a tight fabric of context and content, facts and forms, text and image, sound and touch. As we would expect from a practice that spans almost twenty years, different concerns have shaped different projects, and there is a multitude of examples to choose from.

One work that has already become iconic of how Raqs allow ideas to migrate from one format or dimension to another with minimal loss of precision is *Please Do Not Touch the Work of Art* (2000/2006). The familiar exhortation is both enhanced and subverted in nine permutations that include "WORK. DO NOT PLEASE THE ART OF TOUCH" and "DO THE ART OF TOUCH PLEASE. WORK NOT." What began as a postcard in 2000 has subsequently been displayed as a large-scale wall piece with burnished gold vinyl lettering — for instance at Lunds Konsthall in 2007 — and as an etched white marble plaque. In other words, Raqs have overseen the gradual mineralisation of their original thought from throwaway text through understatedly spectacular image to ironically precious stone object.

In *Guesswork*, their exhibition at Frith Street Gallery in London in February 2012, Raqs chose to foreground object-hood quite literally by allowing operations rooted in language to become manifest as immaculately manufactured information panels with sculptural flair. The exhibition in this commercial gallery brought together pieces already shown by not-for-profit organisations such as the Art Gallery of York University in Toronto and the Festival d'Automne in Paris. At the entrance visitors encountered an updated version, in reflective metal and red LED lights, of the well-known ideogram for an imagined frictionless unity of workers and peasants, in which the hammer's part is played by a *point d'indignation*, a sign invented by the poet Hervé Bazin that looks like an upside-down exclamation point, and the sickle is impersonated by a tilted question mark. This work was first shown at the headquarters of the Oscar Niemeyer designed French Communist Party in Paris. That presentation, in 2011, also included a three-dimensional adaptation of the neologism "revoltage." It depends on the switching on and off of light bulbs forming the different morsels that make up the word and the handsome tangle of black and red electric wires that make this switching possible.

As we see, the tools and building-blocks of intellectual labour — words and the signs used to create and modify them — have become Raqs' intellectual property, but only after going through a process that illustrate the complexity of objectification and commodification. The work of art may or may not be an object, but it needs some kind of support to become visible, whether it is material or relational, based on production or sharing. This time Raqs chose to manufacture and display three-dimensional art objects, but when do such objects become commodities? Is it only when they are put up for sale? Isn't the value of art as a tradable commodity always linked to both the quality of the thinking that goes into its production and the context in which it is offered for consumption? In other words, isn't it linked to the immaterial and relational aspects of the commercial transaction? Isn't commodification in contemporary art to do with what used to be called "content" rather than with form?

Raqs have only recently entered into the commercial part of the art market, and in their case commercial value is clearly related to intellectual achievement. The software becomes the hardware, as it were. At Frith Street Gallery they showed more samples of what we might describe as intellectual new media interior design, playing on motifs from their recent text-based audiovisual work. *Strikes at Time* (2011), another piece premiered in Paris, variously illuminates the words IT IS THE MOMENT TO STRIKE AT TIME, while *Rewriting on the Wall* (2011) uses the handprint of an illiterate Bengali peasant — taken in 1858 and archived as an early example of population control through biometrics — for "copying out" sentences in American Sign Language. Apparently illuminating and transparent, the Raqs' art objects in fact put the primacy of cerebral strategising over design object into question and make the boundaries between solidified thought, art object, and marketable commodity feel less secure.

In my understanding Raqs are much more process-orientated than we might think when we first encounter their articulate assemblages of on-the-edge pictures and well-rounded sentences. The risk of not achieving the right balance between the conceptual and the visual, between plot and production design, is always a productive presence in their work, which incorporates a fair amount of experimentation and improvisation. The sleek image-objects collected at Frith Street Gallery may be seen as illustrations — in the sense I have outlined above — of how the obtuse resists being expressed through the tangible. The industrially finished *objet d'art* can be necessary as a stimulant for this particular act of withdrawal. It also produces an eerie sensation of automatism. It is as if the messages conveyed by Raqs' screens and sign-boards were both written and read by machines, rendering the spectator somewhat superfluous: a bystander who can only watch as the intelligence of the pieces consumes itself. This is object-art that becomes indicative of a process, the process of wilfully over-determining a narrative until it slips away.

Such reflective and expansive remodelling of content is a technique that Raqs have used many times in their audiovisual works. That is how I prefer to label them, rather than films or performances or installations, although they may be described as all those things, even at the same time. The sound component is usually, but not always, an intricate linguistic composition that does the job of setting up a narrative, carrying it forward and turning it back on itself. Raqs often use the visual component as an evocative or meditative background, against which their signature tone of voice — sometimes deliberately contrived, always self-reflective without being self-referential — will be fully appreciated.

This should not lure us into believing that the images, still or moving, are of secondary importance to them. As confident storytellers, they feel no obligation to proceed in a linear or square fashion or to secure their work within a framework of "quality" ultimately dependent on "context," i.e., on the pooled opinions of others. Raqs exercise control over their own means of expression, but keep their structures open to anything that might reveal itself as significant in the process of putting a work together.

A number of recent pieces fall into this category of thoroughly researched audiovisual storytelling, but I choose to comment on *The Capital of Accumulation* (2010). Produced with support from a Goethe-Institut project bringing together Berlin and Warsaw and Mumbai, it uses three channels: two video projections and one soundtrack, which in turn contains several voices and some rather discreet music. The work proceeds by permutation and anagram, interlacing and infiltration. A well-known book is still recognisable in the title, but its author now goes under the almost-credible Indian name of Luxme Sorabgur. For their weaving-together of different cities and decades, Raqs have gathered facts that are more or less verifiable, such as the violent death and unsettled afterlife of Rosa Luxemburg as a limbless cadaver in the morgue at Friedrichsfelde outside Berlin in the twenties, or a light-bulb factory in post-war socialist Warsaw, or images that come to her 97-year-old nephew in his dreams in today's no-longer-Jewish Vilna. They have leafed through her herbarium and read her correspondence with Sonja Liebknecht about migratory birds. They trace the history of Indo-German relations, often a mirror-image of the antagonism between India and Britain, and they attempt to revive the defunct textile mills of Mumbai, or at least their capitalist spirit, by reading aloud from *The Accumulation of Capital* to a empty factory interior, abandoned after a textile workers' strike thirty years ago.

These are only a few examples of how Raqs arrange the subject matter of this audiovisual composition that flows, without haste, through five stations: EXPANSION, ANTAGONISM, PROTAGONIST, LIMITS, and OUTSIDE. These chapter headings are expansive and elastic enough to accommodate not only the narrative elements but also the modulations of tone that are necessary to break through the barrier of correct informational language usage and make the sound *really* speak to the images and vice versa. Only by venturing into the aphoristic or the theatrical and borrowing from the experimental radio play and the philosophical essay film — cultural practices that visual art pretends to like but is reluctant to fully embrace — can Raqs articulate their material so that it becomes a bridge to the unknowable. Only by exposing themselves to the risk of being submerged by their process and carried away by their articulate delivery can they stay "on message" and advance an agenda of unpredictably associative editing.

\* \* \*

I have tried to formulate a subjective critical appreciation of the Raqs Media Collective's art. Their installations can be illustrative, their curatorial projects tend towards becoming self-portraits, their art objects are sometimes commodities rather than materialised thoughts, their audiovisual works do not steer clear of the theatrical. I have said all that, but if my readers have seized only on my critique and registered none of my appreciation, then I hope this isn't just my own fault.

Appreciation, in my interpretation of the term, is about our reflected response to the world, not our reactions to sensual stimuli. It involves a deliberate effort to look beyond the moments of pleasure and irritation that occur in all contacts between humans and

grasp what we believe must be graspable even if we can't understand it at will. When our desire to know is aroused it becomes meaningful to speak of appreciation. Yet we mustn't confuse our passion for knowledge, which is a strong driving force for art as well as other advanced activities, with our systematic quest for it, which unfortunately tends to push art out of the picture. For me the Raqs Media Collective's art is more to do with understanding than with knowledge. Perhaps that is why it has an effect on me that might be called liberating: it makes me aware of new things worth knowing, without claiming to give me the correct version of what is already known. Their art makes me realise that the difference between the unknowable and the unknown can be productive, a productive friction. It inspires me without directing or controlling me, and it does so thanks to — not despite — the imperfections that I have tried to describe.

# NOTES

1 Perhaps it is enough to think of how mainstream media and art outfits such as *Al Jazeera English* or the Berlin Biennial have embraced the Occupy movement.

2 Some examples among recent works: I would describe the many audiovisual works, such as *The Capital of Accumulation* (2010) or *The Surface of Each Day Is a Different Planet* (2009) as annotated images, but also as images dependent on a specific tone (of voice), while sculptural pieces such as *Proverbs* (2011 onwards) and *Revoltage* (2010) or the wall version of *Please Do Not Touch the Work of Art* (2006 onwards) would be writing as picture and *The Untold Intimacy of Digits* (2011) or *Unusually Adrift from the Shoreline* (2008) examples of expressly non-verbal signs.

3 Gilles Deleuze and Félix Guattari's complaint in *What Is Philosophy?*

4 *The Oxford English Dictionary online.* (Accessed 6 May 2012)

5 Ibid.

6 Ibid.

7 Ibid.

8 Duchamp's quote is undated and difficult to place correctly in his oeuvre: "The figuration of a possible (not as the opposite of impossible, nor as related to probable, nor as subordinate to likely). The *possible* is only a physical 'caustic' [vitriol type] that burns up all aesthetics and callistics." Bergson's quote, from his Nobel Prize lecture *The Possible and the Real*, published in 1928, is more elaborate, and I can only provide a snippet here: "As reality is created as something unforeseeable and new, its image is reflected behind it into the indefinite past; thus it finds that it has from all time been possible, but it is at this precise moment that it begins to have always been possible, and that is why I said that its possibility, which does not precede its reality, will have preceded it once the reality has appeared." Reprinted in Anders Kreuger, *Det möjligas konst/Art of the Possible* (Lund: Lunds Konsthall, 2007), 10, 3.

9 The Raqs concept note for this work — effectively an illustration of an illustration — was published in the catalogue: "The relationship between likelihood and the attainable, between possibility and failure, between hope and premonition of danger, is essentially a ratio, a percentage. The mental operations we perform on the basis of our understanding of the idea of percentage are the triggers that catalyse most of our crucial decisions with regard to the future. We are forever calculating the odds, performing the mental arithmetic of hope and despair." Kreuger, *Det möjligas konst,* 25.

10 For a detailed account of the history of the Bialetti Moka Express percolator, see Jeffrey Schapp, "The Romance of Caffeine and Aluminium," in *Manifesta 7 Companion: The Rest of Now,* eds. Rana Dasgupta and Raqs Media Collective (Milan: Silvana Editoriale, 2008), 95–99.

11 My name is in the list of participating artists, because Raqs asked me, and the other two advisors, to contribute more than just advice: they expressly wanted a "work." I therefore made the film *Subtitles* (2008) which in effect is just my own English subtitles — part translation, part commentary — to the entire 25 minutes of the first episode of *Det bara händer* ("It Just So Happens," but also "With My Bare Hands"), a series of children's programmes produced by the puppeteer Staffan Westerberg for Swedish Television in 1972, when I was seven years old.

12 The works by Yane Calovski (an installation on the planned "metabolic" urban renewal of Skopje after the earthquake of 1963), Marysia Lewandowska and Neil Cummings (screenings of workers' amateur cinema projects from the 1970s), Katarina Sedá (her grandmother's drawings from memory of items she used to sell in a hardware store), and Judy Werthein (a video on a secretive post-war community of German Nazis in Chile) deserve to be mentioned as "illustrations" of this tendency in the exhibition.

13 We speak of "a toned body" or "body tone," and this was originally not very different from the tone that a string produces when we apply tension to it (by stringing it or plucking it or hitting it with an object, such as the little felt-clad wooden club inside a piano). Style, on the other hand, does not happen, or at least will not be noticed, until the range of the body is extended with the help of man-made objects such as the Latin *stilus*, "a stake, a pale, a pointed instrument for writing upon wax tablets." See, for instance, the University of Notre Dame online Latin dictionary. http://www.archives.nd.edu/cgi-bin/lookup.pl?stem=stil&ending=us

14 Not least that of the photographer Dayanitha Singh, or the film-makers Ranu Ghosh, Sanjay Kak, and Hansa Thapliyal.

FREEHOLD

WAR FEVER

DECOMPOSITION

PLAYFUL

BARE ACTS

# When the Scales Fall From Your Eyes

Chairs, tables, suitcases, a bed, TV and standard lamp, office equipment, and other pieces of furniture spray-painted white and scattered around in a plain white-walled warehouse space. Some were surmounted by headless life-size transparent glass busts, in turn surmounted by kitchen scales inside which were various small objects, meaningful tokens, and symbols.

The glass bust assemblages were like the results of some variant of a 3D *cadavre exquis*, complete with readymades. We encountered them as figures oriented towards a large disc of LED light changing through a rainbow spectrum, the only light in the space. A riveted congregation for an unspecified ritual.

The figures were drawn to the light, in the same way I am drawn to this computer page, as countless millions of us turn towards illuminated screens in order to exchange information. This digital age has ushered in a strange new crop of sunflowers.

The light here enabled us to wend our way amidst the figures, dimly to scrutinise them and read their dial-faces as they were literally weighed down. One of the kitchen scales contained a small video monitor with an image of the moon, the mediated image of an ancient reflection. A reiteration of the LED circle and all the circles that occur to us naturally, it reminded us that we were indoors.

We were very indoors. Too dreamy to be a critique of a brave new world gone wrong, this installation was like a seventies film set, surrealist, Ken Russell meets Stanley Kubrick on a Pinewood prairie. It was not unpleasant; a good trip.

This was *When the Scales Fall From Your Eyes* (2009). When the scales fell from our eyes? If this was a Damascene experience — where we saw face to face after looking through a glass darkly — scales fell from our eyes to reveal scales. Kitchen scales, scales with (round, transparent) corneal bowls. A typically Raqsian pun, verbal and visual, complicating everything. Certainly we didn't walk into this place to have all our questions answered.

This was a warehouse in Birmingham, the second largest city in Britain, the cradle of the Industrial Revolution, arguably the place that started commercialisation, urbanisation, globalisation, and so on. The sociological process of atomisation. The assembled figures, the assemblages, here did not relate to each other, but instead were staring at a synthesized sun.

All this stuff, these chairs and tables and things, felt stranded as if a tide had gone out, but there was an achromatic integrity. If not colour, there was volume and tone in this weird world of forms. And there was weight, indicated by the scales and their numbers which signified a relentless quantification of modern life, a world where we are adding up rapidly, increasingly with noughts and ones. This was essentially the proposition of the work.

Here we were in an art gallery, a white cube refined out of raw warehouse space. The anthropomorphism embedded in all this stuff made it impossible not to identify with it, to join in and redirect our attention to the wall-based circular light-box, the archetypal work of art in this work of art. Its distinct difference, its colour, was in a constant state of flux. Its fugitive abstraction could not have been less like the thing-ness of the assorted (art) objects, the bits of junk in orbit, that were keeping us company. It was the unfixed centre, making pointless any efforts definitively to apprehend, let alone quantify, artistic experience.

Numbers have to be made up in an art market that thrives on them. They have/can have nothing to do with intrinsic artistic quality and so it is the natural habitat of the cynic, the one who, as Oscar Wilde put it, "knows the price of everything and the value of nothing."

THE IMPOSTOR

OF

EVIDENCE

UNTOUCHABLE
FACTORY

SP

DEEP

FEELI

WAY

ELECTRONIC
PASSING TIME

METRO

OMNI-

TIMES
IMPRINTED
LIGHT

# What did the fish see?

It was the autumn of 1917 in India when the monsoon's annual flooding subsides and, with a thoroughly modern bloodbath raging half a world away in the trenches of Verdun, a small-town *maulvi* was walking along the newly re-exposed Ganges riverbank, preoccupied with concerns of a far more parochial nature: he was looking for building materials, hoping to find them laid up in the drying mud near a town called Didarganj, and he'd spotted the corner of what looked like a promising block of sandstone. It was a theophanic moment, although it took some digging before that became clear: what came out of the Ganges' bank was the large and evidently ancient body of a powerful, volup-tuous goddess. At least that's how the local villagers saw it. Within days, a makeshift structure of bamboo was erected around the image and it was being actively worshipped: hymned and felicitated, awoken in the morning by auspicious songs, dressed in silk and ornamented with vermilion, returning her worshippers' rapt gazes, accepting their offerings and giving them back somehow amplified and divinely charged, showering the congregants with waves of potent bliss.

What they called her we'll never know, because the archeologists and soldiers who came and took her away to the newly constructed Patna Museum in the provincial capital nearby never asked. Instead they helpfully explained to the villagers that the sculpture wasn't a goddess at all. You could tell by some minor detail of her iconography, thank you very much, and you can visit the museum anytime you want. They renamed the sculpture the Didarganj Yakshi, based on its finding place and their tentative identification of the sculpture as depicting a "yakshi," or attendant deity, cleaned off the vermilion, removed the sculpture's ornaments, and put it on a pedestal in a well-lit spot in the museum with a label announcing the "idol" as belonging to the "Mauryan dynasty," dating it to roughly the third century BC.

The episode of the "Didarganj Yakshi," an "artwork" which went on to have a long career — at first, as an emblem of India's putative golden antiquity, and then, under the aes-theticizing dispensation of the new post-colonial nation, as a "masterpiece" and proof positive of India's autochthonous, transhistorical spiritual essence — seems, on the face of things, to be a textbook example of the dichotomy Walter Benjamin drew between

the "cult value" and the "exhibition value" of an object. The museological appropriation, following this reasoning, dislocated the object from its ritual context, stripping it not just of its flowers but of its cultic aura, replacing it with a regime of value based on evidentiary display, circulation, and reproduction. And there is undoubtedly something persuasive about that narrative, perhaps because it fits into a larger set of stories about modernity itself, with its promises to separate myth from history, quackery from science, superstition from reality: this is no goddess, the archeologists informed the ignorant villagers, and "is entitled to no kind of worship."

But of course the goddess wasn't the only one whose identity was being refashioned under the conditions of colonial, museological modernity. The villagers, too, were marked as targets for the same sort of switcheroo. The archeological museum in colonial India was part of a broader project of demonstrating control over the story of India's past — cooked up as a tale of ancient glory slowly tainted by internal moral lapses and waves of Muslim "invaders" — and then putting it on display, transforming illiterate, superstitious worshippers into impressed museum-going citizens intent on self-improvement. Suffice it to say, this whole project of regulation, control, and education was never complete, never completable: regular visitors to the "early Indian sculpture" section in Delhi's National Museum are no longer surprised to find surreptitious flowers left at the images' feet as offerings, some of them — one suspects — by the museum's own staff.

These enigmatic flowers, their neat refutation of Benjamin's polarities, their quietly insubordinate gesture of refusal, are just the sort of stubborn interruption of modernity's teleological (and unkept) promises that drives the work of the Raqs Media Collective, a trio of Delhi-based arts practitioners for whom the museum and its educative potential has been a site of research and inspiration since they first came together as film students at the Mass Communications Research Centre of Delhi's Jamia Millia Islamia University in 1991. Since that time, Raqs' Jeebesh Bagchi, Monica Narula, and Shuddhabrata Sengupta have developed an artistic and curatorial practice largely centered around a sustained inquiry into the problem of pedagogy, the arts, and social change. What has resulted is a body of work that consists not so much in objects — although there are plenty of those as well — as it does a complex network of non-profit institutions, practices, and publications.

Raqs — the word has a layered set of meanings, but derives in part from an Urdu word that refers to the ecstatic state of Sufi dervishes as they dance; it may also simply be an acronym, from "rarely asked questions" — is best known internationally for their multimedia installations and high-profile curatorial work; less well known is their role in the establishment of an extraordinary matrix of institutions in Delhi, ranging from the quasi-academic research-focused Sarai Programme, co-founded by Raqs in 2000, to the community-based new media experimentation of Cybermohalla in Delhi's slums, a project also initiated in 2001 by Sarai and an NGO called Ankur Society for Alternatives in Education that brings their philosophical and political commitment to the incomplete,

unfinished, and in-between into messy, wonderful, decentralized reality. Sarai — its name comes from the travelers' shelters that were once common along the roads of Central and South Asia — takes the figure of the premodern caravanserai — polyglot and open, a site of conversation, fluid identities, tall tales, and mobility — and forges from it a new model for the creation and dissemination of knowledge, turning the difficult process of institution-building, or as they might put it "context-building," into a form of high-stakes conceptual art.

For a group of artistic collaborators whose international work is known for its scale and ambition — for 2008's Manifesta biennial, in Italy's South Tyrol region, they occupied (and filled) a former aluminum factory in Bolzano with a curatorial venture of dizzying scope — that stubborn little flower at the foot of the goddess in the museum is also a reminder of the quiet heart of what Raqs does, how they learn, and how they facilitate learning. The Raqs collective calls them "minor practices," referring to a repertoire of techniques developed initially among the three members as a means of working collaboratively early in their career. At their core, these minor practices — *laghu riyaaz* in Hindi — are mediatic forms that enable the transcription and transformation of individual experience into deeply personal archives, collections, and, ultimately, through a process of conversation and open exchange, into the stuff of art.

Taken singly, the minor practices themselves are unremarkable and quotidian, focusing mainly on things like journal writing, sound recordings, everyday photography, mapping, and drawing — but their strength becomes apparent in their collaborative deployment in the unlikely settings of Delhi's sprawling slums, where Raqs' *laghu riyaaz*, taught as part of Cybermohalla, becomes a strategy for making sense of the experience of the city without falling prey to big-city bombast and the top-down totalizing systems of knowledge and representation that generally hold sway over an invisible citizenry. If the working-class residents of Delhi's "relocation colonies"— doubly displaced rural migrants and day-laborers — constitute a category and a problem for Delhi's authoritarian bureaucrats and paternalistic NGOs, then the archives produced by the young participants in Cybermohalla's open-source, self-regulating multimedia labs — many of them the children of autorickshaw drivers and piece-work tailors, forced to drop out of India's failing school system in order to work alongside their parents — offer a radically different picture of life in the city's metastasizing urban sprawl. Cybermohalla is about liberating its participants from the reformist pedagogical projects that cast them into the role of sufferers and victims; it simultaneously offers to outsiders a privileged glimpse into the lifeworlds of the unprivileged: the project disseminates its practitioners' work through chapbooks, websites, poetry readings, software, and exhibitions.

The Cybermohalla lab represents a relatively autonomous site for the sort of alt-pedagogical liberation that Raqs imagines; by contrast, the museum — and all three members of Raqs are dedicated museum-lovers — is one with a more contested and fraught pedagogical history. In a new essay by the collective titled "Waiting for Rain," Raqs draws attention to a 1936 report on the state of India's museums prepared at the behest

of the British colonial government, taking issue with the report's complaint "that the foremost museological problem in India was the fact that vast hordes of illiterate people flocked to museums not to 'know' but to 'wonder'." The pedagogical project of turning the living goddess into the silent Didarganj Yakshi and her worshipers into museum-goers required the creation of an atmosphere that Raqs' essay describes as still in place, a "sepulchral" blanket of silence where "the living breath of disorderly, ill informed, wondering, and wandering visitors, who walked in and out of galleries as freely as they walked in and out of competing knowledge systems and epistemic frames has given way to the hush of empty halls and display spaces." If the colonial committee behind the 1936 report is principally concerned with creating and maintaining an icily pedagogical decorum in the museum, Raqs' 2010 counter-report takes on the same problem but arrives at a very different conclusion: the museum and its objects become, instead, potential gateway drugs for some radical process of self-expansion, the tipping-points for a Rimbaudian derangement of all the senses, and the opening for an art education at once limitless, ecstatic, and incorrigible. "It will take a long time," they write, "and much banter in many corridors outside many classrooms to restore to museums and galleries in India their capacity to generate wonderment and curiosity."

Much banter in many corridors outside many classrooms is just what we get in one of Raqs' brilliant early documentary films, a 1997 production called *In the Eye of the Fish*. The film, which was shot in Delhi, Bhopal, and Kolkata, takes its title from an episode in the epic Sanskrit poem the *Mahabharata*. One of the young heroes of that ancient narrative, Arjuna, proves his fidelity to his teacher Drona's commands by piercing the eye of a fish on a distant banner with an arrow. The ideal student, one gathers from the tale, is one who, like Arjuna, is able to maintain a precise division between the subject and object of perception, to isolate that object to the exclusion of all distraction, and to demonstrate perfect obedience to his teacher. The Raqs' film, characteristically, inverts this premise, asking "what did the fish see?" Instead of triumphant heroes outshining their peers and pleasing their teachers, we see students navigating their way — haltingly at times — through the byzantine maze of restrictions, instructions, expectations, and economic complexities of studentship in contemporary India. There is no omniscient narrative, no long sweeping shots. The tone of the film is instead quiet and lyrical, built on mundane street-level scenes that don't go anywhere, misunderstandings, minor confessional moments, the shuffling feet of schoolgirls standing at attention, and mumbled insubordinate doubts about the point of it all.

That all knowledge should be contested is a fundamental axiom of the world of Raqs: if the ideal presented by Arjuna is one of undivided attention and absolute loyalty, *In the Eye of the Fish* introduces us to a sensibility with time for hesitations, unanswerable questions, distractions, and tangents, and a jaundiced fish-eyed distrust for hidebound convention and authoritative systems of knowledge. In one telling scene, a bossy schoolmarm glares at a group of stoic-looking uniformed schoolgirls, pounds her desk, and demands "Are you the best? Are you the best or not?" The girls sit in uncomfortable silence as the camera cuts away to long-dead specimens suspended in fishy formalde-

hyde near the window. It's an easy sight-gag but a compelling one, just the kind of side glance a bored student commits to and the film-makers' collusion tells us in unambiguous terms whose side they're on and pulls us into the daydream's escape hatch, precisely outlining what sort of pedagogy we can do without: top-down and authoritative, one based on the uncontested flow of information from teacher into passive pupil, with competitive mnemonics and ribbons for the winner.

What's the prescription? After this long and arid dry spell bleached by modernity's glare what we need, says Raqs, is a bit of rain. The cooling monsoon rain is a metaphor that can be hard for northern audiences to grasp. This fact is really brought home if you watch the classic 1995 Bollywood film *Dilwale Dulhania Le Jayenge*, a morality tale about the re-racinating love between a couple of young London-born Indians as they cavort through Switzerland and then, triumphantly, through yellow-blooming fields of mustard in the Punjab. In one early scene, while everyone is still struggling through life in soggy old Blighty, the young heroine, overwhelmed by her fantasies about love, runs out into a nasty looking British rainstorm and whirls in circles singing, "Tell the one who keeps coming into my dreams and inciting me, to come to me in person some day!" It looks cold out there to a northerner but to a South Asian audience it looks sublime, because in India rain spells relief to the brutally hot summer months and, when the first rain comes, it is like a warm, heady narcotic. As Raqs writes, it "invokes something latent, something unformed, something hidden in us, and coaxes us to give musty, locked-in aspects of ourselves an airing. It awakens sensations just under our skin, makes us remember snatches of forgotten songs and stories and see things in the shapes made by clouds. Our dreams turn vivid." The museum, the gallery, the biennial, and the media lab can, at their best, offer a space for this sort of liquid epiphany, for transformations less sterile than the cognitive straitjackets envisioned by schoolmarms and museum officials. The monsoon rain is, according to Raqs, a model for the best kind of art which calls forth "a re-ordering of the cognitive and sensory fields of its actual and potential publics. It asks them to open doors and windows and let other worlds in."

OMNI-VISIO

ES

IMPRINTED

LIGHT

INTE

A CARTOON IMAGE IS P

RD MIND

PARTICIPATION

MAPPING
ANOTHER
FINE
DAY

# A History of Infinity and Some Fresh Catastrophes: On Raqs Media Collective's *The Capital of Accumulation*

## 1. Moving Titles

An animated sequence at the beginning of Raqs Media Collective's two-screen film *The Capital of Accumulation* (2010) performs the title of the work's reversal of the most important of Rosa Luxemburg's economic studies, *The Accumulation of Capital* (1913). What can this mean as a reflection on the legacy, the corpse, and the spirit of Rosa Luxemburg?

In her 1913 book, Luxemburg boldly exposed the shortcomings of Karl Marx's understanding of the process of the reproduction of capital. She suggested that the necessary growth in demand required by a constantly expanded production process could not be explained by an increase in the consumption of workers and capitalists. Instead, it had to be found elsewhere. Accumulation, Luxemburg showed, was a process that was not restricted to the origins of modernity in what Marx had described as "primitive accumulation"— consisting in the "divorcing of the producer from the means of production of wealth," where "conquest, enslavement, robbery, murder, briefly force, play the great part."[1] Instead, capital's history is tantamount to constant "modernization"— vampirization and ultimately the annihilation of capitalism's others.[2]

We owe to Luxemburg the insight that capitalism is the first and only economy "which tends to engulf the entire globe and to stamp out all other economies." For, as Luxemburg argued, capitalism was also "the first mode of economy unable to exist by itself."[3] This means that, like any other parasitic life-form, capitalism stands in a relation of dependence to whatever it encroaches upon.

How can the action of capital *accumulating* become the predicate, the substance, a key feature of another kind of capital, one that is not the subject of a perpetual and desperate spiral of accumulation, but one that is, in fact, the *profit* and the sedimentary currency of accumulation itself? Raqs Media Collective's film — which grew out of a long and devoted familiarity with Luxemburg's thought that began with the abridged version of

*The Accumulation of Capital* published in Delhi by Kamunist Kranti in 1990[4] — provides a preliminary answer at the very beginning of the film, alluding to the existence of another kind of ghostly, ethereal, and residual accumulation:

> When I saw you walk the city streets, I heard you listen to the voice of falling leaves on the forest floor. This too was an accumulation: this heap of leaves, this gathering of open veins; a compost of dreams exhausted and harvesting the light of oblique sun.[5]

*The Capital of Accumulation* is thus an attempt to tune our ears to the voice of the falling leaves of history. The intention is to move beyond a contemplation of today's capitalist economy, even as it finds itself in the process of finally exhausting (as predicted by much theory, especially that of Luxemburg) the adjacent "non-capitalist" and "pre-capitalist" territories from which it extracted the premise of its own expansion.

The long-standing Hegelian tradition of irony grants the title's pun and the chiasmic device of inverting sentences, categories, and figures a dialectical value: it is, in the case of Marx, nothing less than the grammar of critique, the surgical tool by which error is corrected through semantically turning it on its head. But inversion is also a means to express development — a diagram of the working mechanism of thinking that develops an argument by leveraging the contradictions of thought itself. Inversion is that tentative instrument which, in the wrong hands, became the "logic of the dialectic." To Raqs it is a glimpse into the future of the past, from the vantage point of the present. This "present" is not a hypothetical or theoretical construct, but a thing of flesh and bone.

## 2. The Corpse of Theory (or a Theory of the Corpse)

*The Capital of Accumulation* is, thus, a discourse on the legacy of Luxemburg emerging from the voices of the beings, the matter, the territory, and the social experiences and communities that are engulfed and subsumed within Capitalism. The voices convoked in the film appear as arriving at a perpetual "Victoria Terminus"— the former name of Bombay/Mumbai's biggest railway station, where migrants to the city would disembark — as if having to endure the task of bearing witness to what is left behind:

> They came bearing with them the dust of hinterlands, the ashes of war, and the aftertaste of famines. They were the forest, the mountain, the desert, the scar of an open cast mine. They came every day, day after day.
>
> The forest withers, the mountain falls on its knees, the desert turns into a mirage, the mine makes money and then some more, then the seam runs dry. A factory closes. A mall refuses to open. Variable capital becomes constant and then metastasizes. Living labor dies and then waits its postmortem turn on a gurney in a forensic laboratory.[6]

One of the main narratives of *The Capital of Accumulation* is a drift through an uncertain necropolis: the search for Rosa Luxemburg's body. Yet the pursuit for the missing body of Luxemburg that Raqs evokes does not take place in the Friedrichsfelde Cemetery — where what appeared to be her remains were first buried next to Karl Liebknecht in 1919, after both Spartacist leaders were murdered by the proto-Nazi Freikorps following the failed Berlin Commune of December 1918. That grave lay empty after having been desecrated by the Nazis in 1935.

The identity of the corpse formerly occupying that grave became uncertain (in retrospect) when in 2007 Dr. Michael Tsokos, head of the Institute of Legal Medicine in Berlin, disclosed the possibility that an unidentified mummified torso lying for decades in the vitrines of the Charité Hospital in East Berlin could in fact be the remains of Rosa Luxemburg.[7] Raqs does not just explore the failed attempts to identify this corpse, but more appropriately document their own search: looking at the ruins of the empty vitrines of the Charité Hospital, interviewing Dr. Tsokos and filming his laboratory, exploring the photographs of Luxemburg and the documents that were unable to yield DNA traces adequate to the task of verifying the identity of the corpse.

The (dis)appearance of Rosa Luxemburg's body in Raqs' work occupies the space of a theoretical fable: that of an unsettled and unclaimed genealogy, uncertain precisely because it can't be built on the firm marking of a grave.

This meditation on the evanescent destiny of Luxemburg's corpse is not idle speculation, for it might well be that few cadavers are as decisive in the history of the Left. It is not only that her execution by paramilitary forces — backed by the Social Democrat government whose war minister, Gustave Noske, had spearheaded the repression of the revolution in Berlin in December 1918 — marked the symbolic start of proto-fascist violence in Europe.[8] It is also the marker of the irrevocable schism. As Hannah Arendt wrote in her beautiful assessment of the political significance of Luxemburg's work, quoting in turn Luxemburg's biographer J. P. Nettl:

> With the murder of Rosa Luxemburg and Liebknecht, the split of the European Left into Socialist and Communist parties became irrevocable; "the abyss which the Communists pictured in theory had become … the abyss of the grave" … and it became the point of no return for the German Left … those who had drifted to the Communist Party experienced a bitter disappointment with the swift moral decline and political disintegration of the Communist Party, and yet they felt that to return to the ranks of the Socialists would mean to condone the murder of Rosa.[9]

However, rather than delving into the "truth" of the corpse or making a fetish of it in the way in which "actually existing socialists" mummified their quasi-monarchic leaders, Raqs turns their quest for Luxemburg's ghost into a transcontinental investigation of the encroachment of capitalism upon the organic resources of our bodies and upon the

time of the living, while maintaining a relation to the history of labour and the labour movement through a number of poetic excavations of the social fabric of three contemporary cities: Berlin, Mumbai, and Warsaw. Their procedure has a certain wandering, peripatetic quality, echoing perhaps the fact that rather than the arrested stillness of the embalmed cadavers in "red mausoleums," true revolutionary heroes and martyrs are those who are marked in death, as much as in life, by the restlessness of their bodies.[10] Raqs' journeys yield analytical allegories and travelogues, written in an algebra of the relations between exploitation and resistance, desire and alienation — an algebra of the micrologics of daily life found when sifting through the evidence that gathers as history stands trial. "Who's ever measured (re)voltage?"

Looking at the "crater" of ash where clay tea mugs are baked in Mumbai, they throw themselves into a meditation on the function of stimulants in the process of extracting surplus value.

The tea, a sweet, hot cutting of chai, injects a shot of caffeine and calories into a multitude of bodies. A spark of energy bolts the body out of the fog of fatigue. The spark sets a flame of concentrated labour. Work continues till the next tea break. Calories burn like forest fires on the second shift of the working day. And the working day is full of working bodies ... Every tea break is a battle; a campaign in the long history of class antagonism. How often, where, when shall we drink tea? Every second and every calorie is fought for in the shop floor. Each fraction of time saved is put away in trying to understand the ghost in the machine.[11]

Filming the dust that accumulates in a former light bulb factory named after Rosa Luxemburg in Warsaw, they find the place suitable for new readings on the accumulation of capital. They echo a voice that identifies the abandoned factory as the space where the "underground haunts (the) memory of production." The informal exchanges born in the street market in a former stadium in Warsaw appear as evidence of the activity of "the last international." There, they listen to all kinds of immigrants who appear as the constituents of a "babel reborn in Babylon." Raqs stands with them under "a canopy of solidarities" and within "a network of needs" that introduce different rhythms on top of the ruins of a failed dream. All of these are the sights and sounds of the sublime, seemingly impossible reverberations produced by the current extension of capital, inhabited by ghosts and paranormal phenomena, embodying the possibility of post-industrial reincarnation. It is all of this that prompts Raqs to ask: "Can the relations that we desire be written in terms of addition and subtraction? Can a factory die in one place and be born in another?"

These recursive moves, slices of life and afterlife, culminate in an examination of the relationship between life-forms and the logic of accumulation. We hear the voices of the animals caged in the Berlin Zoo — whose predecessors must have witnessed the body of Rosa Luxemburg floating in the nearby canal — talk about liberty, the forest, and the demands of growth as they testify to her execution. We witness a meditation on how

the "two thousand fragments of possibility"— a flock of flamingoes that occupies the mud flats at the edges of Mumbai — remains oblivious to the plans to transform the space into a special economic zone in six months time.

The life-forms appear as bearers of an un-thought resistance to the plans of expansion. Living in a time other than that of the constant acceleration of capital, they appear to Raqs as if they were echoing the last words written by Rosa Luxemburg, which reflected on the persistence of the revolution despite the temporary prevalence of order: "*I was, I am, I will be.*" [12]

These sequences point towards a new sensibility, an epistemology that confronts the brutal poetics of globalization by counterposing affect to the idea of gross product, such that even the abundance of capitalism can only be seen as but a pale shadow of the exuberance of life and desire.

## 3. In Defense of the Infinite

Beyond the symbolic value Luxemburg carries as an icon of an alternative revolutionary-democratic Left, she remains an intriguing example of the possibilities of a creative non-dogmatic thinking. Her practice of theory and her theory of practice are based on a heightened sensitivity to long-term and distant processes; on the identifications of resonances between the realms of nature and history; on the need to constantly relate specific, concrete observations and general, social theories; and on the cross-fertilization between the tasks of reflecting on political experiences and recognizing the worth of organic forms of life.

This is the sensibility that Hannah Arendt tried to rescue when she argued that Lenin's criticism of Luxemburg's "theoretical errors" was in fact a reaction to her robust intellectual independence. Arendt argues that Luxemburg's thought, as embodied in books like *The Accumulation of Capital,* appeared as "essentially non-Marxist" to Lenin because of the way it refused to stay confined within the internal presumptions of Hegelian dialectics: "The trouble was that what was an error in abstract Marxian theory was an eminent faithful description of things as they really were." [13]

In the summer of 1916, British astronomer Oliver Rowland Walkey published several articles in scientific magazines like *Nature* and *Scientific American* claiming that the Sidereal Center of the universe could be roughly located at the position of the Canopus Star. [14] When reading about Walkey's discoveries while imprisoned in Poznań for trying to mobilize the proletariat against the imperialist world war, Rosa Luxemburg became enraged at what she felt was a petit-bourgeois attempt to reduce the universe to a measurable ball: "It seems that even without any fault of mine the world of stars has got into disorder ... nothing more nor less than the infinity of the universe goes by the boards." Her claustrophobic horror at the absurdity of a "globe-like infinity" was not merely

astronomical. As she suggested in a letter to Louise Kautsky, the idea of emancipation was, for her, conditioned by the supposition of the limitless: "For my spiritual comfort, I must have something more than human stupidity to think of as infinite! As you can see, I literally have the cares of Herr von Kant."[15]

Luxemburg's ironic allusion to Kant's *Critique of Practical Reason,* which famously relates "the consciousness of my existence" to the awe at "the starry heavens above and the moral law within," goes well beyond the space of a private joke between two women who were friends and comrades.[16] It encapsulates the centrality Luxemburg attributed to a fluid form of reason and knowledge based on experience and sense perception, conditioned by a pursuit of cultural refinement, in *her* project of the international revolution.

4. The Oracle in a Herbarium

If capitalist modernity has both repressed and preserved in the notion of "art" the connection between a concrete modality of practice and an overreaching form of dissident thinking, which depends on a certain restricted field of production, Luxemburg's attempt to think through the connections of the organic particular and the abstractions of capitalism found an instrument and referent in her practice as amateur botanist. From May 1913 to October 1918, all through the years she spent in and out of German prisons, Luxemburg kept a herbarium consisting of eighteen notebooks, which are currently kept in the *Akt Nowych* (Recent Records) Archive in Warsaw.[17]

I had an opportunity to handle these notebooks myself in 2011.[18] Browsing through those slim and slender blue notebooks full of glued samples of flowers and leaves that fall into fragments in one's hand, one cannot but feel awe at the complex subjectivity that gave rise to revolutionary thought well before "the suppression of percipient thinking" (as Victor Serge called it) imposed the stereotype of the communist militant and the intellectual as the cog in the wheel of a historical legality embodied by the party avant-garde.[19] When Luxemburg confides her need to give "a good look at the trees and shrubs in the park ... to see that they were all old friends" rather than deal with people with whom contact "grows continually more unsatisfying,"[20] she appears close in spirit to her critique of the incapacity of "the rigid, mechanical-bureaucratic conception [that] cannot conceive of the struggle save as the product of organization at a stage of its strength." In fact, as Luxemburg puts it, "the living, dialectical explanation makes the organization arise as a product of the struggle."[21]

The act of browsing through the herbarium somehow makes it abundantly clear that the ethos that the revolutionary had tried to convince her comrades to respond and remain alive to was the "growing heat" of the "delicate, vibrant, sensitive political atmosphere in which the waves of popular feeling, the pulse of popular life, work."[22] If she could raise a warning about the dictatorial course that the Bolsheviks took after seizing power

("the remedy which Trotsky and Lenin have found, the elimination of democracy as such, is worse than the disease it is supposed to cure, for it stops the very living source from which alone can come correction for all the innate shortcomings of social institutions"[23]), it was because she had managed to escape the shortcomings of a restricted economy of reason, one based on the idea that thought, theory, and will dictate action. Instead, she developed the idea that action arose from a complex mixture of understanding, sensation, and practice within the perplexing maelstrom of history. It was precisely because she had a catastrophic view of society that was tantamount to some sort of "natural history" of capitalism that she could also remain faithful to an ethical stance that was not compromised by the monstrous nature of her time.

The notion of "catastrophe" is not necessarily the idée fixe of those who yield to a determinist view of society. Their fidelity to determinism leads them to relinquish their ability to create power. The notion of "catastrophe" is also the signature that distinguishes those who conceive the indeterminacy of history as a condition of action and thought. This contingency then becomes the ground on which they undertake their "thinking-while-acting-out" of an open concept of time.

There is a certain impassioned amorality in Luxemburg's view of modernity that helped preserve her own faith in the possibility self-organized collective action. This is based, precisely, in an awareness of the enormous complexity of the situation that confronts the revolutionary, an awareness that could not be domesticated into simply mirroring the moralistic ways of thinking of the bourgeoisie:

> It is absurd to apply moral standards to the great elemental forces that manifest themselves in a hurricane, a flood , or an eclipse of the sun ... Manifestly, objectively considered, these are the only possible lines along which history can move, and we must follow the movement without losing sight of the main trend. I have the feeling that all this moral filth through which we are wading ... may all of a sudden ... be transformed into its very opposite, as if by the stroke of a magician's wand it may become something stupendously great and heroic.[24]

This is the breadth of a view that, on the one hand, rejected the notion of historical determinism, and on the other, berated the lack of sensitivity entailed in the avant-gardism of political cadres.

The overall effects of different social structures on societies, individuals, and organic beings overrides, to a certain extent, purely political notion of "history as class struggle." It was the same awareness that noticed the connection between the disappearance of song birds in Germany and the extension of agriculture and the colonialist extermination of Indians in North America. This was the economic theorist who corrected Marx's Eurocentric view of industrial modernity by underscoring the fact that capitalist accumulation depends on the appropriation of the resources originating in nature and "from all corners of the earth, seizing them, if necessary by force, from all levels of civilization

and from all forms of society."[25] This redefinition of the global economic process as "a relationship between capital and a non-capitalist environment" is the core of Rosa Luxemburg's argument in *The Accumulation of Capital*.[26]

None of this would probably have made sense to Luxemburg without her recognition of the commitment within her that she playfully mocked as the "morbid intensity" of her "interest in organic nature."[27] It was the intensity of this interest that allowed her to think through the continuous disaster of capitalist history without recourse to any illusion of permanence or control. The words she wrote from the prison in Breslau on May 12, 1918 appear, today, as pertinent as ever:

> What we are now witnessing is the submergence of the old world, day by day another fragment sinks beneath the waters, day by day there is a fresh catastrophe. The strangest thing is that most people see nothing of it, but continue to imagine that the ground is firm beneath their feet.[28]

Thoughts like these call out to be taken forward. They would need to be the points of departure of the (as yet unwritten) treatise that Raqs Media Collective has baptized as *The Capital of Accumulation.*

It is this spirit that retains the capacity to animate the kind of enquiry needed today in order to overcome the gloom of post-Marxist theory: an openness to the miscegenation of illuminations and facts, rebellion and receptivity, stories and theories. This is where, in fact, the true legacy of Rosa Luxemburg lies waiting for its inheritors. And so the interrogation of the accumulation of defeat and rebellion can begin afresh. Such an undertaking, according to Raqs, may prove to be much more fruitful today than the exhaustion and surrender that results from the perpetual and sterile analysis of capitalism itself:

> – We have looked too long to find the face of Capital. We thought we could turn a mirror to Medusa's head, but the mirror became our mask and we found Medusa's image infecting our vision. Like birds with mirrors, we have fought with our own reflection. We fought images with images, and we are like exhausted birds who have succumbed to the hardness of the surface that they were railing against.

> – So how do you stop being imprisoned by this mirror? How do we stop analysis from turning into fatalism and then fatally wounding us?

> – You might allow yourself to be surprised by what the world might become.[29]

Surely, such a horizon of possibilities does not spring from mourning the corpse, neither does it emerge from the emulation of specific political historical choices of the past, or fidelity to specific dead words and tactics. Rather, it arises in the attempt to hold on to a

relationship with an ever-surprising world where the revolution, rather than being a slogan or a theoretical object, merely *is*.

Because, against the mechanical logic of history, "victories will spring from ... 'defeat.'" [30]

Because, in the midst of barbarism, every layer of time and thinking needs to co(i)nspire, reverberate, and accumulate, as if they were forming the heap of dead leaves that constitutes the fertile biomass of the forest floor. It is in the depths of that immense herbarium of undergrowth that *The Capital of Accumulation* finds its moisture, its sustenance, and its seeds.

A version of this essay was published as "A History of Infinity and Some Fresh Catastrophes: On Raqs Media Collective's The Capital of Accumulation," *e-flux journal* #38 (October 2012).

## NOTES

1  Karl Marx, *Capital: A Critique of Political Economy, Vol. I* [1867](Moscow: Progress Publishers), Ch. 26.

2  "Capitalism needs non-capitalist social strata as a market for its surplus value, as a source of supply for its means of production and as a reservoir of labor power for its wage system … Capitalism must therefore always and everywhere fight a battle of annihilation against every historical form of natural economy that it encounters." Rosa Luxemburg, *The Accumulation of Capital*, trans. Agnes Schwarzchild (New York: Routledge, 2003), 348–349

3  Ibid., 447.

4  Rosa Luxemburg, *The Accumulation of Capital [An Abridged Version]* (Delhi: Kamunist Kranti, 1990). Kamunist Kranti (KK) was a left-wing worker-student group located in Faridabad (an industrial suburb of Delhi). KK included Jeebesh Bagchi amongst its members, who two years later, in 1992, together with Monica Narula and Shuddhabrata Sengupta, formed the Raqs Media Collective.

5  "Prologue" in *The Capital of Accumulation*.

6  Ibid.

7  For a concise narrative of the case, see Emily Witt, "The Mystery of Rosa Luxemburg's Corpse," *The Observer* (1 March 2011), http://observer.com/2011/03/the-mystery-of-rosa-luxemburgs-corpse/

8  As Hannah Arendt put it: "Since this early crime had been aided and abetted by the government, it initiated the death dance in postwar Germany … Thus Rosa Luxemburg's death became the watershed between two eras in Germany." Hannah Arendt, *Men in Dark Times* (New York: Harvest Books, 1993), 36.

9  Ibid.

10  I borrow the idea from journalist Emily Witt: "The most romanticized Marxists, though, are the ones that got away, the locations of their bodies not verified for decades: Che Guevara, who was shot in the jungles of Bolivia; Patrice Lumumba, who was shot in the jungles of the Congo; Salvador Allende, who was shot (or shot himself) in the Chilean presidential palace and dumped in an unmarked grave in Valparaíso for the length of Augusto Pinochet's dictatorship. And finally there is one whose corpse remains officially missing: Rosa Luxemburg, who was also shot, in a car in Berlin, and dumped in a canal." Witt, "The Mystery of Rosa Luxemburg's Corpse"

11  From "Antagonism" in *The Capital of Accumulation.*

12  Rosa Luxemburg, "Order Prevails in Berlin," January 1919.
See: http://www.marxists.org/archive/luxemburg/1919/01/14.htm.

13  Arendt, *Men in Dark Times*, 40.

14  O. R. Walkey, "The Sidereal Center: Considerations Tending to Indicate that Canopus Occupies this Position," *Scientific American Supplement* 2111 (17 June 1916):, 386.

15  Rosa Luxemburg: *Reflections and Writings*, ed. Paul Le Blanc (Amherst, NY: Humanity Books, 1999), 216.

16  Immanuel Kant, *Critique of Practical Reason and Other Works on the Theory of Ethics*, trans. Thomas Kingsmill Abbott (New York: Barnes and Noble, 2004), 260.

17  There is a facsimile of them: Rosa Luxemburg/Ròza Luksembург, *Herbarium/Zielnik* (Warsaw: Fundacja im. Rozy Luksemburg, 2009). The book reproduces the whole of the document but adds a mocked-up frame to the pages that alters the simplicity of the notebook to suggest the idea of a collection of independent images.

18  Instigated by the implications of the work of the Raqs Media Collective on Rosa Luxemburg, I unsuccessfully tried to borrow the herbarium for Manifesta 9 in Genk in 2012. Reasons of conservation made this project impossible. This text is, however, inspired by the smell of those fragile plants I had the privilege of browsing through in Warsaw.

19  Victor Serge, *Memoirs of a Revolutionary*, trans. Peter Sedgwick (Iowa City: University of Iowa Press, 2002), 375.

20  Rosa Luxemburg, *Letters from Prison*, trans. Eden and Cedar Paul (Berlin: Publishing House of the Young International, 1923), 11.

21  Rosa Luxemburg, *The Essential Rosa Luxemburg: Reform or Revolution and The Mass Strike*, ed. Helen Scott (Chicago: Haymarket Books, 2008), 157.

22  Ibid.

23  Rosa Luxemburg, *The Russian Revolution*, 1918. See
http://www.marxists.org/archive/luxemburg/1918/russian-revolution/ch04.htm.

24  Luxemburg, *Letters from Prison,* 48–49.

25  Luxemburg, *The Accumulation of Capital*, 338.

26  Ibid., 398.
27  Luxemburg, *Letters from Prison*, 67.
28  Ibid., 68–69.
29  From "The Protagonist" in *The Capital of Accumulation.*
30  Luxemburg, "Order Prevails in Berlin."

COPYRIGHT
FOSSILIZATION

ZERO SURPLUS VALUE

SMOG
CONSTRUCTION

HED STRANGERS

DEEP        FEELIN

WAY

NORES LOUDER

SRINIVAS ADITYA MOPIDEVI

# A Thought in Two Registers

A digital drawing on the computer screen at Raqs Media Collective's studio is the site I begin with. Partly resembling a world-scape, and partly a memory drawing, the process of this work was conceptualised as a network map of links, layers, nodes, conversations and friendships shared through and between three personal computers of the Raqs members. From being a digital drawing, this image went on to take the form of *The Great Bare Mat*, fuelling levels of conversations and collaborations between artists, anthropologists, historians, philosophers, scientists, and musicians from different parts of the world.[1] On a second take, the image resonates through/across the lines of experience we inhabit in today's world that is made up of the sign system of graphic scribbles. It suggests to us imaginary geographies beyond a specific cartographic representation, aiding us to see them as threads, lines and colour hues, whose beginnings and belongings are multiple and are continuously multiplied. In as much as they are scribbles, they are rewritings as well, on the uneven landscapes of past and present, embarking on new and unseen terrains while rethinking known ones. Two such registers, of archival past and its artistic afterlife, are what I shall limit myself to at the moment.

In an instance of voyages, transitions, and departures, Raqs Media Collective uses found footage of the last voyage of ship-building cranes down the River Tyne in northern England. Titled as *The Knots that Bind Are the Knots that Fray* (2010), this seven-screen video work tells the story of early April 2009 when "the distinctive Titan cranes from the Tyneside Swan Hunter shipyard in northern England were loaded up onto a heavy load vessel and sailed out of the River Tyne. These vast iconic forms were dismantled and were shipped to a new life at the Bharati shipyard on the west coast of India."[2] The dismantling of these massive cranes followed by their displacement also lets their histories float away from northern England and into sites on the distant west coast of India, acquiring newer forms and, perhaps, roles. The footage excavated by Raqs from the collection of a video enthusiast now relives in a digitally reconfigured life-form. These binding and fraying knots crucially point our attentions to not only the specific voyages that history has not registered, but remind us to see the histories of spaces/places, also in terms of past/lost voyages and found footage.

In another register of excavation, a photographically indexed afternoon from the year 1911 is restaged. This moment, frozen in time by the famous British Photographer James Waterhouse shows the examining room of the Duffing section at the Photographic Department of the Survey of India, then housed in the city of Calcutta.[3] Almost a century after its original configuration, this image was culled from the archive of the British Library in London and translated into its extended artistic life in 2011.[4] Titled *An Afternoon Unregistered on the Richter Scale* (2011), the photograph is reconfigured into an animation interlacing layers and levels of what Raqs calls "subtle interruptions" into this century-old moment of an afternoon: A person — perhaps an intruder — walks through the "windows" in the background; a constellation of stars begin to appear on the drawing board; the fan that was static starts to slowly spin in reverse; the color indigo rises to conquer the mood of the image; the light brightens and dims. These immensely delicate alterations and tremors collaborate to make the afternoon too subtle for the Richter scale to register.[5]

Both these instances, one of the voyage and other of an afternoon, produce intimate conversations with the past and its archive fuelled by the forces of the digital. The intimacy, produced here by the digital interface, does not recover the archival past as it is. Instead, it opens it up for an arena of engagements, interruptions, and, more crucially, reconfigurations. In a sense, such pasts are not to be seen as sites of lament and moaning; rather one needs to locate them as what Raqs calls "latent possibilities" that might trigger a different range of artistic and intellectual journeys. They are to be seen as the "footnotes" that bear the potential to debunk dominant assumptions of existing historical discourses.

In a time that is increasingly fuelled by the digital, links to the past and the present are spread across archival databases, blurring and redefining the cartographic conceptions of the world. Raqs' artistic processes conceptualize the world through scribbles and scratches where "footnotes" radiate as possibilities, leading us to terrains that we have not anticipated or foreseen.

## NOTES

1  Raqs Media Collective. The Great Bare Mat & Constellation, Gardner Museum, Boston, 2013.
   http://www.gardnermuseum.org/contemporary_art/exhibitions/past_exhibitions/great_bare_mat_
   and_constellation (Accessed 16 March 2013).

2  Raqs Media Collective, "The Knots that Bind are the Knots that Fray," 2010.
   http://raqsmediacollective.net /result CC.aspx?id=63&type=works (Accessed 12 April 2012)

3  Raqs Media Collective, "An Afternoon Unregistered in the Richter Scale,"
   http://www.raqsmediacollective.net/resultCC.aspx?id=143&type=works (Accessed 16 August 2012)

4  Ashita Nagesh, "Artforum.com Critic's Picks,"
   http://artforum.com/index.php?pn=picks&id=31234&view=print (Accessed 14 August 2012)

5  James Bridle, 'Frozen Moments,' Booktwo.org, http://booktwo.org/notebook/frozen-moments/
   (Accessed 15 August 2012)

CRITIQUE

AND

AFTER

WANT TO BELIEVE

GEOMETRY

B

SUPERMA

E BOY SNORES LOUDER

HETEROTOPIAS

DESIRE MIST

WATCHTOWER

LITTLE

PARASITE
TRANSÈXPERIENCES

# Classroom and the Plane of the Contemporary

What I find arresting about Raqs' art practice is the way they intervene in the global contemporary, refusing to fit into the script written by dominant discourses on art.

Raqs' practice is transgressive in the way they inhabit a space of the global contemporary that dissociates ethnicity from thinking. This frees them from the constraints of "Indian" identity and lets them think temporality not in terms of "their time" and "our time" but just time as infinitely foldable into space. It seems that often it is the multicultural art theorists in the west who keep lapsing into ethnic labels in their attempt to recover "non western thought" in some imagined purity. For Raqs, time is not a universal but archival in scope and capable of moving in different directions: "The point is not that we are all fascinated by the past, rather it is that we are not blinded by the present. This leaves us all free to explore the record of times past as well as the dreams of times future. And these outward moves in turn, allow us to look at the present. Because one can only look at the present as an object if one can position oneself away from it."

It has never been easy to enter Raqs' work. Each time I would come away from their exhibitions trying to piece together fragments of meaning and their visual impact. But I did have an epiphany when they were invited to offer an MA course to the students at the School of Arts and Aesthetics in 2011. I had imagined that these sophisticated media practitioners would use visually enticing PowerPoints as teaching aids. It was their course title, "The Traffic of Images and the Tangle of Thought," that gave me a clue to their thought process. To get tangled, thought must have some materiality. Thinking is not pristine, it's a messy affair with the "things" of the world. How disembodied are images if they jostle against each other in traffic?

Their classes turned out to be laboratories for thinking that often did away with audio-visual aids altogether, spurring intense discussions around the visible and the legible, the text and image, theory and practice. I asked them, "How do art practitioners handle pedagogy?" They replied, "It's like being at a dinner party where the guests have to share in cooking the meal that everyone will eat and enjoy, and then clean up (together) after. A semester of teaching can be seen as a design conceived by a single intelligence, or it can be seen as that which emerges and is built as a result of a series of exchanges between different intelligences." Can thinking and eating partake of the same intellectual activity? Can a class be a dinner party where the division of labour between the teacher speaking and the students listening dissolves?

Indian aesthetics is steeped in such culinary metaphors — like the one used by Bharata Muni to explain *rasa* as a delicious dish that results from getting all the spices and ingredients in the right combination of *vibhavas* (causes), *anubhavas* (effects), and *vyabhichari bhavas* (transitory mental states). Today this can be seen as a paradigm of interactivity in which *rasa,* or aesthetic tasting, is not the prerogative of the artist and actor but belongs equally to spectator as collaborator.

Rancière's *Emancipated Spectator* comes to mind.[1] He asks, "can there be theatre without spectators?" to which I respond, "Can there be a class without students?" And how does that translate into "can there be art without viewers?"

Hierarchies can be set up and upset at many levels: within the senses (the ear versus the eye, the nose, the mouth), between the one who imparts knowledge and the one who receives it, between Plato and Bharata, or between artists and the public.

Let's unpack these inequalities through the classroom.

Single intelligences versus many intelligences. How is a teacher different from the students? But here the model of a single teacher does not work, as teaching is an act carried out by a collective. So is it the case of multiple intelligence in dialogue with ignorant pupils? This is where we turn to Rancière for disturbing the neat equation between knowledge and ignorance.

Rancière traces this hierarchy of knowledge and ignorance to Plato and his creation of the foundational split between truth and appearance. He feared the actor and the artist for masking the separation of the world of fiction from reality, which in turn gave birth to a passive spectator. From now on calibration of intellect and labour will divide the world into philosophers and artists. From now on, space and time will divide thinkers and workers, creating conditions which will continually churn out philosophers and artists who can never exchange places despite their existence in the same space-time continuum.

A critique of illusionistic mimesis also happened in India, the story of which is largely untold. The colonial and nationalist idea that India was the land of spirituality dispossessed its intellectual tradition of a theory of mimesis, *anukriti vada*. These ancient texts, re-discovered in modern times, came into the space of an archive that withheld as much as it revealed — depending on the lens of the researcher. The critique of mimesis is an important section of the commentary on Bharata's *Natyasastra* by Abhinavagupta. In his commentary, Abhinavagupta turns to his teacher Bhattanayaka who first questioned the theory of mimesis that had held sway until the ninth century CE. Those who supported *anukriti vada* were Sri Lollata and Sri Sankuka, who held up mimesis as integral to *rasa*. The pleasure of seeing a mimetic play, they claimed, is the same as when we come face to face with a mimetic painting of, say, a painted horse. The very logic of mimesis, pointed out its critics — foremost being Abhinavagupta — was based on the premise that the agent of mimesis, *anukartri,* is different from the object of mimesis, *anukarya.* When an actor imitates

character through gestures and facial expression, his own emotions and self, *svatma,* is also stirred and the very difference between the two melts (*galito anukaryanukartribhava*).[2]

This view strikingly resonates with Derrida when he points out the possibility of representation mingling with what it represents[3] and echoes the Deleuzian critique of representation. The emancipated spectator has the best chance of flourishing within such a set up which not only brings the character and actor close but even undermines the hierarchy between the actor and the spectator — the latter may be seen as a potential actor.

Collaborative art practice has been a dominant trend in contemporary times but its success depends on the politics of representation it invokes. Metropolitan artists try often to join hands with artists from vernacular traditions but the conversation fails in the face of unequal transactions between knowledge and ignorance. When artists put on the cap of the activists to speak to a larger public, they stop listening to the voices they claim to speak for. It is for this reason that Raqs refract their view of activism through silence — "We think silence is not given its due in the world. Silence is important, because you can't listen effectively if there is no space created through silence around any given instance of speech. Though we use text and words quite often, we have often preferred to work through an ethic of listening rather than speaking in our work. If at all we could be described as activists, then the only way would be to see (or hear) us as 'activist listeners.' We listen to everything."

Living densely networked lives, it is easier to have conversations with Raqs through emails than personal encounter. As dervishes on the move, one rarely associates them with a stable address. The first time I met Shuddha was on a train from Kolkata to Santiniketan (an unlikely destination for this globalist). My face to face conversation with Jeebesh and Monica have been longer outside India than in Delhi, where the internet is a more likely means of communication.

Yet Delhi has a special resonance in their art practice. "Delhi is a good place to whirl from and to whirl back to and to whirl in. There is a tradition about Mehrauli, in Delhi , being the centre of the world. The Iron Pillar that never rusts next to the Qutab Minar in Mehrauli is said to mark 'axis mundi.' It reaches deep underground, impaling Vasuki, the mythic world-snake, making sure it doesn't stir, and that the world does not come tumbling down. We like this image. It's nice to live in a city that keeps the world balanced on the head of a quivering snake. Delhi is a palimpsest, a city of the future and the past, tangential to the present. It suits our time-travelling proclivities. We feel at home here, because we are at home, at large, in the world."

## NOTES

1   Jacques Ranciere, "The Emancipated Spectator," *Artforum* (March 2007), 271–80.
2   Raniero Gnoli, *The Aesthetic Experience According to Abhinavagupta* (Rome: Istituto Italiano per il Medio ed Estremo Oriente, 1956).
3   Graham Coulter-Smith, ed., *The Visual-Narrative Matrix: Interdisciplinary Collisions and Collusions* (Southampton: Southampton Institute, 2000), 1.

BYE - BYE

PORTRAITS

PAINTE

LANDSCAPE          CRITIQUE

WAN

AND

G

AFTER

1E

LITTLE BOY SNORES LOUDER

HETE

DESI

SPECULATION

WATCHTOWER

EEL ING

# The Curious Case of the Serpent that Goes to Sleep when Comets Appear

**The event/An image:** The commodity produces time flights jetting across the skies of labour that could be likened to a comet, energetic heroic action in its head propels the comet along leaving behind scenes of dreadful stasis in its tail. There is no way out of this destiny for the comet of human action if only because all flights of energy launched by stimulus will in the end tail off into entropy. Reading the French novelists of the nineteenth century we see how commodities create novels, a thing that attracts around it the fates of a few individuals, packages them into one nice little packet of events and takes them to their graves in the end. What are put into flight by commodities, in its glow, are lifetimes that can become public spectacles if for nothing else than that the single greatest virtue of the commodity is to call us out from privacy into action in the great exterior. When Jacques Rancière speaks of workers who recount their lost childhoods it is precisely this loss of motor activity answering to the siren call of that which attracts us to play outside to a childhood of dreadful labour that is being conveyed to us. And because the energies of attraction too are in the last instance slaves to the logics of entropy it is attraction that creates the notion of life itself, an action that has a finite beginning precisely because it tails off into nothingness. This dip of action downwards towards dissolution and disappearance produces the 'perspective' from which we can perceive a bound space in which all that happens belongs to the field of a single stroke of heroic response to stimulus. The end produces a measure of all that went before, even the notion of origins. Thus when we speak of life then we must begin at the tail of the comet and work backwards to see what "life" is.

But before that, something, a birdsong or a commodity, produces our coming out of interiors to fly like Icarus in the eye of all those who care to watch. Well, here too we have no option, we are live sentient beings and we cannot but react to a sharp jab of stimulus to our senses. All else is ordinary.

Investigations Begin: Third Worlds are those where we can see the simultaneous presence of the head, body, and tail of the comet of human labour without the ghettoisation of sight that defines the First. Or to put it more precisely it is impossible to edit out bits

of the phases of labour in the collective by plan or diktat. It is not possible to not perceive even by habits of class and training. The Great Confinement that Michel Foucault speaks of was what broke the backs of those who wanted to fly in the most delirious and joyous ways. It was as much about putting the wild into prisons and asylums as it was about training us to not look at what could not be contained by this discipline. The great virtue of Foucault's work is that he is beginning to tell us about the sources of our paranoid existences in the present. It is not as if Foucault is applying the 'wild disciplined' formula to everything from schools to hospitals to prisons as many might think. The scholar is making a subtle point across his work and it is this: The action of the force of discipline across institutions is an action across all aspects of life; it produces the trace of the wild detected anywhere in human life as a source of danger to our unconscious. To take the point to its logical extreme — any sign of free movement becomes a problem for the system of labour being constructed in the Great Confinement. The philosopher muses by way of warning us — I wonder why everything has become dangerous.

In Third Worlds it is difficult to keep out delirium; it takes flight, bashes its wings and head against the facades of the concrete and glass of corporate capital, and keeps bashing itself until the time of the comet tail begins in the fatigue of desirous action having run its course. Life retreats to dungeons of despair after it has struck its heads against Father Time which is nothing but the feeling of time running out, of the comet of action stimulated by things around us tailing off into the nothing in the face of resistance to play. The night sky of our megalopolis becomes the repository of the darkness approaching the lives of so many of us. The image properly edited can only intimate to us this awaiting fate. And that's why such images need to be produced and seen.

**An image:** The Yaksha and Yakshi, those spirits connected to the delirious energy of the serpent that activates life in the soil, are today frozen by the violence around them; they can only cast a frozen gaze at a landscape teeming with varied and organically delirious life. Guardians of the tyrant's wealth hidden underground as he flees, they are also guardians therefore of the positive glories of human material histories. They guard wealth only to yield it to the just prince hence they have the power of prophecy, to tell us what awaits us in the future since this future is already encoded in the structure of the commodity that they guard, histories that have gone into its making. They freeze at the slightest intuition of a violent unearthing of earth's wealth. The great achievements of technology and progress when won through a violent digging up of organic energies of life are registered as zooming across the corner of their frozen eyes. Their tense stillness codes our paralysis in the face of this violence—we cannot jump in joy at such achievements although that is precisely what the state wants us to do. The land across which such technologies can play has been won by the State through systematic violence against those who take time to move; the State has no time for deliberations and negotiations with people who might need some time to adjust the new to their genealogies of life. This land won through violence has to be sustained through violence. Capital is restless for movement and profit-making; it threatens the State with mass insurrections if

enough money is not coursing through the innards of the body public over and above the hefty paychecks to the planners and the kickbacks that win competitions. The State must clear land to profit's bidding for this reason alone; a bored State reacts to threats of mass rebellion as a matter of form, mere theory. And those who threaten the State have learnt the body language of past mass rebellions to play out the drama of revolution for a few minutes in order to win their trophy. They have learnt to do so by reacting to the political battles fought in their midst with the anger they have felt inside their homes against their pathetically violent parents. Blink and you miss this reality of Third World adolescences between home and revolution outside. The cunning of the mind gives petty Oedipal struggles of the in-between middle class autonomous authorship of a tyrant in the making. All else is ordinary.

Ordinarily, we have guns that hold back land against the anger of the dispossessed such that progress can play to profits through the corridors created in the approach of the Great Confinement in the Third World. To play today would be to be heroically open to the possibilities of accidental death at the hands of others' wild playfulness. This is what Foucault the life discovered and lived out. If one has to avoid the maudlin sentimentality of mourning a tragic life, the spectacle that Capitalism creates of our lives bound to fail against its strictures and impossible labour demands, then one would need to indeed play oneself out to one's accidental death to defeat this logic of Capital, the tyrant's melodramatic solace that all is well despite the tyranny. Spectators must be treated to the horror of violent accidental deaths in the throes of *jouissance* if this system is to be cured. To lop off the king's head still needs to be done. Every instance of such sublime terror is one step towards pensioning him off into the oblivion of the comet's tail. For this, image seekers need to be treated to their own fascinated horror when they see serpents, Yakshas and Yakshis, copulate; the sight is sublimely beautiful and yet serpents are scary...in the last instance. Another philosopher says — show me an animal and I shall ask of it what its intensities are, what its capacities are. But are we clearheaded enough to take in the glorious sight of an animal in full flight of its intensities and capacities?

Nature's endless energy flows are endlessly malleable to the play of force creating our states of the mind. Stimulus that creates the original rift between our selves and our selves is on the whole reacted to by a desire to wrestle with what stimulates us to bring things to harmony in an expanded field of perception where another is accommodated. The one becomes two and so on. Hence the figures of bodies wrestling/in athletic copulation that are the content of the cosmic animal, the life of the collective in the measure of human life itself but in a Oneness that saturates all the fields of life's organic forces expanded by the sharp prick of stimulus. So much the animal in full flight of its energies can encompass in one flap of its wing.

Mid-case Ruminations: There are times when we would need to produce virtual figures, dynamic, cinematic, to reach this oneness in our own energies. There aren't enough people around to fill us. We may read books, look at pictures, dialogue with worlds far

away from us to find bodies that we might want to wrestle with, bodies that attract the configurations of my motor powers. We might make a film to show this wrestling in progress. Especially when we realize that the one we wanted to play with is dead or has been killed or has gone mad or has been incarcerated. Maybe all those who are friends are dead and gone but they have left behind their traces, the manner in which they wanted to play, traces that we can then pick up and start play again. Such is the danger of our times in the incarceration of our senses by tyranny that we would rather play with the dead than fade away…a game that has had the haloed name of history. But earlier history had the logic of wrestling with the dead to produce those ideal bodies from the past in contemporary ones so that the game could be played for real. It was a collective recollection of the great feast after the hunt to replay it in the present. Today, in the Great Confinement, the play with the dead is all we have…no living bodies to be taken on in a great recollection of the past such that we may play once more. All else is ordinary.

**An image:** Some films may speak of the utter loneliness that Capital's incarceration of our senses produces…a neon lit truck flashes its lights of attraction at us many times but we are too tired to react to it…or worse still, nothing is left after the tyrant has wiped out all possible popular insurrections. Thus other films may document the manner in which this tyranny coursing within us made us lonely…in the last instance. Some others might mourn the loss of comrades who could have been and find solace in the flight of migratory birds into our presence that console us in the wilderness of memory after the Holocaust is over…the rosy hue of the plumage of migratory birds recalls the name of a friend we have lost to the violence of history even before we were born. As the world dies around us she dies once more in the failure of history…in our passage into entropy in our prisons. We dash back one more time through the passage of the traces of her life…two ghosts passing one another on the staircase. Too dangerous the world is for ships to pass one another calmly in the night.

Life was always a dangerous game but wrestling with attractors could give form to the world that horrifies us in the shock of emergence into the full force of daylight in growth. The Gnostic serpent, that cosmic yo-yo with which the human eye played Freud's *fort-da* game in the wild to the scale of history; now we see it darting away, like a comet, dangerously from us in the medium of our distracted anxiety, then we see it in calm as a beautiful continuous movement that negates time in its graceful unhurried passage through space. It was a measure of civilization, the ascent of duration of perception over the reflex to strike out at the 'enemy,' when the Yaksha figure became a beautiful body from origins in terrifying gnomic idolatry. Detail unfolding in time being wrapped up as they unravel into the Oneness of formal coherence is the antidote to the dangerous game of life. Hence the stubborn formalism of art as a cure for our ills.

Investigations Continue: Capitalism has, over time, instigated all historically possible movements in all possible bodies through the attractions in commodities (the flipside of Foucault's desire to be surprised by unimaginable pleasures/Diaghilev challenging

Cocteau — *étonne-moi!*). The global light that bathes us is the glow of comets — flights of our desire launched anywhere, everywhere. And this simultaneous instigation of all motor movements possible in our evolutionary destinies was bound to be both war and the Oneness of all humanity in its cosmic destiny. As empires became contiguous giving rise to dreams of world empires the armies that sallied forth to collect the treasures of the earth to embellish these phantom empires-to-be burgeoned to encompass more and more of the populace. The Marxist industrial commodity was in some ways an entropic form tending towards stasis in the wars unleashed by empire. It was a symptom of the ascent of war, in the entropy following destruction that descended towards the end of the nineteenth century like a pall of gloom on our globe. However the energies unleashed by world discovery, instigation of the world motor reflex in commodity followed by war gave rise to successive cycles of the reflex spreading far and wide, each war being answered by another and so on. The fragility of the digital image today is a symptom of how weakened the commodity has become in the ravages of successive wars instigated by the world becoming One. Of course it could have been the other way round…and it shall be in the last instance…even if it means an art collective of three is all there is left of humanity to enjoy the triumph of the ideal of Oneness over that of war. For each war also made us more inter-visible, inter-communicative…we still become One in war.

**An Image:** We pay with our lives for the ills and competitive violence that begins to fester underneath the soil when populations get confined by historical circumstances, when the serpent beneath the soil gets restless about unbridled fertility instigated by human labour. The normal historical observation that times of great prosperity are also fertile times for the growth of Absolutism is so because productivity turns unruly as the edges of historical circumscription alight upon kingdom. The tyrant arrives when the innards of a system bristling with productive energy threatens to belch its belly open to the world leading to wars of conquest helmed by the new hero of a new empire to come. Worlds hitherto apart come together in wars but always a little more than was intended by the warring factions. The growth of modernity on a global scale gives rise to penumbral zones just beyond the umbral regions of war that are brought into the logics of the unification of the world in human perception through war and communication. Global war is of course as we know fought between metropoles through outsourcing of war to Cold War neo-colonies creating a network of penumbral zones tending towards the World as One. With the passage of the Cold War such penumbral zones face a crisis. It is the neo-colony of the past, the outsourced site of global wars that now threaten to become insurgent with their own imperial ambitions as their hegemons retire from the field in fatigue. This threatens the erstwhile penumbral zone of global Oneness to be absorbed into neo-empire. A new kind of crisis film can emerge from perceptions of the approaching storm of Third World neo-imperialism. All else is ordinary.

Realization: All else is ordinary. Therefore it is difficult to maneuver the energies of the performative reflexes unleashed by the insertion of the commodity that precedes the expansion of global war into neo-colony. Such regions are as a rule bordering on

cosmopoles created by colonialism and are by the time global war arrives heaving with tensions that colonial commodity regimes have elicited. And the commodity that has been arriving there for the last few decades is of an entirely different order from the durable good of the high industrial modern. This commodity has taken on the hue of the primitive fetish thanks to its being polished again and again by a racist centralizing empire that refuses to give up an originary dream of world domination, a dream born out as revenge against tyranny that binds us and beats us without any room for self-defense — we would want to be reborn pure and unbeatably muscular so that none can resist the arm of our force; all will be dominated. The commodity of the global war codes this pure musculature that dominates everything. It has been treated to wipe out all possibility of duration in which the possibility of love might be glimpsed, as it was in the older romantic bourgeois commodity, stasis of the household goods of the bourgeois Absolutist king. The more war has weakened this empire the more it has made up for failing musculature by polishing up its winged golden shoes one more time...to make it gleam a little bit more, to make it sharp as a weapon...to tune it to intensities that will induce the war reflex amongst populations, instantaneously forbidding the thinkability of any other course of action in reaction to its stimulus.

**An image:** The wild serpent of our anxious eye is darting all around. The doom of the Yadus, the erstwhile serpents and Yakshas, is nigh it seems. Once wrestlers they turn to automatic war after they have participated in the imperial war to end all wars. We could have wrestled in *agape* once in this coming together of the world but now instead we fight in the war. All the motor movements of human destiny, all its histories, are the sharpest here in the neo-colony of global war. Entry of the world and its histories into such zones is free and random unhinging all possibilities of hierarchical thinking...there is a democracy instigated by commodity fetish here... war it is that ensures this. And general intellect flees to outlying penumbral zones. As war intensifies in neo-colony we go to sleep in the penumbral zones tired of mediating this onslaught of all history and motor action in our incarcerations. And in this sleep we become prospectors of the terrain of experience to excavate these histories that lie buried in motor fatigue. The general intellect is gradually going to sleep because the centre that wages global war is determinedly racist supremacist and believes in the rule of one. Resisting it is tiring, boring, and pointless. But in the half-sleep of fatigue we could, in our reveries, release the World Histories we have learnt in the touch of the war in the neo-colony. Once in a while a beautiful sublime/ simple image appears in the passage of garbled media noise...paradise as a pause in war...to be traveled to in the distant future when our tasks here are done.

Denouement: We are in the Great Confinement because the commodity of global war unleashes memories of all historical circumscription in historical memory. We are in the Great Confinement because the war the commodity unleashes encodes the muscular stubbornness of historical circumscription. We are in the Great Confinement because this war will ensure that all remain alert and confined in alertness to its codes of alertness which are nothing but the memory of a prior historical circumscription. The deadly

shine of the commodity of the global war is nothing but the coding of the intensities of musculature in resistance to the Great Confinement. It is a missile that is aimed in revenge by those escaping confinement at the forces that confined them but at the last moment is diverted on to us so that we are immobilized by its force in order that the escapees can conquer the world in our paralysis. It is made up of the slave's total knowledge of all the forces at work within the confinement. Thus the Third World is today the repository of World History precisely because the commodity coding the totality of human reflexes possible in human evolutionary history gets activated at its most intense in the global war in the neo-colony; World History gets deposited in the penumbral zone just outside the centre of war.

One would need a miracle to re-insert the general intellect into war. A positive media history of modernity has probably been nothing but cascades of generations of motor movements being wrestled with by generations of interconnected moderns in the pages of their historical memories. Re-inserting this global history of *agape*, to re-enchant the general intellect towards work in a positive history of technology within the global war, to reach that moment when the embrace of war magically transmutes into the embrace in *agape*, is the task of the machine within the image. Scenes of war need to be re-shown in the voice of love, in duration, to show up how the image of war is also the image of loving embrace. To see the loving embrace in the sharp reflex of the new commodity of global war needs an infinite unfurling of the folds of the racist supremacist flag to reveal the core warmth of self-sustaining ego energies that is also the glow of the birth of consciousness in organic electricity. We need to show that the light of the commodity outside of which it seems no sight is possible today is also this senseless glow that is the only proof of life — a life which has no aim or objective to act towards. Action comes later with the insertion into us of the language of memories of historical wrongs to be avenged.

**The event/An image:** Meanwhile, the Great Confinement approaches us as global war moves into our midst. We are striking against time which is nothing but the obstinacy of the tyrant to stay singular in the one, in fatigue the bells are tolling inside our heads as the systems shut down. The comet of attractions is tailing off into oblivion. Our restless travels through penumbral zones of war in trying to insert experience into war wear us down. Accidents are proliferating. The serpent of desire slips into hibernation, into cosmic sleep. It's time to close the case. One would need to sit down for a drink with one's comrades in order to live to see another day.

Verdict: All else is ordinary.

PASSING TIME

AFTER

LITTLE BOY SNORES

CE

UNTOUCHABLE
FACTORY

SPECULATION

WATCHTOWER

EEP

FEELING

WAY

METROPOLIS
OMNI-VISION

PA
TRA

LIGHT

INTERVIEW

GARDENS

# Nightwings

*We aeronauts of the spirit! …Other birds will fly farther!* This insight and faith
of ours vies with them in flying up and away; it rises above our heads and above
our impotence into the heights and from there surveys the distance and sees
before it the flocks of birds which, far stronger than we, still strive whither we
have striven, and where everything is sea, sea, sea! — And whither then would
we go? Would we *cross* the sea? Whither does this mighty longing draw us, this
longing that is worth more to us than any pleasure? Why just in this direction,
thither where all the suns of humanity have hitherto *gone down?* Will it perhaps
be said of us one day that we too, *steering westward, hoped to reach an India* —
but that it was our fate to be wrecked against infinity? Or, my brothers. Or?

— Nietzsche [1]

Questions like Nietzsche's last ones at *Daybreak* can be countered by stories. Tales slow
the questions down. When slowed, they fall into the rhythms of ponder, speculation,
and dream. They will have to turn with the pages. They are but a portal, a way to begin.

In the late spring of 1979, Roland Barthes had difficulty finding an end for the book he
was calling *Camera Lucida.* Its subject, nominally, was photography. Its course had been
sparked by the pictures he had seen in the special photography numbers of *Le Nouvel
Observateur* responding to the new wave in thinking and collecting, as much an erotic
subculture as it was a vogue. But Barthes' book was motivated by his own private photo-
graph of his late mother. It showed her as a girl in a Winter Garden, the best likeness
of her that he possessed, he wrote, though it was a face he, being too young, had never
seen. The book does not reproduce this photograph. It was left to hover, like a ghost,
over everything that was said.

The manuscripts show Barthes changing certain elements right up to the point when the
last draft had to be sent off, irrevocably, to the printer. He had labored over the *punctum.*
He had stalled at the end. Late in the game he had thought of a finish that would let his
own thought just break off short, as if it had snapped. He would then have handed over
the last words to Marpa, a Tibetan sage of the eleventh century, a man known for bringing
the Buddhist teachings from India north:

Marpa was shaken when his son was killed, and one of his disciples said: "You have always told us that everything is illusion. And so, with the death of your son, is it not an illusion?" And Marpa replied, "Certainly, but the death of my son is a super-illusion." [2]

In the end, Marpa's remark would be cut free from the book and floated onto the back cover, uncommented, as if it too were an image or a cherry blossom branch. The last paragraphs of *Camera Lucida* show Barthes writing on alone, wrestling with the edges of reality and the kinds of form that can touch them. Form aspires, but can only aspire, he thought, to the condition of light. He was left alone with his questions. Was the photograph to be subjected to the civilizing force of the perfect illusion? Or would the photograph be allowed to rouse the dormant mind to open its eyes to see, now, verily, the intractable reality?

The arguments put forward inside *Camera Lucida* have come to stand for the final word on the photograph, and even though Barthes was careful not to speak of photography entire, but rather of photographs, one by one, the book spawned a new order of criticism which, almost incomprehendingly, reflexively, has followed the old modernist bent, insistent upon seeing photography rather than photographs, totalities rather than acts, an art of abstractions bereft of geometries, a single medium. It is also a criticism which has wilfully confused realities with texts. Reality is not at the end of the day, or the merry month of May, a text — texts can only have their own time and place and objects. They are at first and last only words that strike when they have hit on something hard. For example, Marpa's words were used by Barthes as if, they too, were a phenomenon far apart, something belonging more to nature, to the branch, than man. And yet, they are striking.

A few years later a quotation from Racine hung onscreen briefly as Chris Marker's new film *Sans Soleil* began.

> *L'Eloignement des pays répare en quelque sorte la trop grande proximité des temps.* [The distance between countries compensates somewhat for the excessive closeness of time.]

In the English version a stanza from the poem "Ash Wednesday" by T. S. Eliot took its place.

> Because I know that time is always time
> And place is always and only place
> And what is actual is actual only for one time
> And only for one place. [3]

Then an image of three little girls walking through fields on a cold bright day appeared. They walked uphill. A woman's voice began reading, elegantly, from a letter:

The first image he told me about was of three children on a road in Iceland, in 1965. He said that for him it was the image of happiness and also that he had tried several times to link it to other images, but it never worked. He wrote me: one day I'll have to put it all alone at the beginning of a film with a long piece of black leader; if they don't see happiness in the picture, at least they'll see the black.

Words made to stand apart, recounted, as they are in *Sans Soleil*, and in *Camera Lucida*, words suspended, live differently. Nothing is passed, only lit for an instant. Super-illusions cannot have form or fire or sound in the usual sense of those words. They glide away, staring back. Night falls quickly over them. When, thirty years later, words come like this in the *Strikes at Time* (2011), a double-screen work by Raqs Media Collective, time, they will say, is struck. Time is not hard. Words do not touch it. Time being the greatest super-illusion of them all.

Their time is at first a word. *Strikes at Time* opens with a man in the distance climbing to the top of a hill. A horizon line of sand. A light sky. Dawn. A dog's bark and a jingling bell heard off in the distance. On a second, smaller screen, to the right, a vehemently straight, brilliant blue line crosses through the words of the title as they are brought into focus. Blue strikes but the words do not drop. Of the three, only *Time* is crossed out. Then the scene changes completely.

The stone Yaksha and the Yakshi, Indic guardians of wealth, are shown at their posts, on guard, the treasure they protect fenced in by riddles. Each night, if one keeps vigil with them, an answer will be issued, or so we are told. The stone figures give small hints of another reality, waving fingers, tapping toes. Do not rely on their magic. We are reminded that for all this cheer, the questions still multiply. We may assume that gods and the riddles will see to it.

We are set down firmly in India. Eventually we will understand that the hill is the best place from which to hold vigil. For it is the place of ultimate boundary, the line between earth and sky, matter and spirit, dawn and dusk, a place for crossing. Blue will be the border color. It becomes the work of the film to locate border signs in human existence below.

From a distance an unnamed French example is being gently parsed, mentally, by an industrial worker who keeps a journal in his off-hours. He accounts for his ideas each day, listing them together with his expenses. The rest, he usually notes as he concludes, is ordinary. Which means that to think and to buy something both become extraordinary acts.

Monday
Left home at 6 p.m., returned at 4:30 a.m.
Thought produces fallout.
The finer it is, the more dangerous.
Spend Rs 5 on tea.
Bought this diary for Rs 18.

Got a pencil for a rupee and, with another rupee, purchased a pen.
Everything else is ordinary.

Jacques Rancière wrote the *La Nuit des Prolétaires*, a long book, at the same time that Marker sat sunless and Barthes put the pen toward his camera lucida. *La Nuit des Prolétaires* was published in 1981. Rancière chose to open his account at the Gates of Hell in the year 1841. A locksmith is writing an article for the readership of *La Ruche populaire*:

You ask me what my life is like right now. It's pretty much the same as always.
At the moment I look at myself and weep. Forgive me this bout of puerile
vanity. It seems to me that I have not found my vocation in hammering iron.[4]

The lives of French Utopians, laborers by day and visionary political men and women by night, are documented individually as well as collectively as they head toward the great testing ground of 1848. Rancière took care not to speak for them but to transport the real complexity of their thoughts and dreams forward. Dare one breathe the name of Scheherazade? Their nights become tales told by a philosopher. As Rancière set out his account of the Saint-Simonian vision in the early 1830s, "it is in the moments when the real world wavers and seems to reel into mere appearance, more than in the slow accumulation of day-to-day experiences, that it becomes possible to form a judgment about the world."[5]

The many utopian efforts to make judgments and give them political form would rely upon the existing conditions of metaphysics but not mimic them. One worker, a joiner, wrote to another, a ragpicker, "Plunge into terrible readings. That will awaken passions in your wretched existence, and the laborer needs them to stand tall in the face of that which is ready to devour him. So from the *Imitation* to *Lélia*, explore the enigma of the mysterious and formidable chagrin at work in those with sublime concepts."[6] Rancière follows their explorations. They never did speak or write with one voice.

*Strikes at Time* flies these matters into the twenty-first century. It too is factual, its script edited by a workers' collective, the Cybermohalla, and based on the journal of one Heeraprasad. It too, like the woman relaying the letters she received in *Sans Soleil*, gives its report in relay, recounting, phrases extracted, refracted across images and aligned with them, but words are not spoken aloud in *Strikes*. At intervals we see the words written on the leaves from the worker's journal. They appear on an accompanying smaller screen. A blue liquid streams around them, wending a way.

It neither leads nor follows. Meanwhile the larger screen moves at its own pace, making long additions of images, none of them the sum of all others. One worker in particular comes and goes toward the night after his factory shift is done. His own time is free and he uses it to think and write. Worlds of disobedience and wonder are attaching to his lists. His thoughts are in swift pursuit. They change him. Increasingly he seeks out the view from the hill. He craves the sky. He writes carefully:

Tuesday
Left for duty in the morning.
Medicine for myself for Rs 32.50. 4 rupees on bus fare.
Oranges for Rs 8. Rs 20 on photographs.
The next episode of a story can be written
only when you stake your life, your own self.
I am proud of my abundant poetry.
Everything else is ordinary.

His face will appear blue, like the avatar Krishna? a reflection of Pierrot le Fou ricocheting westward? Perhaps he has drunk the night draught and it has colored him. But the blue being repeated and painted on a machine, on a book cover, on a roadside elephant, is carrying something more than a color forward. Blue becomes the wing, a river, a place to arrive, the raw material of new images. The writer sees it plainly enough. *Strikes* floods each one of his lines with a full image. A jet crosses high in the sky, its trail flares gold. A view from the clouds begins pale and azure fading with the day into night. As time strikes it, the lights from the city below appear. A field of distant beacons glows.

Friday
The day has dawned especially for me.
I got back home at 4:45 in the morning.
Rs 180 for electricity. Bought milk for Rs 10.
What does it mean to belong to everyone?
When the cool twilight sky turns deep blue
and becomes an image of limitlessness,
it produces a restless interference.
That thing which belongs to the entire world,
that thing which evokes desire,
or any sensation at all in the body or the mind:
somewhere it builds a connection between us all.
It was the best day today.

The writer sees his own place, the one in everyone else, yet nothing on that earth is certain or foretold. Goethe made much of the fact that because blue colors seem to recede, we are drawn to follow them.[7] We are drawn to the top of the hill where it could be night, or day. We are also being drawn into these thoughts which do not stop or surrender. The writer seems to repeat a parable — when the bird takes flight, it leaves the storm incomplete behind it. He has questioned the lights.

Blue rides the nightwing of improbability. It seems to take the place of time and its storms. It dyes. It spills. We see a blue city, albeit only briefly. If let out to run free in the world, this blue will need a new order, new guardians and citizens. Whose children? Blue strikes. Old orders do not simply fall. *Time* is crossed out. We end where we began, with the horizon of sand. We repeat without understanding much of what we have

seen. It seems important to take the strangers' words along with us, filed with Marpa, Eliot, and Racine. The sky is maroon.

Actual tales can be actually recounted. They move like a candle passed through a crowd. Details slip. Fire can quickly get out of hand. Someone else's story will arrive to stop the action short. These arrests are largely peaceful. They release us over and over again into the endless state of the question. Some call it existence, others the future. Whether inside or this side of India, we cross that state now.

# NOTES

1   Nietzsche, *Daybreak*, trans R. J. Hollingdale (Cambridge: Cambridge University Press, 1997), Book V, 575, 228–9.

2   "Marpa fut très remué lorsque son fils fut tué, et l'un de ses disciples dit: 'Vous nous disiez toujours que tout est illusion. Qu'en est-il de la mort de votre fils, n'est-ce pas une illusion?' Et Marpa répondit: 'Certes, mais la mort de mon fils est une super-illusion.'" Roland Barthes, manuscript for *La chambre claire*, IMEC (L'Institut Mémoires de L'Edition Contemporaine, Caen), BRT2.A21.02, 64. Cf. Chögyam Trungpa, *Pratique de la voie tibétaine* (Paris: Editions de seuil, 1976). The first French edition of *La chambre claire* (Paris: Cahiers du cinéma, 1980) put Marpa on the back cover. The English translation by Richard Howard, *Camera Lucida* (New York: Hill and Wang, 1981), did not include it. Geoffrey Batchen seems not to have been able to examine the manuscript for *La chambre claire* at the time of writing his introduction to the edited volume of essays on the book, *Photography Degree Zero* (Cambridge: MIT Press, 2009). The translation here is mine.

3   Chris Marker, *La Jetée/Sans Soleil, Criterion Edition DVD* (2007), insert, 31.

4   Jacques Rancière, *La Nuit des Prolétaires: Archives du Rêve Ouvrier* (Paris: Fayard, 1981). In English as The *Nights of Labor*, introduction by Donald Reid, trans. John Drury (Philadelphia: Temple University Press, 1989), 3.

5   Ibid., 19.

6   Ibid.

7   Goethe, *Theory of Colours*, introduction by Deane B. Judd, trans. Charles Locke Eastlake (Cambridge: MIT Press, 1970), 311.

SIMPLE S

LIKE S

MOTHER

PERCEPTUAL

PERIPHERAL

ORACLES

N-

ECONOMY

CONFIDENTIAL

INTRUSION

# Contents Undisclosed

*On June 18, 2011, five time capsules, one belonging to Raqs Media Collective, were interred into the grounds of the Alby Estate in Moss, Norway—their contents undisclosed. The receptacles exact location is registered with the ITCS (International Time Capsule Society) and should not be unearthed until 50 years have passed, on June 18, 2061.*

On each befitting occasion it should be reiterated that these time capsules lay in wait, since what is most perilous for anything of the sort is paradoxically time. Time capsules are oftentimes forgotten, simply because they intrinsically demand the time it takes for us to forget them. While they lay in abeyance, things, places, and plans come to attenuate in our minds until removed from the surface of recollection. Without intermittent reminders these boxes would almost certainly linger past their designated duration and then never be exhumed — a prolific archive of capsules scattered worldwide serve as proof, most of which will forever remain in a tick-tocking state.

But an aide-mémoire such as the one above might in the end mean very little. When time comes and the people involved in the capsule's interment likely to have passed away there are no guarantees that those we hope will conclude this undertaking will in their time disinter what we in our time buried. It might be that they simply don't care because for them, those we hope will be concerned with our little boxes, there is nothing to even remotely recall. There is only a curious appointment to keep, a note in the calendar no more substantial than any other engagement. We must however remind ourselves that it might not be their fault if the capsules come to stray. Perhaps the liberties of traveling that some of us currently enjoy will have been rescinded, or what today is land might then be nothing but water. One cannot possibly count on the world being the same in 2061— or even exist, if one wants to be particularly melodramatic!

What Raqs Media Collective conceived for their capsule none but they know. And no one will until 2061. At the same time they do not know exactly where it is buried. But the task in the end is not so much to guestimate what Raqs put in their parcel (even though it can be quite amusing) or figure out exactly where it is located. Rather, it is to

negotiate two instances, one that seems to be more 'now' than others and another more 'then' than usual. If we are for example unsure of our ability to remember the first instance we have to invent and rehearse mnemonic practices that assist recollection up until the second instance, and perhaps even consider that these practices might serve to guide those whom we hope will bring this to an end. We need a map, of sorts, that through time traces the anticipation of times' passing even though we don't have the slightest gauge to direct us.

Two things made public by Raqs Media Collective in correlation to the capsule might however begin to guide us. One is a published letter to Amália Jyran, who was four at the time of the capsules' interment and who will be 54 at its unearthing. With it comes an intriguing point of view best unraveled by Raqs themselves in the letters' last paragraph:

> Within this moment that we call 'now' between ourselves is the time in which we fill and seal the time capsule in your four-year-old presence, on the blue floor of the studio. Imagine that one of us fetches memory, the other, experience, and the third, expectation from what St. Augustine would call the well of our conjoint soul—the intersection of our imaginations. We will create combinations of these three things to make a compound of the times present of things past, the times present of things present and the times present of things future. We will then shut the lid and seal the parcel. This is our present to you. A box of our time. To be opened, at leisure, within a box of your time.

The second inkling comes from two images of the aluminum box that holds Raqs' ingredients in suspension. One image shows the box open but empty and one closed and presumably filled. An open box signals a beginning, a closed shows duration — the period of time through which Amália will grow and become aware of times' constraints and possibilities — the same period within which many of us will leave this world. The notional beginning is the box open whilst the closed box stands in as time, the end would be to see the box open again. Here, somehow, time becomes a bit more timey.

By way of these two intimations it becomes obvious that Raqs' parcel will ultimately escape us, even if it is only one generation away and not only because most of us will be deceased at its conclusion. It is a venture centered on things we don't know in places we can't find in an uncontrollable and unpredictable future. All we know is that we know that we can impossibly know. But the letter and box turns us towards what could very well become our imperative map. The diary, Philippe Lejeune once said, "sculpts life as it happens and takes up the challenge of time." The diary is a matter of stringing together disconnected entries that ultimately become connected by way of the rhythms and repetition they follow. It is a space we can enjoy within this interval of now and then that allows for a temporal disenthrallment, where insufficient vocabulary can be elaborated on and where a series of notations each being much like time capsules for the future can express our concerns, hopes, and gradual understanding of that which we do not know.

Perhaps it could be that the letter is the beginning of a diary and the box in turn the start of something *diaristic*—no matter where and what lay in its dark interim until hopefully, on the last day, unearthed.

LANDSCAPE

AND

AFTE

ELECTRONIC
PASSING TIME

R

OF

LITTLE BOY

EVIDENCE

UNTOUCHABLE
FACTORY

SPECULATION

HAT

DEEP

FEELING

IC

WAY

TIME

METROPOLIS

OMNI-VISION

RINTED

LIGHT

# Off-Modern *Pentimenti*

## 1. Meteorology of what if

During the Off-Modern workshop in the fall of 2011, Shuddha Sengupta presented Raqs' most futuristic project to date, the *Time Capsule from 2011 (to be opened in 2061)*. He showed us an image of a mysterious box that resembled a suitcase from a 1960s science-fiction movie belonging to an anxious alien with a one-way ticket to the future. The box is sealed, and will remain so for the next fifty years, to be eventually opened by Amália Jyran, Monica Narula's daughter and the collective's favorite. According to Raqs, the contents of the box encrypts "the state of play between the ways in which the . . . collective inhabits the present, interprets the past, and faces the future." The container was interred into the earth on June 18, 2011, on the Alby Estate in the city of Moss in the county of Østfold in Norway in the presence of the four-year-old Amália, who loves rabbits and ribbons and probably doesn't fully understand yet her future historical mission.

One of the participant in the workshop wondered why Raqs didn't chose a more con-temporary form of archiving their gifts to the future: "Why inter it into earth? Why don't you store the content of the time capsule on Google Cloud?"

Shuddha responded to the question with a question: "What if it rains?"

This poetic "what if" is at once reasonably cautious and playfully daring. Shuddha literalized the digital metaphor in order to interrupt political and technological utopias. The archive for the future has to have the texture of our present in order to contain a promise of aura, that aesthetic glow of distance and warmth. It can only envelop the material ruins of today's castles in the clouds shaped by the virtual realities of imagination, not incorporated into the digital warehouses of marketable solidarities and profitable obsolescences. Raqs' work appeals to a particular kind of atmospheric scenography or poetic meteorology in which another lucid dreamer of the twentieth century, the poet and critic Osip Mandelstam, saw the creative laboratory of the future. Such poetic mete-orology does not strive for the "form creation"(*formoobrazovanie*) but for the "impulse creation" (*poryvoobrazovanie*), not the making of a new language but a dynamic grafting

and hybridization, more estranging and vital than a neologism.[1] This is a virtuoso performance with vectors directed towards the past and the future that combines the transient science of meteorology with earthly mineralogy, the sister of ancient divination and aunt of astrology. The time box whose designs embody the past dreams of the future will surely age; it will acquire meteorological traces of the next 50 years.

Raqs' recent projects are about this improbable texture of our time and about our fragile free-spirited humanity that interrupts time's irreversibility. They are not postmodern, posthumanist or even postcolonial. In fact, the prefix "post" was entirely alien to their whole endeavor. The "a" (as in arrhythmic), "counter" (as in counterpoint), or off (as in off-modern) seem more appropriate. I would like to explore Raqs' texture and gently include myself into the provisional "we." We are con-temporaries, never coinciding with our time, always a little out-of-synch and yet intensely co-creating with it, occasional escape into nostalgia or utopia notwithstanding.

We met by chance in the virtual public space, or rather our texts entered into a certain intercourse before we did. What we shared was a diasporic intimacy and an erotic inter-textuality of the late twentieth-century modern, this ability, to quote Walter Benjamin, to love at the last sight and not to despair about it. As I was examining the Raqs' project *They Called it the XXth Century*, I discovered a reference to my first off-modern manifesto published in *NeMe art magazine* based in Cyprus.[2]

We began to correspond then but our paths crossed later, in New York City in 2009 where we had our first dinner together sharing warmth, smells, sounds, auras, and a good conversation. Our uncanny virtual connections acquired texture and unfolded in multiple unruly directions. We shared the gift of the alternative solidarity and a budding friendship within what Hanna Arendt called *fermenta congitionis,* the fermenting field of cognition which allows new creativity into the world.

## 2. Off-Modern Thoughts on the Folded Paper

> What if we could fold time in the same way as we can fold a piece of paper? Supposing we could fold it into a boat or an airplane, what kind of voyage would we find ourselves embarking on? Would we realize that our sense of our time, the time(s) we live in today, are also amenable to being folded in a way that can make us sense other times in a way that is suddenly up close and personal even as they retain their chronological distances?[3] — Raqs

Folding is a fruitful modern metaphor that brings together the past and the future. Henri Bergson believed that human memory open to the virtual realities of imagination could be envisioned as a magic fan keeping the breeze of the time. Both Mandelstam and Benjamin loved this image of the fan of memory, Benjamin famously asserting that "only in its folds does the truth resides." Late twentieth-century philosopher Gilles

Deleuze proposed to recover the baroque folds that "unfurls all the way to infinity." To describe such folds a cryptographer is needed who "can peer into the crannies of matter and read into the folds of the soul," following the vibrations and oscillation of multiplicities and account for the "curvilinearity" of the marbled matter.[4] Deleuzian bifurcation always lead to another labyrinth, "forming a webbing of time embracing all possibilities." I see in the folds of Raqs another kind of design — not the unfurling into a rhizomatic plateau of the dehumanized infinity but the unfolding realm of human errors, affects, embarrassments, and surprises that amount to nothing less than a reconfiguration of contemporary creativity.

I hold in my hands (in the virtual reality of my imagination) that unfolded sheet of paper that can metamorphose into a boat or into an airplane for time travel; it is crisscrossed by light wrinkles and traces of coffee and ink that mark the impulses of making, composing, reconfiguring, participating, creating. This sheet of paper contains Raqs' signature in the form of improbable *pentimenti*.

A *pentimento* is defined in art history as a presence of traces of previous work or an alternative composition, showing that the artist has changed his or her mind in the process of work. For restorers and art historians the discovery of a *pentimento* often serves as proof of originality of the work, something like a signature of the artist that reveals the imperfections and bifurcations of the creative process that no copyist or disciple can imitate. The word derives from the Italian *pentirsi*, meaning "to repent." In the off-modern context, the *pentimento* is not treated as an instance of remorse, or something to repent and redeem, but as a map of creative bifurcations and multiple possibilities.[5] The archeology of *pentimenti* combines the history of concrete material experiments with the virtual realities of imagination and phantasmagoric awareness of smiling ghosts.

What I love about Raqs' work is that their practice of *pentimenti* originates on the dusty streets of the present. It reveals an ambivalent emotional agency of unrepentant experimentation and essayistic wander, of unearthing alternative scenarios of the past always with an eye on the future. Their logic is *and&and*, not *either/or*. Pentimenti disclose histories of "what if" and many human efforts and errors that persist no matter what.

In their practice, Raqs follow what Mandelstam and Viktor Shklovsky called "honest zigzags" of reflection, and their relationship to modernity is not literal but *lateral*. Here I will evoke my discussion of the off-modern and Raqs off-modern antechambers where we first met waiting for our folding wagons-lits.

Unlike the thinkers of the last *fin-de-siècle*, we neither mourn nor celebrate the ends of history, art, or critical thinking. Post-modernism has been buried in the zero decade of the twenty-first century together with other spectacular cultural derivatives while we continue to cohabit with our ruins and ghosts. In our context of multiple cultures of peripheral modernization and conflicting and intertwining pluralities beyond external pluralisms, the prefix "post" is passé. Instead of fast-changing prepositions — "post,"

"anti," "neo," "trans," and "sub" — that suggest an implacable movement forward, against, or beyond, and try desperately to be "in," I propose to go off: "Off" as in "off kilter," off Broadway, "off the path," or "way off," off-brand, off the wall, and, occasionally, "off-colour." "Off-modern" is a detour into the unexplored potentials of the modern project. It recovers unforeseen pasts and ventures into the side alleys of modern history, at the margins of error of dominant philosophical, economic, and technological narratives of modernization and progress. It opens into the modernity of "what if," and not only postindustrial modernization as it was.[6]

After the major revolution of the twentieth century, Shklovsky proposed to explore the knight's move in the game of chess which traces "the tortured road of the brave," and not the master-slave dialectics of "dutiful pawns and kings."[7] Oblique, diagonal, and zigzag moves reveal the play of human freedom vis-à-vis political teleologies and ideologies that follow superhuman laws of the invisible hand of the market or of the march of progress. Like his contemporaries, Shklovsky was fascinated by modernist science, from Einstein's theory of relativity to the quantum and wave theories of light and Nikolai Lobachevsky's conception of a non-Euclidian geometry that does not accept the axiom that parallel lines cannot meet. In the words of Vladimir Nabokov: "if parallel lines do not meet it is not because meet they cannot, but because they have other things to do."[8] Here zigzag, a path between two parallel lines at once jagged and regular, is not a simple one-dimensional figure but an opening of an alternative intellectual tradition that brings together natural sciences, physics, and poetics — from the ancient swerve of the Epicurean philosophers to the squiggle of the eccentric Enlightenment; from baroque anamorphosis to the Möbius strip; from bifurcating veins in marble to the contemporary mathematical models of hyperbolic space.

The knight's move allows for an anamorphic coexistence of both Euclidean and non-Euclidean geometries and, more broadly, of different models of the universe side by side. This non-exclusionary logic of *and&and* and not *either/or* does not impair judgment and decision-making in the world but invites rigorous perspectives and creative action.

The preposition "off" is a product of linguistic error, popular etymology, and fuzzy logic. It developed from the preposition "of," with the addition of an extra "f," an emphatic and humorous onomatopoeic exaggeration that imitates oral speech. "Off" suggests a dimension of time and human action that is unusual or potentially off-putting. It either describes something too spontaneous (off-the-cuff, off-handed, off-the-record) or too edgy (off-the-wall), verging on the obscene (off-colour) or not in synch with the pace (offbeat). Sometimes "off" is about the embarrassment of life caught unawares. It is extemporaneous and humane. The "off" in "off-modern" designates both the belonging to the critical project of modernity and its edgy excess. Most importantly it is not a marker of margins but a delimitation of a broad space for a new choreography of the future possibilities. Off-modern is not antimodern; it is closer, in fact, to the critical and experimental spirit of modernity than it is to the existing forms of industrial and postindustrial modernization.

In the twenty-first century, modernity is our antiquity. We live with its ruins, which we incorporate into our present, leaving deliberate scars or disguising our age marks with the uplifting cream of oblivion. Off-modern is a contemporary worldview and a form of historic sensibility which allows us to recapture eccentric aspects of earlier modernities, to "brush history against the grain," to use Benjamin's expression, in order to understand the preposterous aspects of our present. The off-modern project is still off-brand; it is a performance-in-progress, at once con-temporary and off-beat vis-à-vis the present moment.

Off-modern does not suggest a continuous history from antiquity to modernity to postmodernity, and so on. Instead it confronts the breaks in tradition, the loss of common yardsticks, and the disorientations that occur in almost every generation. Off-modern acknowledges the syncope and the off-beat movements of history that were written out from its dominant versions edited by the victors, who cared little about the dignity of the defeated. Off-modern reflection does not merely try to colour the blank spots of history green or red, thus curing longing with belonging. Rather, it veers off the beaten track of dominant constructions of history, proceeding laterally, not literally, to discover the missed opportunities and roads not taken.

Off-modern is a part of a contemporary cultural and artistic reflection on "unfinished modernities." Yet unlike the "altermodern," the term proposed by writer and curator Nicolas Bourriaud in 2009, the off-modern does not define itself merely as a new modernity "reconfigured to an age of globalization," nor as "a new universalism [...] based on translations, subtitling, and generalized dubbing."

The off-moderns are not "early adapters" of posthistorical globalization or internet technology gadgets; they search for experimental platforms that would connect public squares of the world with the digital humanities of the future, for which no gadgets have yet been invented.[9]

Bourriaud opposed the "modernism of the twentieth century which spoke the abstract language of the colonial west." The off-moderns don't subscribe to such a definition of modernism in the singular and don't give up their exploration of the peripheral artistic movements that often defied periodizations and typologies. Instead they developed their own accented languages of estrangement that embarrass Western art histories.

## 3. Porous Time and Syncopal Kicks

Off-modern has a quality of on-going improvisation that blurs the boundaries between artistic, curatorial, theoretical, and everyday practice. Raqs' *They Called it the XXth Century* gives a material space to the abstract concept in the form of "waiting rooms" that refer to the tradition of nineteenth-century modernity. In old railway stations in India, there were nicely decorated "waiting rooms," or "green rooms," where the would-be passengers, impostors, lovers, double-agents prepared for their journeys with a mixture of anxiety

and exhilaration. Raqs explain the connection between the conception of improvisation and this peculiar kind of "waiting for modernity": "The relationship between these spaces and modernity is not however marked by chronological lag alone. Rather, perennial anticipation, or perpetual regret, or enduring skepticism, or sustained enthusiasm, or continuing bewilderment — or combinations thereof could also qualify it. What you have then is the possibility of a nuanced and fluid spectrum of attitudes towards modernity that can be rehearsed ad infinitum in these 'green rooms' or 'waiting rooms.'" [10] The antechambers of the modern are places where we can take time off to explore the new off-modern trains of thought and to rehearse our unpredictable errands into many dimensions of affect and thought.

Raqs elaborate the idea of porous time that works in counterpoint to the finitude of space and allows for generous cohabitations, alternative solidarities, and a new art of slow friendship that our fast culture of one-click obsolescence might not favor:

> The Ottoman solution to the seemingly intractable conflicts over the control of different Christian churches built upon the site of the Holy Sepulchre in Jerusalem evolved into a carefully calibrated arrangement in which the very important element of co-inhabiting time was deeply embedded. Because no single denomination could lay full claim to the space of the church, in order to ensure that no one had a monopoly, each was persuaded to agree to share time, such that no one felt completely left out of the running and maintenance of the site. While this was by no means a perfect solution, and conflicts (especially over procedure and precedence) could not always be avoided, it did go a long way towards settling endless disputes over ownership and control.
>
> To co-inhabit a time is not to establish orders of precedence or chronology, but to create structures and processes by which different rhythms of being and doing can act responsively towards each other. [11]

Raqs describe such "cohabitation" in time as something akin to musical syncopation, a phenomenon where two different rhythms enter the frame of the same composition and "two rhythmic cycles influence each other's sonic presence in time without necessarily entering into conflict with each other." Syncopation, as we shall see in the discussion of diasporic intimacy, was also a trope of immigration and modern dislocation in space. In his autobiographical *Speak, Memory*, Nabokov wrote that in retrospect the experience of immigration allowed him "a syncopal kick" that he "wouldn't have missed for worlds." Syncopation is not about symbols but about synecdoche. It is about contingencies and worldly details, "the asides of the spirit" that can turn traumas into creative impulses. Syncopation, a missed beat, the gap, the faint foreground the fertile possibilities of the oblique and out-of-synch creativities.

Raqs propose a "syncopated mode of curation" that "can liberate an event or a process from being trapped in only one mode of articulating time — in essence, the modern

world's understanding of 'clock time.'" For the off-moderns, subversion is sometimes necessary but it is not a duty. In the early twentieth century, Freud spoke about poly-morphous perversity; we now live it and take it for granted: we are all metro- or peri-sexuals. Rather than a perversity or subversion, the off-modern is a form of versatility. Polymorphous versatility and a play of perspectives.

## 4. *Marchroutka* and the Ordinary Marvelous

> Let's think momentarily of modernism as a four lane highway, let's say — a "national highway" that claims to take you from A to B, and then let us imagine a few tracks off the high road — that meander alongside, and cross the highway, some-times in a disorderly, zigzag fashion.... Unlike the highway, where there is never any turning back, except at sanctioned U-turns, the off-tracks are meant for Janus-faced journeymen and journeywomen (which is what we aspire to be) who know well the ruses of the archive and the contingencies of the present but have also equipped themselves with an open-endedness towards the dilemmas of the future. They have ambivalences, they are equivocal, as befits the task of moving on a surface as jagged as that of the contemporary world. They resemble the crooked move of the knight in chess. Interestingly, the post-Soviet aesthetician and writer, Svetlana Boym, often speaks of the "lateral move of the knight in a game of chess. A detour into some unexplored poten-tialities of the modern project" to explain what she means by her call to fully inhabit the "off-modern" condition.[12] — Raqs

In the Raqs 2011 installation *Strikes at Time,* defined as a "lucid dream," I found a shared vehicle of our off-modern creativity and some refracted echoes of Soviet montage cinema. In this work Raqs offer a poetic commentary on the work of Jacques Rancière that challenged some ideals of the proletariat not by debunking them but by giving actual workers a poetic human agency that embarrassed theoretical representations and politi-cal assumptions. The lucid dreamer in the film is a local worker who is neither a typical representative of the working class nor the model of 1920s homoerotic masculinity from Sergey Eisenstein's films. He is an uncanny poet-worker who applies dark blue paint to the ruins/construction sites of the twenty-first-century postindustrial landscape. Something even uncannier happened to me while I was watching the split screens of the installation.

On the left screen we see homage to early twentieth-century cinema — a rapid progression of syncopated shots of fast landing and ascending airplanes and communication poles, reminiscent of Dziga Vertov's celebrated classic of montage cinema, *The Man with a Movie Camera.* On the right screen we follow at our leisure slow zigzag moves of a mysterious human-scale vehicle familiar and uncanny at once, in the shape of a white trapezoid. Let us leave it for now and begin by examining the right screen and its avant-garde wire. We remember that Vertov's film offered a montage of new industries in the

implacable march of progress which the director's alter ego, a little man equipped with an all-powerful apparatus, ecstatically records. Vertov's film has a modernist temporary structure of one day in a life of a representative Soviet city (in fact, a montage of three cities) that comprises the cycles of life, death, technology, and creativity. Raqs' film is not structured around one spectacular day of plenitude in the life of the modern world but around belated modern dailiness traced through the workers' diaries where there is still a small window for the ordinary marvelous.

The relationship between two screens doesn't fit into any kind of dialectical or associative montage. Rather, Raqs' montage is an arrhythmic comment on our off-modern condition in which we cohabit with new and old technologies and struggle against the technological colonization of the human habitat. So now we turn our attention to the right screen and follow the slow motion of the white trapezoid vehicle reflected in a large urban puddle. What is this bizarre abstraction traveling through on the edges of the city? Its lines are parallel and receding, it echoes and refracts the avant-garde forms. Ok, this is not a mere abstraction; the vehicle has a cozy interiority. In the Russian of my childhood the name for such vehicle was *marchroutka*. This strange word is made of two foreign roots: *march* and *route* plus a suffix of diminution and endearment. In *Strikes at Time* the off-modern *marchroutka* doesn't follow the march of progress but explores the side alleys of the urban sprawl and modern history. The interior of this human-size vehicle is a space of ephemeral solidarities. It can hold a human community of transient workers giving them a brief time for a poetic reflection. Only from the window of this off-white *marchroutka* can one see a blue elephant.

At the end of the film we realize that the *marchroutka* housed the moving viewpoint for the whole project; it criss-crosses both right and left screens and slowly vanishes from each of them leaving us to reflect on the last quote of the poetic diary: "I no longer have faith in time." Wistfulness aside, I am left with a suspicion that the authors of the film still persist in their tenderness for time, sometimes reluctant and other times frivolous love without faith, which Nabokov called "Epicureanism of duration;" the trademark of the forward-looking reflective nostalgics.

5. Friendship in *chiaroscuro* for the next 50 years.

> Our sense of diachronic is different — polyphonic searches in the minor scale undertaken by a multitude of actors.[13] — Raqs

All Raqs' works are about porous time, arrhythmic montage, and unconventional solidarities — between humans, animals, elements. They make syncopal compositions of multiple polyphonic actors and friends working all over the world.

The word *solidarity* combines solidity and porosity in its meaning. It was coined from the French *solidarité,* "mutual responsibility," a coinage of the *Encyclopédie* (1765)

from *solidaire* "interdependent, complete, entire." The word suggests a new crystal-lization of relationships that combine integrity and interconnection. It is opposed both to complete individual autonomy and a community of any kind that is based on a unified collective ethos and some kind of *volonté générale*. Solidarity includes estrangement and engagement, suggesting interdependency without the loss of singularities and multiplicities.

Solidarities can be of a political and personal nature; sometimes they call for strategic public allegiances, other times for the celebration of personal elective affinities and a revival of an outmoded — and yet not obsolete — conception of friendship.

We live in the world of friending, not friendships. Friend has become a euphemism — for something more or less than friendship; "friend" is a conspicuous casual acquaintance who overcrowds our homepage or an inconspicuous lover who likes to escape home.

The word *friendship* shares etymologies with *freedom* in English and *freude* (joy) in German with affectionate love or *philia* in Romance languages and in Greek. In Russian, the word for "friend," *drug,* is related to "the other," but not a foreign other, for which there is another word, *inoi*. The aspect of otherness is important because there are many things friendship is not. Friendship, in my understanding, is neither a conventional intimacy, nor a brotherhood or sisterhood, nor a networking opportunity. Rather, it is an elective affinity without finality, a relationship without a plot and a place in our society, an experience for its own sake.

Hannah Arendt wrote that friendship of a serious kind is what makes life worth living. Such was her own friendship with the American expat writer Mary McCarthy.[14] Yet she also emphasized that friendship should not be confused with romantic love for a "single one," which for her can become "a totalitarianism for two" because it makes the whole world around the lovers vanish. Nor is friendship the confessional intimacy advocated by Rousseau, an echo chamber of one's overflowing narcissism: "We are wont to see friendship solely as a phenomenon of intimacy in which the friends open their hearts to each other unmolested by the world and its demands."[15] Friendship for her is, in fact, precisely about being molested by the world and responding in kind — by expanding the dimensions of existence and by co-creating on the worldly stage. This stage has a particular scenography. Neither brightly lit nor completely enlightened, it has a scenography of chiaroscuro, of the interplay of light and shadow.

Writing about men and women in "dark times," Arendt observed that in circumstances of extremity, the illuminations do not come from philosophical concepts but from the "uncertain, flickering, and often weak light" that men and women kindle and shed over the lifespan given to them. This luminous space where "men and women come out of their origins and reflect each other's sparks" is the space of humaneness and friendship that sheds light on the world of appearances which we inhabit. In other words, friendship is not about having everything illuminated or obscured, but about conspiring and playing

with shadows. Its goal is not enlightenment but luminosity, not a quest for the blinding truth but only for occasional lucidity and honesty.[16]

Such friendship between writers and artists works like a *fermenta cognitionis*, producing and rescuing insights and intimations that, in Arendt's description, are "not intended to communicate conclusions, but to stimulate others to independent thought."[17] Raqs conception of non-Hegelian history with interconnected actors performing their polyphonic searches in a minor key is connected to the miraculous shadowplay and flickering aura of our (still) human, all-too-human world.

Maybe we have a little less than conventional fifty years left for our future conversations but we can take an extra helping of the porous time; for on the off-modern calendars the schedule is never full and its folding pages are open to collective *pentimenti* and cordial dinners.

Postscript: As a transient gift in the present, more ephemeral than the time capsule, I wanted to offer Raqs a picture of the wondering peacock. I found him on the ruins construction site behind St John's Cathedral in Manhattan and followed him around. This peacock could have been a fleeing extra from one of Raqs films. Making of this print was a mini-performance of intervention and imperfection. It was pulled out prematurely from the printer, leaving the lines of passages and splashes of color. "Communication error!" screamed the disgruntled computer voice. This human error makes each print unrepeatable and uniquely imperfect. In collecting errors, I defy the understanding of photography as an art of mechanical or digital reproduction. The process is not Luddite but ludic. *An error has an aura.*

## NOTES

1   Osip Mandelstam, "Conversation about Dante," in *Mandelstam: The Complete Critical Prose and Letters,* ed. Jane Gary Harris, trans. Jane Gary Harris and Constance Link (Ann Arbor: Ardis, 1979), 406.

2   See http://neme.org/309

3   Moinak Biswas, "Off-Modern: Conversation with Raqs," *Humanities Underground* [website] (6 August 2011).

4   Gilles Deleuze, *The Fold*, trans. Thomas Conley, (Minneapolis: University of Minnesota Press), 62.

5   Even if we look at the original canvas of the master of suprematism Kazimir Malevich, we find there the traces of the pencil around the suprematist black square; for the "ultimate" work of suprematist art was made without technical props as a labor of the artisan of abstraction. Malevich's other abstract works reveal the figurative ghosts from the other paintings. In his case it is also possible that these *pentimenti* of the avant garde speak also of its forgotten historical context, the hungry postrevolutionary era when a pristine new canvas would have been an unaffordable luxury.

6   For the full-length discussion of the off-modern condition see my forthcoming book *The Off-Modern Condition.* See also Svetlana Boym, *Architecture of the Off-Modern* (New York: Princeton Architectural Press, 2008) and "The Off-Modern Mirror," *e-flux journal* 19 (October 2010). For the most recent updates see www.svetlanaboym.com.

7   Victor Shklovsky, *The Knight's Move*, trans. Richard Sheldon (Champaign, IL: Dalkey Archive Press, 2005) and "Art as Technique," in *Four Formalist Essays*, ed. and trans. Lee T. Lemon and Marion J. Reis (Lincoln: University of Nebraska Press: 1965), 3–24. For a detailed discussion, see Svetlana Boym, *Another Freedom: An Alternative History of an Idea* (University of Chicago Press, 2010), chapter 5, and "Poetics and Politics of Estrangement: Victor Shklovsky and Hannah Arendt," *Poetics Today* 26:4 (2005), 581–611.

8   See Vladimir Nabokov, *Lectures on Russian Literature* (New York: Harcourt Brace Jovanovich,1981), 58.

9   To some extent, the theory of the altermodern still followed post Marxist and post-postmodern logic while off-modern offsets this way of posthistorical thinking with the swerve and the knight's move that opens into alternative genealogies and conjectural histories of modernities. Instead of the subtitled and translated languages of the new universalism, off-moderns focus on accents and affects, on the material singularities and alternative solidarities between cultures that often circumscribe the center creating a broad margin for peripheral scenographies. The examples can be found in the long standing connections between Latin American, Eastern European, and Indian modernities that didn't always go via Paris, London, or Berlin, where metadiscourse to end all metadiscourses is perpetually enunciated as if anew.

10  In Cédric Vincent, "Meeting in a Waiting Room: An interview with Raqs Media Collective," *Springerin* (January 2007).

11  Raqs Media Collective, "Earthworms Dancing: Notes for a Biennial in Slow Motion," *e-flux journal* 7 (June 2009).

12  Biswas, "Off-Modern: Conversation with Raqs."

13  Ibid.

14  Boym, "Scenography of Friendship: Hannah Arendt and Mary McCarthy," in *Cabinet* (Spring 2010).

15  Hannah Arendt, "On Humanity in Dark Times: Thoughts on Lessing," *Men in Dark Times* (New York: Harcourt, Brace & Company, 1968), 24.

16  Hannah Arendt's own unlikely relationship with Mary McCarthy offers an interesting example of an unconventional elective affinity. The two women, one immigrant philosopher and the other expat writer who theorized and practiced friendship in the passionately non-euphemistic manner, had the type of relationship that can be described only through a series of expressions whose oxymoronic character allows us both to get to its passionate core and avoid the touchy-feely confessional mode for which the two women had little patience — luminous opacity, diasporic intimacy, asymmetrical reciprocity, impolite tactfulness, homoerotic heterogeneity.

17  Arendt, "On Humanity in Dark Times," 10. The conception of worldliness and freedom in Hannah Arendt is further discussed in Boym, *Another Freedom.*

## An Impossibility

The "how long" of a work is considered important, not necessarily because the work is time-based. Many people would say, "We sat an hour contemplating a painting." And they mean it too. Works that demand an hour, or more, of viewing time do exist. And yet, there is a tendency to obliterate the time-basis of a work. Time-based work is a shift in the experiential realm. When, in an exhibition, a number of video works are shown, demanding days and days of viewing time, a conundrum emerges: What is the phenomenology of art experience here? What does it mean to have seen a complete show, when seeing a show in its entirety no longer exists as a possibility? This idea of the impossible itself can be a starting point.

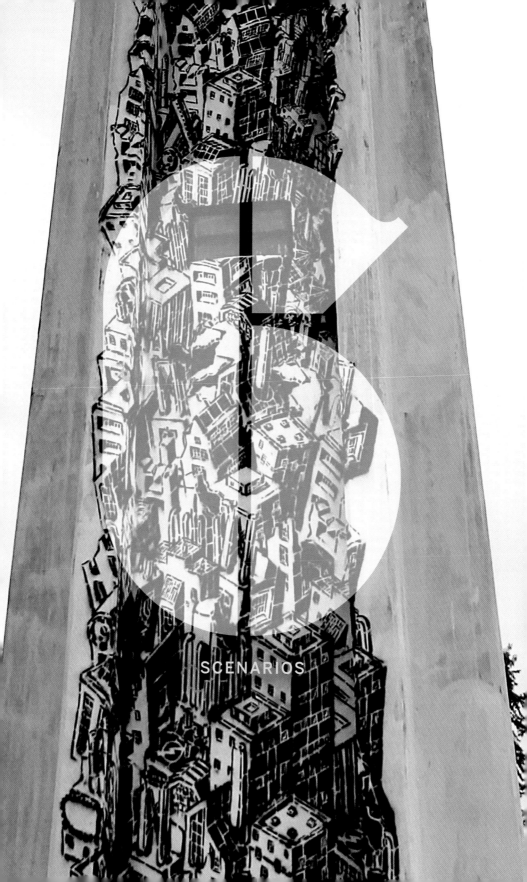

SCENARIOS

Contested Commons /
Trespassing Publics

A Public Record

Pirate Modernity

Delhi's media urbanism

Ravi Sundaram

sarai    01

THE
PUBLIC
DOMAIN

sarai READER 02

The Cities of Everyday Life

sarai READER 03

SHAPING TECHNOLOGIES

sarai READER 0

CRISIS/MED

sarai READER 05

BARE
ACTS

sarai READER 06

TURBULENCE

sarai READER 07

FRONTIERS

sarai READER

FEAR

ravi vasudevan

the
melodramatic
public

FILM FORM AND SPECTATORSHIP IN INDIAN CINEMA

bhagwati prasad
amitabh kumar

Tinker.
Solder.
Tap

a graphic novel

WRITINGS FROM THE BELLY OF THE METROPOLIS

TRICKSTER
CITY

The
Water
Cookbook

# Sarai

Sarai meant many things to many people. For some, it was a place where the sharpest idea and the oddest notion could seek each other out for company and antagonism amidst the turbulence of a city like Delhi. For others, it was where you went to invoke and anticipate the future through practice, reflection, and research, with books, art making, online material, discussion lists, software, screenings, exhibitions, conferences, tea, and rum. For yet others, it was a place for conversation, a platform and a seemingly endless occasion for rigorous thinking with signals and images, against the grain when necessary and with the current of all that was incandescent when possible. Sarai was a studio, a seminar, a salon, a laboratory, a playground, an archive, an incubator, a cafe, and a refuge.

For Raqs Media Collective, Sarai (which they co-founded in 2000, together with Ravi Sundaram and Ravi Vasudevan as a program of the Centre for the Study of Developing Societies in Delhi) functioned for many years a sort of intellectual anchorage, a place for the production of a new model of practice. Open, inter-disciplinary, peripatetic, and committed to an ethic of auto-didacticism, Sarai is the most ambitious collaborative work of art that Raqs has embarked upon.

The word sarai, or caravansarai, common to many Central Asian and Indian languages, refers to the shelters for travellers, sometimes large and extravagant although usually modest and improvised, that traditionally dotted the cities and highways of this part of the world, facilitating travel, pilgrimage, commerce, and adventure but also enabling the creation of rich, hybrid languages and cultures and the exchange of stories, concepts, and ideas across large distances. Delhi is dotted with place names that hyphenate to include sarai as a suffix, pointing to its rich cosmopolitan heritage, reminding us that people from all over the known world once sojourned in the city. Their transits shaped the city's history, its language and ways of life, and continue to infect the way in which the denizens of Delhi dream the past and imagine the future. Sarai inherited the legacy of these associations, these dreams and itineraries.

For Raqs, Sarai remains what it was when they worked on its inception: a site and an ongoing proposal that makes it possible to imagine and embark on audacious journeys in thought and practice, as well as an ever-expanding arc of possibilities in contemporary

culture and intellectual life grounded in a sense of engagement with city spaces. Sarai's areas of interests grew to include media research and theory and the urban experience in South Asia, along with history, environment, culture, architecture and politics, new and established media practices, media history, cinema, contemporary art, digital culture, the history and politics of technology, visual/technological cultures, free and open source software, social usage of software, the politics of information and communication, online communities, and web-based practices.

Its sense of promise was, and remains, contagious: transgressing forms, disciplines, genres, world-views, and practices across a dozen years as it occupied several registers at once — creative, scholarly, committed, and attentive to the nascent while remaining mindful of the obscured.

Sarai's impact on the intellectual and creative scene, especially in India, has been deep and sustained. Issues such as the Public Domain, Intellectual Property and its Critics, Technology and its Cultures, Politics of Information, Surveillance and Censorship, and the transformation of urban spaces, which were either marginal or low on the agenda of discourse in the intellectual milieu have become fairly significant as a result of work at Sarai. Sarai's commitment to FLOSS (free, libre, and open source software) has led to a wider public acceptance of alternatives to rigid intellectual property as the only model for cultural production, at least in India. A new interdisciplinary ethic of practice became much more significant as a result of Sarai's activities. There has been a modest increase in the level of publicly available support for independent artistic and research projects through fellowships, as the Sarai fellowship model (which supported more than five hundred independent researchers and practitioners in diverse fields all over India) found takers in other initiatives and organizations working within the South Asian context. Further, the support extended by Sarai through fellowships, and the work of the Sarai Media Lab and Sarai's Cybermohalla Project brought forth dividends in terms of an increased international visibility for contemporary art from South Asia, as well as paved the ground for the emergence (within the Indian context) of new forms such as the graphic novel, media installations, sound art, tactical media forms, experimental public architecture, and collaborations between artists, media practitioners, architects, performers, writers, and software programmers.

From its inception in 2000, Sarai was committed to publishing new and original material that could transgress familiar and habitual intellectual boundaries. The Sarai Reader Series, which saw the making of nine landmark books, beginning with the publication of the first Sarai Reader, *The Public Domain*, in 2001, and ending with the publication of *Projections* in 2013.

The books aimed at bringing together original, thoughtful, critical, reflective, well-researched, and provocative texts and essays by theorists, artists, writers, practitioners, lawyers, architects, students, and activists grouped under a core theme. The themes chosen over the years related to the contemporary condition, opened out through

the intersections of practice, discourse, art, criticality, and research, especially within a global urban context.

The Sarai Reader Series consists of the following books:
*The Public Domain: Sarai Reader 01* (2001)
*The Cities of Everyday Life: Sarai Reader 02* (2002)
*Shaping Technologies: Sarai Reader 03* (2003)
*Crisis/Media: Sarai Reader 04* (2004)
*Bare Acta: Sarai Reader 05* (2005)
*Turbulence: Sarai Reader 06* (2006)
*Frontiers: Sarai Reader 07* (2009)
*Fear: Sarai Reader 08* (2010)
*Projections: Sarai Reader 09* (2013)

Raqs Media Collective has been central to the conception, editing, and production of the entire Sarai Reader Series.

In a dozen odd years, Sarai has contributed to how the twenty-first century will be thought and imagined in South Asia, and elsewhere. As infrastructural support for independent initiatives such as Sarai wanes, what will remain as Sarai's legacy is its promise as a proposition — that it is possible to combine creativity, criticality, commitment, and community in sharp and interesting ways, and find new, expanding constituencies that locate the intellectual and cultural life outside elite bastions and ivory towers.

This promise is already materializing itself in a constellation of spaces, initiatives, and processes within and outside Delhi, in dialogue with Raqs, as well as autonomously, by many different kinds of people who have passed through or encountered Sarai. In time, Sarai may become primarily a fascinating archive of what the future once felt like in Delhi when this century was still young, but repeated returns to its spirit will also remain necessary to keep the future alive. Raqs will do so, in different ways, as long as they and their practice endure.

# BUILDING SIGHT: CURATORIAL PROJECT

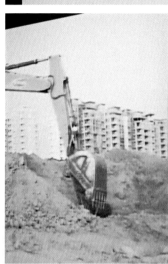

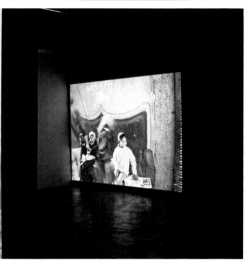

# Building Sight

Curated by Raqs Media Collective

Artists: Sanjay Kak, Ruchir Joshi, Satyajit Pande, Solomon Benjamin, Ravikant Sharma, Prabhat Kumar Jha, Nancy Adajania, Cybermohalla Ensemble, Sarai Media Lab, and the Sarai.txt Broadsheet Collective

*On Difference #2: Grenzwertig*, Württembergischer Kunstverein, Stuttgart (2006). *Building Sight*, Watermans Art Centre, London (2008).

*Building Sight* is a sketch of how a way of thinking about a city has to be constructed, brick by brick. Cities are being built all the time. Construction never ends; no one can say precisely when it began, work is in progress. The task of constructing an image of a city involves more than collating material about buildings, roads, and walls. It also requires you to render all the arguments and feelings that gather around a place. There is no guarantee that all this will resolve into a neat diagram of urban utopia. Every indication, in fact, is to the contrary.

The pleasure of our immersion in cities lies as much in our awareness of their discord as in their design. To think about cities is to consider relationships: between a planned city and its messy footprint; between tower block, hollow ground, and dust bowl; between a wall that you can lean on and a house that is demolished; between cul-de-sacs and streets for walking. Between the admonitions inscribed on surfaces and the never-ending games and dreams that are played out and whispered at street corners and crossroads.

The city can strike you as a maelstrom. Evictions bring new people from all over the hinterland — as dams flood valleys; as plans spiral out from blueprints, emptying forests, fields, and pastures. Old towns haemorrhage into the metropolis. The city swells, becomes strange, crowded, dense. Old evictions breed new ones. A city becomes something you have to hang on to as you lurch into daily uncertainties. And yet, time is sought for pauses, for breath, for play, for dreaming, for the carving out of spaces and handholds and corridors which make the city a place to live in, regardless. And there are encounters that bring things face to face when eyes have to meet eyes, gazes have to cross and settle on the beholder and the beheld. And there are conversations — some strident, others tentative; some even have episodes of accord.

A building site is a place where people bring things with which they will construct something. *Building Sight* is an island of design inlaid into the surface of this construction. *Building Sight* brings together a number of different visions in order to provoke new

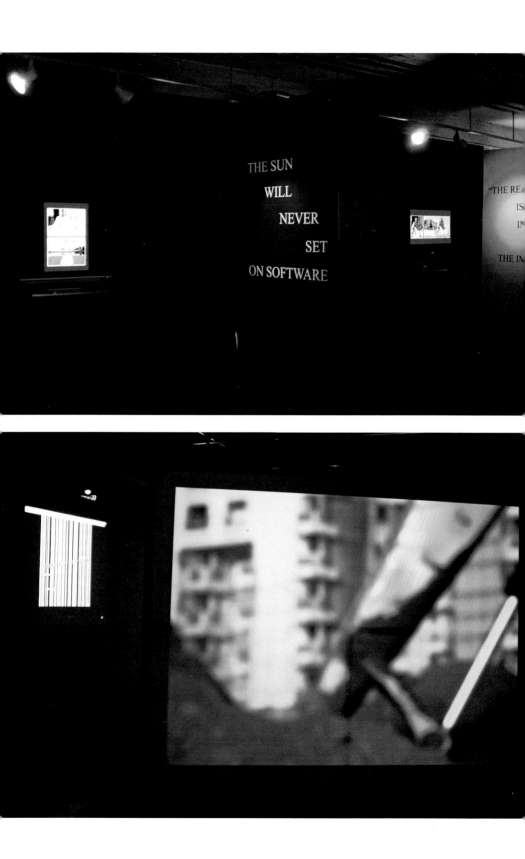

conversations about the making and unmaking of cities. *Building Sight* is a provisional index of a handful of conversations that we have been having for some time with friends, colleagues, and correspondents who have helped us to think about what it means to live in cities. Their work anticipates, rather than represents, what the response of contemporary art to the South Asian city can be. The dialogue that we have had with these practitioners has led to an eclectic mélange of possibilities and the tentative laying of foundations as a series of fragments creates unsettling, pleasurable provocations. In all of this we can see arguments gather: we see images of disparate dreams and realities unsettling maps, plans, and blueprints. One is an architect, two are documentary film-makers, one is a cinematographer, one a curator, critic, writer. Then there are collectives and communities — a writer and a community worker, three editors of a broadsheet in dialogue with a designer, a constellation of media practitioners in a working class neigh-bourhood. Each of these, many from Delhi, some from Mumbai, one from Bangalore — is a stranger to galleries. Sometime in the nineteenth century, a poet who lived in Delhi, Mirza Asadullah Khan Ghalib, gave voice to a query about his city. "'What is Delhi?' I ask myself. I reply, 'The world is a body, and Delhi, the soul.'" In the end, *Building Sight* — brick by retinal brick, pixel by pixel, frame by frame — is a consideration of what it means to continue a conversation with the body of the world, and its soul.

# Manifesta 7: The Rest of Now

Curated by Raqs Media Collective

Artists: David Adjaye, Stefano Bernardi, Kristina Braein, Yane Calovski, Candida TV, contemporary culture index, Neil Cummings and Marysia Lewandowska, Harold de Bree, Latifa Echakhch, Marcos Chaves, etoy.CORPORATION, Anna Faroqhi, Ivana Franke, Matthew Fuller, Francesco Gennari, Ranu Ghosh, Rupali Gupte and Prasad Shetty, Anawana Haloba in collaboration with Francesca Grilli, Graham Harwood, Nikolaus Hirsch & Michel Müller, Hiwa K, Emre Hüner, Helen Jilavu, Sanjay Kak, Zilvinas Kempinas, Reinhard Kropf and Siv Helene Stangeland, Anders Kreuger, Lawrence Liang, Charles Lim Yi Yong, m-city, Teresa Margolles, Walter Niedermayr, Jorge Otero-Pailos, Martin Pichlmair, Piratbyrån Party (featuring a performance by Jem Noble), Jaime Pitarch, Prof. Bad Trip, Kateřina Šedá, Dayanita Singh, TEUFELSgroup, Meg Stuart, Melati Suryodarmo, Jörgen Svensson, Hansa Thapliyal, Alexander Vaindorf, Judi Werthein, Harwood, Wright, & Yokokoji, and Darius Ziura

*Manifesta 7*, Ex Alumix, Bolzano/Bozen (2008); Curatorial essay published in *Manifesta 7 Index* (Milan: Silvana Editoriale, 2008)

## 1.

A hundred years ago, Filippo Tommaso Marinetti, artist, poet, and high priest of a muscular industrial aesthetic, was seriously injured in an automobile accident on the outskirts of Milan. During his convalescence, he wrote a passionate paean to speed, the very force that had so recently threatened his life. His words, clad in the brash cadence of the first Futurist Manifesto, ring out as a fanfare to the velocity of the twentieth century.

> We declare that the splendor of the world has been enriched by a new beauty: the beauty of speed… We are on the extreme promontory of the centuries! What is the use of looking behind at the moment when we must open the mysterious shutters of the impossible? Time and Space died yesterday. We are already living in the absolute, since we have already created eternal, omnipresent speed…

A hundred years later, standing inside the disused Alumix factory in Bolzano/Bozen, which for five decades had been dedicated to the production of Marinetti's beloved aluminum, hindsight suggests that we consider a different rhythm. Not the speeding regularity of *architettura razionale*, but the soft, syncopation of desuetude. Let us rest for now, between an odd and an even beat, and consider what remains from a century devoted to the breathless pursuit of tomorrow's promised riches.

An empty factory, which once produced aluminum — the substance of bombs, aeroplanes, and coffee percolators, the metal of speed, death, and light — is the stage and provocation for us to invoke that which is left behind when value is extracted from life,

time, and labour. Aluminum, which as tinfoil and scaffolding is used for the cladding of everything from sandwiches to building sites, is also what is thrown away the moment the sandwich is eaten and the building finished. Mountains are flattened to mine bauxite, the main aluminum ore. Mountains of aluminum waste may eventually take their place. The Alumix factory, like its counterparts all over the world, is a monument to its own residue.

Turbines, transformers, motors, smelters, furnaces, production targets, and megawatts of electrical power have long since vacated this building. Marinetti's "great agitation of work" has departed to other continents, making room for dust, fungi, and the anticipation of resurrection. *Manifesta 7* enters the building in this moment of pause, stealing in between the downtime of industrial abandonment in the core of Europe and the overture of global capital's next move.

The "rest of now" is the residue that lies at the heart of contemporaneity. It is what persists from moments of transformation, and what falls through the cracks of time. It is history's obstinate remainder, haunting each addition and subtraction with arithmetic persistence, endlessly carrying over what cannot be accounted for. The rest of now is the excess, which pushes us towards respite, memory, and slowing things down.

Remembering what has departed, recognizing what is left behind and preparing for what is yet to arrive means making sense of the relationship between living and having lived. It means reading the things that almost happened, or didn't quite happen, or that were simply desired, against the grain of that which is occurring or has taken place. Residue is a space of open, uncharted, alterity. The residual and the imminent share a paradoxical working solidarity.

In "Lance," a short story about time and space travel, Vladimir Nabokov wrote, "the future is but the obsolete in reverse," suggesting that even the impulse to hurtle into futurity is always, already, shadowed by its own imminent obsolescence. The Alumix factory, like so much of the twentieth century's heroic and tragic dalliance with the future is now a repository of the residual. What better place can there be for the rest of now?

## 2.
An exhibition is a design in space. *The Rest of Now* is also a figure in time. In Bolzano/Bozen, the ex-Alumix factory sits nestled between the elevations of the Dolomite mountains, whose every fold is a reminder of the fact that industrial time is only a faint ripple on the surface of geological time.

To draw a figure in time is to inscribe a mark on a difficult and slippery surface. As time passes, the reasons to remember grow stronger, but the ability to recall is weakened. Memory straddles this paradox. We could say that the ethics of memory have something to do with the urgent negotiation between having to remember (which sometimes

includes the obligation to mourn), and the requirement to move on (which sometimes includes the necessity to forget). Both are necessary, and each is notionally contingent on the abdication of the other, but life is not led to the easy rhythm of regularly alternating episodes of memory and forgetting that cancel each other out in a neat equation that resolves to zero.

Residue is the fulcrum on which the delicate negotiation between memory and forgetting is undertaken, because it is the unresolved, lingering aftertaste of an event that triggers the task of retrieving and dealing with the difficult of its recollection. The question of what is to be done with residue — should it be burned, buried, frozen, embalmed, mourned, celebrated, commemorated, carried over, forgotten, or remembered — haunts us all the time. It haunts us in our personal lives as much as it haunts the larger histories we participate in and draw from. To draw a figure in time is necessarily to encounter and reflect on the difficulty of the residual. There are no easy answers to the questions posed by residue.

Images are not always the most reliable allies against forgetfulness; words play tricks with memory. Oblivion is easily accomplished, especially with the aid of what is usually called restoration, which makes it possible to ignore or cosmetically invert the action of time on a physical surface. Monuments, contrary to the stated intentions of their construction, abet forgetfulness. Sometimes the *work* of art can be a matter of ensuring that the time it takes to think and recall difficult questions be given its due; that instead of purchasing the processed and instant sense of time mined from a monument we explore the option of accessing the potential of even a modest memento to destabilize the certitude of the present.

How can images and objects be brought together in a manner that helps etch a lingering doubt onto the heart of amnesia? How can concepts and experiences that sustain an attitude of vigilance against the impulse of erasure be expressed as tools to think and feel with, to work with in the present? How can we remember and reconsider the world without getting lost in reverie? How can a meditation on history avoid the stupor of nostalgia? What work must memory be put to, in order to ensure that we erect, not memorials that close the roads to further inquiry, but signposts that ask for more journeys to be undertaken?

*The Rest of Now* is an occasion for the asking of these questions. It offers both the building blocks of an argument and a disposition to be alert to the material, cognitive, and emotional consequences of temporal processes. Underlying the argument and the disposition is a hunch that the after-image of residue may be a critique and an antidote to the narrative conceit of progress. We can move on only if we understand that the debts we owe to the past are a long way from being settled, and that we are required to carry them with us into the future. We can move on only if we understand that the future is constituted by the debts we incur in the present. Residue is an unlikely, but effective, engine.

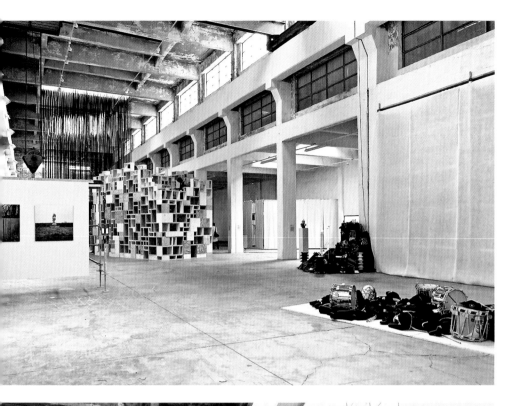

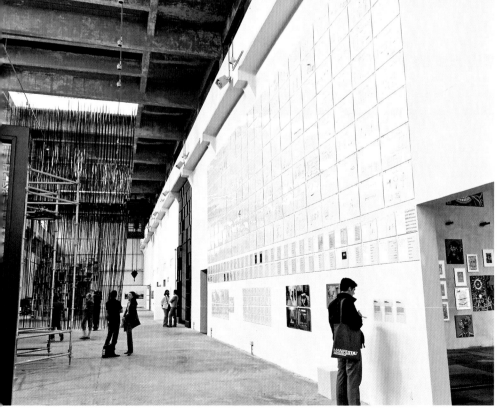

The artists we have invited to *The Rest of Now* have responded in a variety of ways to our proposition. Coded within their responses are entire archives of forgotten, retrieved, and imagined worlds; exemplars of practices of persistence and refusal; instances of play, investigation, questioning, and speculation. Looking out with them, out of the factory, towards the mountains, this exhibition layers, leaches, and addles time. It arrests and thickens time, sows time's seeds in a garden, bores time's holes in masonry, scrapes time's dust off a wall, build's time's bridge to nowhere, measures time in terms of detritus, tells stories about the stubborn persistence of things, people, and ways of life that refuse to admit that either their time is over or that it hasn't yet come. This exhibition takes time and lays it across a long table, makes it climb a high tower, skip a heartbeat in a tap dance, rise like mist and fall like sunlight, run like an engine and dance like a worker, sleep like a hill and wake like a factory, shine, escape, and elude capture like the enigmatic memory of a dead grandmother.

**3.**

> The extraction of value from any material, place, thing, or person involves a process of refinement. During this process, the object in question will undergo a change in state, separating into at least two substances: an extract and a residue. With respect to residue: it may be said it is that which never finds its way into the manifest narrative of how something (an object, a person, a state, or a state of being) is produced, or comes into existence. It is the accumulation of all that is left behind, when value is extracted … there are no histories of residue, no atlases of abandonment, no memoirs of what a person was but could not be. — "With Respect to Residue," Raqs Media Collective, 2005

When faced with any apparently "abandoned" situation, it quickly becomes clear that a lot remains. Even the walls of a shut-down factory teem with life forms, only some of which are visible to the eye. To recognize this is to encounter the fecundity of residue.

In 1855, the English botanist Richard Deacon published a botanical study of the ruins of the Flavian amphitheatre in Rome, *The Flora of the Colosseum*. His meticulous and monumental account catalogues the 420 species of vegetation growing in the six acres of the ruined edifice. These included several species so rare in Europe at that time that Deacon speculated that they must have been transported as seeds in the guts of the animals and slaves imported into Rome from Africa and Asia for the staging of gladiatorial spectacles. Deacon speaks of these rare plants with affection and awe, saying that they "form a link in the memory, and teach us hopeful and soothing lessons, amid the sadness of bygone ages: and cold indeed must be the heart that does not respond to their silent appeal; for though without speech, they tell us of the regenerating power which animates the dust of mouldering greatness." By 1870, the Colosseum in Rome had experienced the first of several modern attempts at "restoration," and the ancient cosmopolitan exuberance of vegetation that had been the botanist's consolation had begun to give way to naked stone.

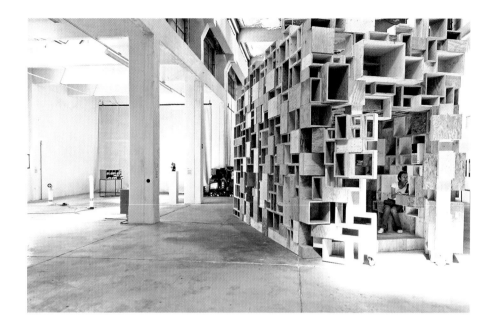

The vocabulary of contests and gladiatorials has not changed much in the last two millennia. Speed and prowess matter as much as they did when prisoners, slaves, and beasts fought it out in the Colosseum's arena. If anything, the Olympic virtues, "citius, altius, fortius" (faster, higher, stronger) have become the governing maxims of the contemporary world — the pace of life and labour gets faster, profits and prices rise higher, and armies get stronger. Our societies are Colosseums reborn. We are spectators, gladiators, and beasts.

The late Alexander Langer, autonomist activist, thinker, maverick European Green politician, and native of South Tyrol, with his interest in the residual and his ecological emphasis on slowness, provides us with an interesting late twentieth-century counter-point to Marinetti's cult of speed and the gladiatorial imperative. He proposed a challenge to the "citius, altius, fortius" maxim with a call to consider an alternative trinity of virtues: "lentius, suavius, profundius" (slower, softer, deeper).

For quite some time now, the Olympic virtues have been defended with armed police pickets all over the world. It becomes necessary, at times like this, to consider a few good reasons and methods to slow things down, to reclaim the stone with wild seeds.

# Manifesta 7: Scenarios

Curated by Adam Budak, Anselm Franke & Hila Peleg, and Raqs Media Collective
*with* Ant Hampton (dramaturg), Hannes Hoelzl (audio design), Martino Gamper (furniture), Shahid Amin, Hélène Binet, Brave New Alps, Adriana Cavarero & Mladen Dolar, Harun Farocki, Karø Goldt, Larry Gottheim, Renée Green, Timo Kahlen, Karl Kels, Thomas Meinecke, Glen Neath, Margareth Obexer, Philippe Rahm, Arundhati Roy, Saskia Sassen, Michael Snow, and Saadi Yousef

---

*Manifesta 7*, Forte Asburgico, Franzenfeste/Fortezza (2008)

---

*Scenarios* represented the collaboration of the three curatorial units of Manifesta 7. It was located in the Habsburg fortress at Franzensfeste/Fortezza, the northernmost venue of Manifesta 7. The fortress sits along and astride the highway and train line that cuts through the Dolomites between Bolzano/Bozen and the Brenner Pass.

A fortification finds its purpose in standing up to an assault. Fortezza/Franzensfeste, built in the 1830s in the wake of the Napoleonic Wars, was never attacked. Having never been attacked, it never had the occasion to embody the promise of its foundation. Assault, unrealized, transforms the space into an arena for the playing out of a series of never-ending scenarios. The enemy never came, but *what if* they had? A perception of possible threat became a threat-perception sculpted into a fold of the mountains. What if these walls could literally speak, this light could thicken, this silence made tangible?

*Scenarios* encountered the paradox of the fortress made redundant by its own invulnerability as an invitation to consider and conceive yet other scenarios — codes that encrypt other possibilities that can shape our understandings of the past and the future, circumstances and possibility. The project transformed its spectacular backdrop into a scripted space: The fortress became a stage for a variety of scenarios taking place in the imagination of its visitors.

*Scenarios* was a critical reflection on the role that scenarios occupy in contemporary societies, within both individual and collective imaginaries. Today, we all participate in the unfolding of 'scenarios' that have already framed us, preconceived our presence, been projected on us. These projections condition the situations and experiences of everyday life. The project aimed to invoke reflection on how we come to fulfill and perform the parts scripted for us in these scenarios.

The curators commissioned ten writers, some from nearby, many from afar, to respond with texts to the enigma of the fortress, to its sonorous walls, its labyrinth of memories, its whisper of war, its tales of lost gold. Novelists, philosophers, historians, poets, play-

wrights, musicians, and artists (Arundhati Roy, Saskia Sassen, Adriana Cavarero, Shahid Amin, Margareth Obexer, Saadi Yousef, Mladen Dolar, Thomas Meinecke, Renée Green, and Glen Neath) sent in texts in the form of letters, briefings, dialogues, poems, and meditations.

The project deployed these texts as the building blocks for an immaterial exhibition that took two forms — an audio-visual & architectural ambience in the fortress and a stand-alone publication. The texts were presented as voice recordings in multiple languages within the fortress. These recordings were produced by theatre director Ant Hampton and sound artist Hannes Hoelzl. The listening situations in the fortress were punctuated with furniture designed by Martino Gamper. The recordings were accompanied by a light installation by architect Philippe Rahm and a sound work by Timo Kahlen. The fortress also hosted a programme of silent cinema screenings featuring the work of Harun Farocki, Michael Snow, Larry Gotheim, Karø Goldt, and Karl Kels and a workshop programme conducted by Brave New Alps. The publication featured a photographic interpretation of the space of the fortress by architectural photographer Hélène Binet.

The exhibition was "rehearsed" in the visitors' imagination, playfully reflecting the conditions of suggestivity, immersion, and imaginary identification. It explicitly demanded a break with the regime of visibility, and the imperative to produce (material) evidence.

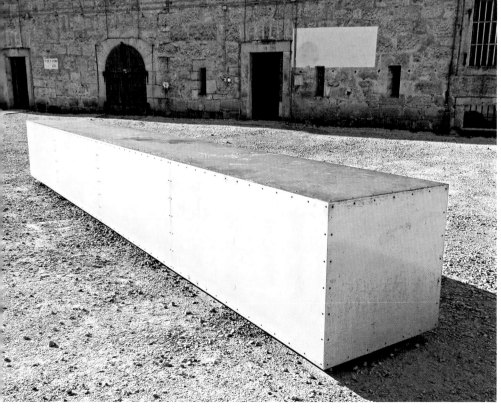

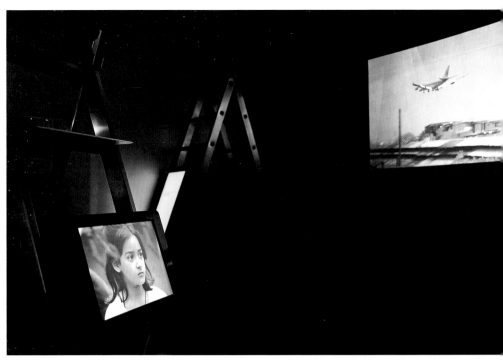

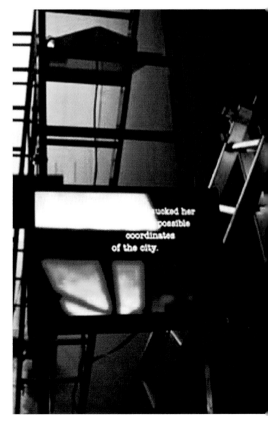

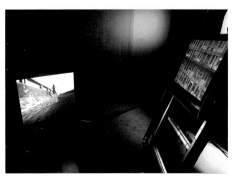

# Steps Away from Oblivion

Curated by Raqs Media Collective
Artists: Debkamal Ganguly, Ruchir Joshi, Kavita Pai and Hansa Thapliyal, M.R. Rajan, Priya Sen, Surabhi Sharma, Vipin Vijay
Exhibition Design: in collaboration with Nikolaus Hirsch and Michel Müller

*Indian Highway*, Serpentine Gallery, London (2008-09), Astrup Fearnley Museum, Oslo (2009), Lunds Konsthall, Lund (2009-10), Herning Museum of Contemporary Art, Herning (2010), Musée d'art contemporain de Lyon (2011), MAXXI Museo nazionale delle arti del XXI secolo, Rome (2011-12), Ullens Center for Contemporary Art, Beijing (2012).

As their contribution to *Indian Highway*, an international traveling exhibition curated by Hans Ulrich Obrist, Julia Peyton Jones, Gunnar Kvaran, and Thierry Raspail, Raqs Media Collective curated *Steps Away From Oblivion*, a circuit of eight video works — seven by different documentary film-makers working in India, and the eighth by Raqs themselves.

The videos invoke eight different rhythms of transformation and repose in the landscape of India today. Much of the current discussion about India's emergence as a global power seems to fall into the trap of an easy intoxication with the promise of wealth, influence, and power — an oblivion where no questions need asking any more. The works in *Steps Away from Oblivion* were brought together as a collection of moves made in the course of persistent attempts to steer away from this vacuous celebration of India as a so-called super-power. Raqs' intent was to annotate the exhibition notes with marginal notes that could act as a counter-narrative to the core rhetoric of the imperatives of a survey show.

Thinking back over documentary films from the last fifteen years — the period of India's increasingly effulgent entry into the bandstand of global attention — the members of Raqs were struck by a number of images by independent documentary film-makers that refused to be on parade for the march of contemporary amnesia. Their fascination, and their relevance, seemed only to have increased over time. In curating *Steps Away From Oblivion*, Raqs asked these film-makers to revisit those images — to re-edit them or shoot them again — to see what new resonances could emerge today.

Raqs Media Collective's own contribution, *The Sleepwalkers' Caravan (Prologue)*, presented the wandering figures of a Yaksha and a Yakshi, mythic male and female guardians of treasure and keepers of riddles in different Indic traditions. The Yaksha and Yakshi provide a crepuscular subjectivity to the entire show, their questioning gaze passing softly over the landscapes opened out in the other videos.

## Interruption

A big shift that has taken place in recent decades is the interruption in the cultural field through a dispersion of what was earlier known as the "media." With this, people from diverse disciplines took on the role of media practitioners. The singularity of "practitioner" got sliced. Ways of thinking about practice diversified, and this facilitated a fresh coming together of things, which in turn made possible a shift within artistic imagination. One no longer felt intimidated to walk into things which would otherwise be considered external to one's domain. The confidence in the possibilities through which one could translate what they are doing into something else grew. A wide range of practices seeped into one another. Sarai was, and is, one such media interruption.

# 7

UNUSUALLY
ADRIFT
FROM THE
SHORELINE

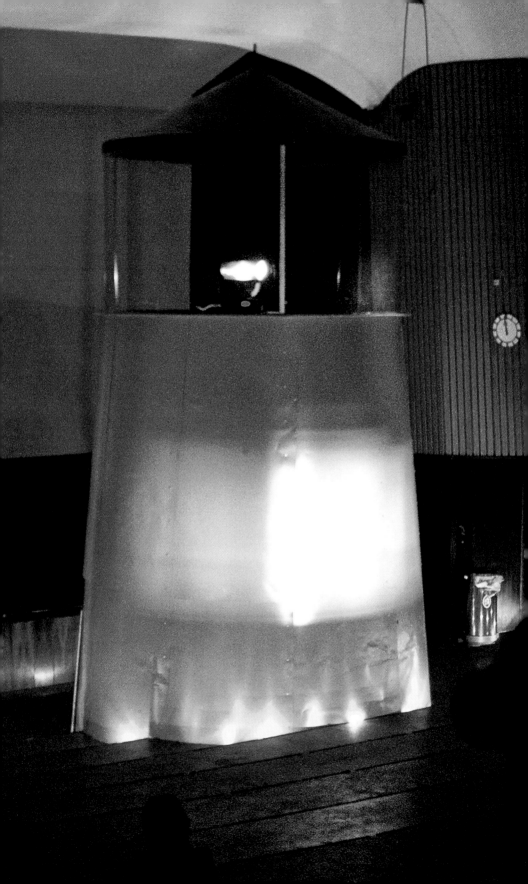

# UNUSUALLY ADRIFT FROM THE SHORELINE

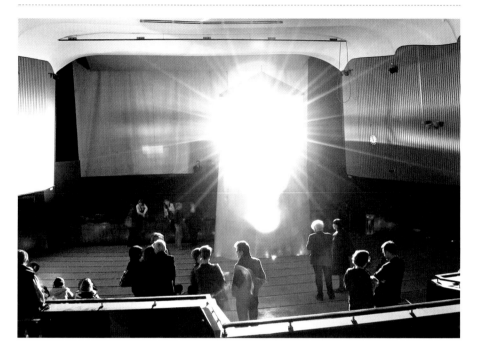

2008/ Site-specific installation

*Neighbourhood Secrets Project/Stavanger 2008*, Rådhusteateret, Sandnes, Norway (2008).

A cinema invites us to see in the dark. A lighthouse helps a sailor see where he is. Both work with beams of light. Both cause observers to question their own coordinates.

Visitors to the old cinema of Sandnes stumble upon the uncanny sight of a great lighthouse, unusually adrift from its shoreline.

The abandoned cinema, with its wave-like stepped floor, has become an echo of the sea, and the lighthouse has apparently erupted there, as if from the depths, to scan the aquamarine darkness with a solitary, roving beam. The cries of whales ring out in Sandnes' solid streets and shopping malls, as if the buried world of water has reclaimed the city, and great submarine creatures summon people to revisit its submerged places.

*Unusually Adrift From the Shoreline* is a work about darkness, light, navigation, and memory. Centred on a cinema lost to time, it is intended to prompt unfamiliar thoughts in the city. Thoughts and feelings about the pleasures and the hidden perils of losing oneself: in movies, at sea, and in the oceanic expanse of time.

# REVERSE ENGINEERING THE EUPHORIA MACHINE

2008/ Installation with furniture, 2 videos, objects, drawings, photographs

*Chalo! India*, Mori Museum, Tokyo (2008-09); National Museum of Contemporary Art, Seoul (2009); Essl Museum, Vienna (2009).

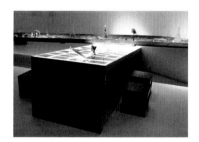

The Euphoria Machine takes the form of a "demonstration table" that works as a diagram for a conceptual engine of the desire for perpetual energy and limitless economic growth. The key product of the Euphoria Machine is processed perception. The perception that all "growth" is wonderful, that happiness can be indexed by GDP, that there is such a thing as an "Indian" economy, and that this thing known as the "Indian economy" is booming, all these are products, and by-products, of the working of the Euphoria Machine.

This work takes the form of the processual elaboration of the "reverse engineering" of the Euphoria Machine at work. It assumes that we know the machine exists. The project's intent is not to show how it works, but to lay bare its rhetorical components. Its proofs are all around us: in plans, projections, advertisements, policy statements, blueprints, balance sheets, and reports. The project aims to analyse its constituent parts, their operations and their interconnections in such a manner as to show how the "fuel" (human drives and desires) is combusted and how that energy runs the moving parts of the machine so as to achieve the desired end.

# 1986

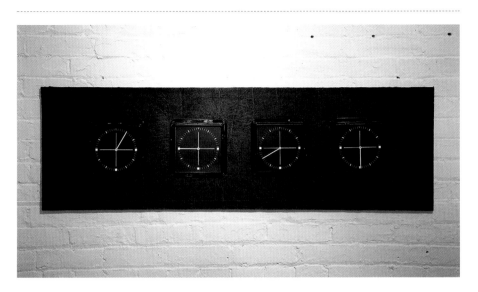

2007/ 4 non-working clocks mounted on felt. 44 x 142 cm

*India: New Installations, Part II*, Mattress Factory, Pittsburgh (2007-08).

Four standard issue wall clocks, with their hands arrested at the digits 1, 9, 8, and 6. Together, they point to 1986, the year the steel industry collapsed in Pittsburgh and time stopped ticking by the furnaces.

# REVOLUTIONARY FORCES (THE THREE TASTERS)

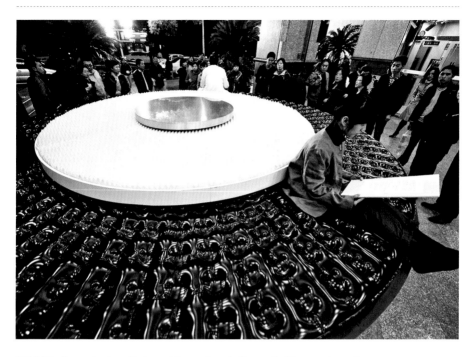

2010/ Performative installation with rotating platforms, 2 video monitors, 3 actors

*Place:Time:Play*, West Heavens, Shanghai (2010).

Three volunteers tell three stories. The surface underneath them is in a state of permanent revolution.

As the ground turns, as they turn inside out, one speaks about the shattering of illusions. Another about the balance between liberty and solidarity. The third about the delicate thread that binds passion to analysis.

Each tell the story by talking about the substance of stone. Stone, unbreakable, becomes fluid in their accounts. They drink the arrack of stone like the "three tasters" — Confucius, Lao Tze, and Buddha — who, in drinking vinegar, tasted different flavours of truth.

Revolutions occur when the apparently unyielding rock of our world melts and flows like heady wine.

# WHEN THE SCALES FALL FROM YOUR EYES

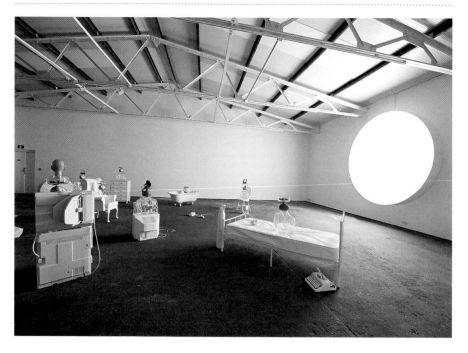

2009/ Installation with mould-blown glass busts, found objects, variable-colour light source

*When the Scales Fall From Your Eyes*, IKON Gallery, Birmingham (2009).

*When the Scales Fall From Your Eyes* features an array of glass busts with heads made of weighing scales.

The items and assemblages placed on the scales comprise a beachcomber's treasure trove, ranging from the useless to the absurd with detours into violence, fetishism, preciousness, and straightforward banality.

The assemblages are read as the "contents" of the characters' heads, providing an estimate of their weightiness. The glass busts face a large flat circle of light that changes colour.

The promise and dystopia of relentless measurement, the fantasy of controlling life by owning things, and the melancholia of empty illumination all figure as the themes that underlie this work.

# ONE FOUR FOUR ZERO

2009 / Acrylic glass tubes in circular acrylic housing. 15 x 64 cm diameter

*Escapement*, Frith Street Gallery, London (2009).

One thousand four hundred and forty crystal acrylic glass tubes, some square, some circular, some hexagonal, sit tightly packed in what looks like an transparent empty clock set on a plinth. Each handcrafted acrylic glass tube suggests the slot each minute takes up in the course of a day. Together, their jagged profiles add up to the suggestion of a dense urban skyline, a crystalline Hong Kong grafted on to Manhattan or São Paulo in somebody's lucid dream. They are reminiscent of a cross section of the retina, crowded with the photoreceptor rods and cones that carry light signals from the eye to the brain. Deep within the recesses of the brain, the pineal gland reads the light that comes in and transduces light to synthesize and secrete melatonin, the hormone that communicates a sense of ambient time to the body. Sometimes, the conditions that people are compelled to inhabit — prolonged stretches of distortion in ambient light levels or irregularities in sleep and wakefulness induced by transcontinental flights, overwork, pharmaceuticals, or torture — lead to distortions in the somatic sense of time. Then, time is really out of joint, under our skins, in our bones.

# SLEEPWALKERS' CARAVAN

2008/ Video. 11:00

*Steps away from Oblivion/Indian Highway*, Serpentine Gallery, London (2008-09).

A video featuring the wandering figures of a Yaksha and a Yakshi, mythic male and female guardians of treasure and keepers of riddles in different Indic traditions. The Yaksha and the Yakshi provide a crepuscular subjectivity to a landscape, their gaze passing, leaving open the question whether the guardians of wealth are leaving the city or entering it.

# WE THE FUEL

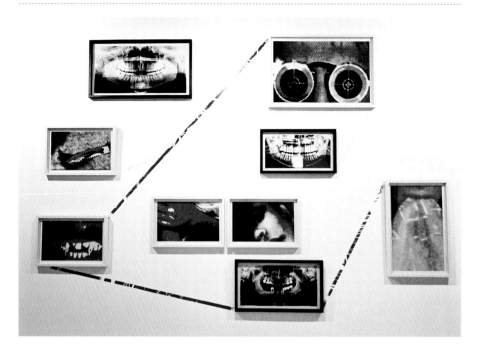

2011 / 9 framed photographs, tape residue. 210 x 180 cm

*Premonition*, Experimenter Gallery, Kolkata (2011).

A chimney once sent out a smoke semaphore foretelling a cancelled future. A furnace once burnt fuel.

We are the fuel. Sleeping under tons of earth like the ghost of a forest, waiting for prospectors with toothy grins.

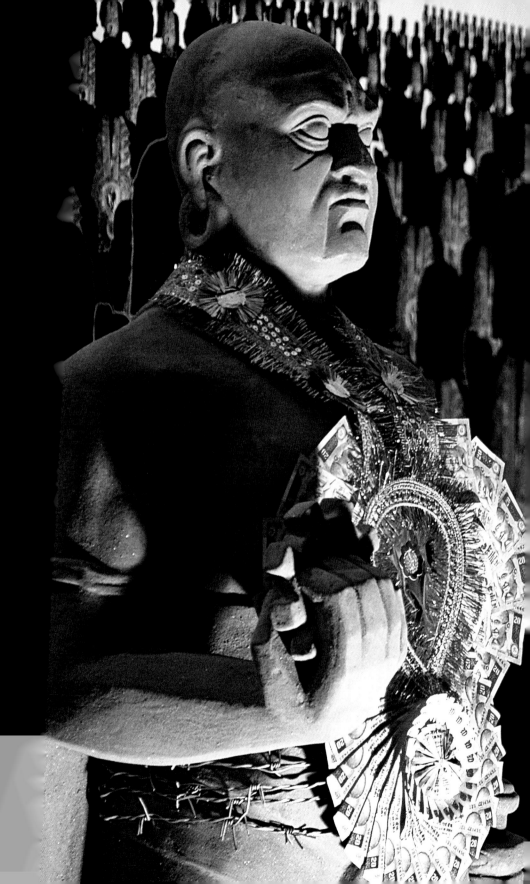

# RESERVE ARMY

2008/ Human-sized sand finish fibreglass sculptures, cash, and barbed wire ornaments, printed
vinyl screen. 335 x 214 cm

*Santhal Family*, MuHKA, Antwerp (2008). *The Audience and the Eavesdropper*, Phillips de Pury, London and New
York (2008-09). *Republic of Illusions*, Galerie Krinzinger, Vienna (2009).

*Reserve Army* is a tribute to the perspicacity of modernist Indian sculptor Ram Kinkar Baij and to the Reserve Bank of India's commission of Baij to adorn its portal with a Yaksha and a Yakshi in the first decade after the formation of the Indian Republic. In Indic mythology, Yakshas habitually pose difficult questions to unsuspecting wayfarers in order to protect hidden treasure. By sculpting a pair of monumental guardians on two stone pedestals, a Yaksha and a Yakshi, as gatekeepers of the Indian Republic's wealth, Baij has left us with two question marks frozen in stone: How is Money to be guarded? and to what purpose?

Today, the guardians and gatekeepers have multiplied. Yaksha clones are on the march, but their asking of questions has been muted in this euphoria.

With *Reserve Army*, the Yaksha and Yakshi are downsized to human scale, taken off their pedestals, and stone substituted by fibreglass and sand, and set free to work the world wearing bandoliers of currency and belts of barbed wire.

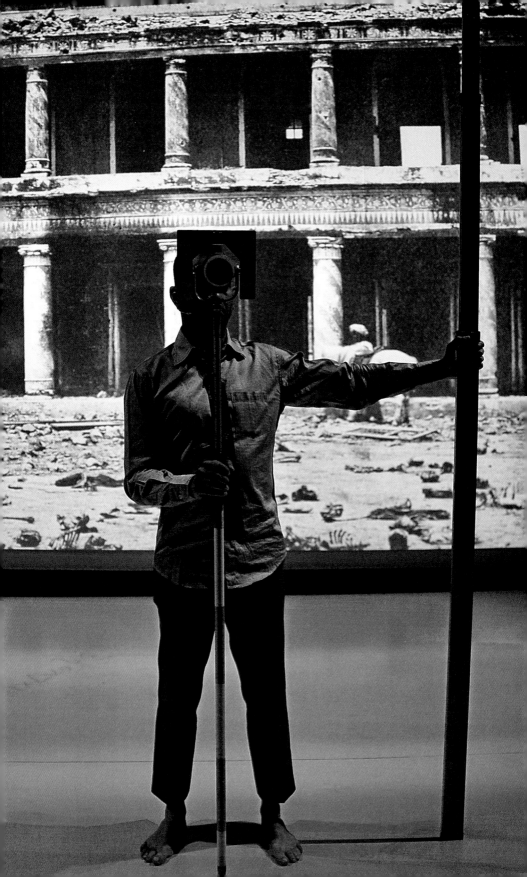

# SEEN AT SECUNDERABAGH with Zuleikha Chaudhari

2011/ Performative installation with actors, video projection, sets

*Seen at Secunderabagh*, Koninklijke Vlaamse Schouwburg, Brussels (2011); Festival d'Automne, Le Centquatre, Paris (2011); Festwochen, Vienna (2012).

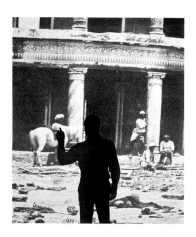

The starting point for *Seen at Secundrabagh* is a photograph taken in 1857 by the war photographer Felice Beato three months after a bloody mutiny within the British East India Company. Four men and a horse pose in front of the lens, surrounded by bones that had simply been left there.

Fixing a moment in India's colonial history, the image seems to be a faithful representation of the facts. However, knowing that the exposure of a photograph in those days took a long time, we can deduce that it is the outcome of pure and simple staging

*Seen at Secundrabagh* questions the deception of images and lays bare the intrinsic simultaneity of past, present, and future.

# THE SURFACE OF EACH DAY IS A DIFFERENT PLANET

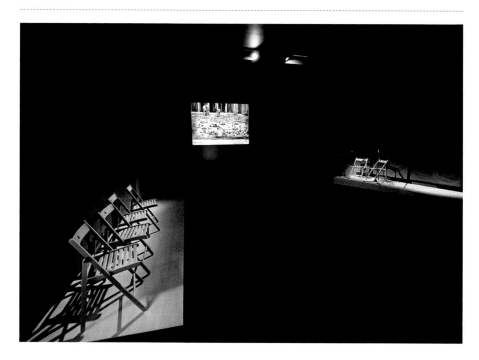

2009/ Installation with video projection, furniture, theatrical illumination, audio. 38:00

*The Surface of Each Day is a Different Planet*, Art Now Lightbox, Tate Britain (2009).

*The Surface of Each Day is a Different Planet* is a film-installation that combines historical photographs from collections in London and Delhi with video, animation, and a soundscape of overlapping voices set in a sparse, barely furnished space. Stories leak, histories collide; bones, bodies, faces, and handwriting blur; crowds gather and move en masse, cosmonauts land on unfamiliar terrain. Intentionally open-ended and anti-documentary, this work examines how collectivity and anonymity have been represented over time and how these renditions contribute to ongoing crises of identity and entitlement.

This work brings together several strands of thinking in our practice — a concern with the measurement of human forms, an interest in archival documents and images, and a way of thinking about situations of intense conflict. This work grew of out of several research processes undertaken over a number of years in India and in Britain. It also is the first instance of our attempt to find a cross-over between installation, film, and the lecture-performance form that we have been developing over the years of our practice.

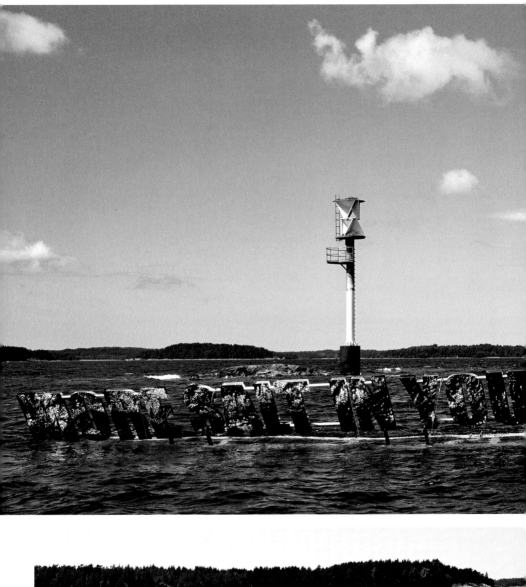
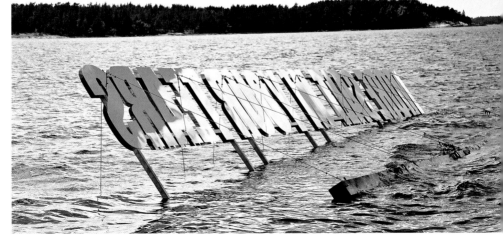

# MORE SALT IN YOUR TEARS

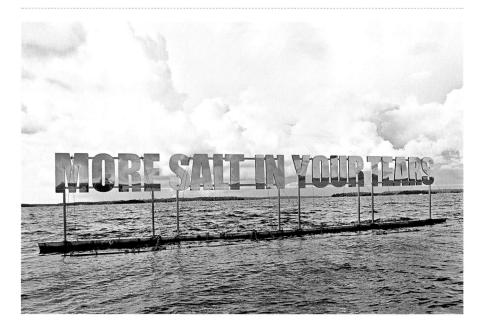

2011 / Site-specific installation in the Baltic Sea with stainless steel, steel cable, wood, concrete anchors. 200 x 1300 cm

*Contemporary Art Archipelago*, Turku, Finland (2011).

*More Salt In Your Tears* is a text sculpture composed of three dimensional stainless steel letter-forms anchored onto a shallow section of seabed of the Baltic Sea near Turku, Finland. The letters combine to form a single phrase, More Salt In Your Tears, that can be visible from the decks of passing ferryboats, ships, and low-flying aircraft.

*More Salt In Your Tears* moves into another register, of reading the sea, of weighing tears and tasting the feeling what it means to be close to the sea. This is heightened by the startling realization that our tears have more salt than the Baltic Sea.

In recent years, climatologists and oceanographers have expressed concern that global warming may increase the salinity of the Baltic Sea and by so doing cause irreversible damage to the unique ecosystem of this marine environment. In that sense, *More Salt In Your Tears* is a paradoxical statement of hope and optimism, for although tears are universally understood to stand in for sad tidings, the day there will be more salt in the Baltic Sea than in our tears will indeed be an occasion for mourning. The hope that there may always be more salt in our tears than in the Baltic Sea is a strong undercurrent of this work.

## Limits of Horizon

An interesting split exists between knowledge and thinking. One often hears, "We don't know." But one doesn't really need to know. Nobody needs to know anything. In seeing a work, one may encounter something which is outside the horizon of their experience. Welcoming it allows one to extend one's horizons. After the experience of the work you may already have become a different person. You may have a different image of thought.

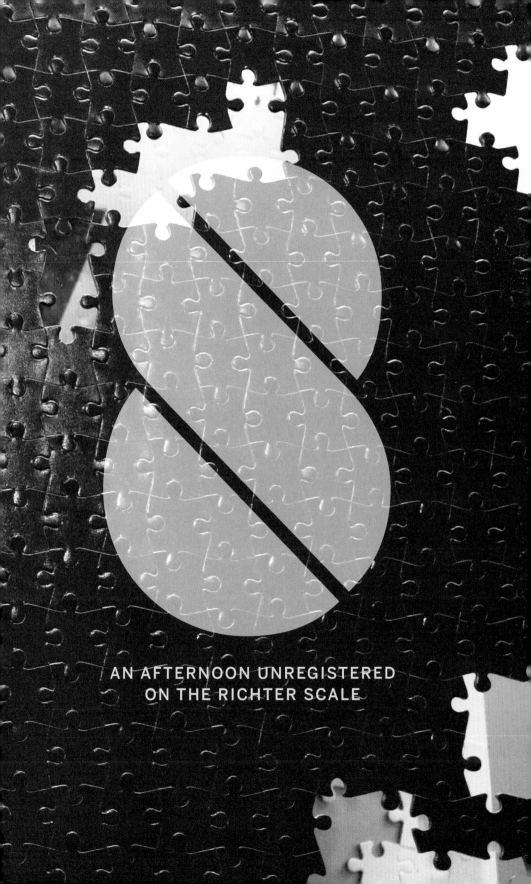

AN AFTERNOON UNREGISTERED
ON THE RICHTER SCALE

# AN AFTERNOON UNREGISTERED ON THE RICHTER SCALE

2011 / Looped video projection. 3:30

*Surjection*, Art Gallery of York University, Toronto (2011). *Raqs Media Collective*, The Photographers' Gallery, London (2012).

*An Afternoon Unregistered on the Richter Scale* is a looped video projection of an archived photographic image in which a room full of surveyors is transformed through a series of subtle alterations. The photograph in question is titled *Examining Room of the Duffing Section of the Photographic Department of the Survey of India*. It was taken in 1911 in Calcutta by British photographer James Waterhouse.

We intervene in this image to conjure a constellation of stars onto a drawing board, induce tremors too gentle to disturb the Richter scale, reveal a dreamed up desert, make time wind backwards, stain the afternoon with indigo, and introduce a rustle and a hesitation in the determined still-ness of the surveyors hard at work mapping an empire. The work functions as a meditation on the condensation of time in the photographic image as well as a gentle disturbance in the serious enterprise of recording and commemorating the imposition of order on a fractious landscape. The surveying department is unhinged from empire and annexed to the commonwealth of dreams.

This work indexes our interest in working with archival traces (which has been a longstanding pre-occupation), entering them to create layers within our experience of time, memory, and duration. However, in a departure from earlier works which reference archival materials (*The Surface of Each Day is a Different Planet* and *The Capital of Accumulation*), *An Afternoon Unregistered on the Richter Scale* enters the archive not for investigative and analytical but for poetic purposes, leaving behind a trace leavened by whimsy.

PARASITE .
TRANSEXPERIENCES

# DECOMPOSITION

2009/ Site-specific installation at the Asia Art Archive with index cards, self-inking stamps, printed ceramic tiles, customized jigsaw puzzles

*Decomposition*, Asia Art Archive, Hong Kong (2009).

This installation uses found poetry and accidental discoveries in archives and takes the form of a playful gesture of appreciation of the labour of the archivist.

# emotions surge but do not count

# PROVERBS

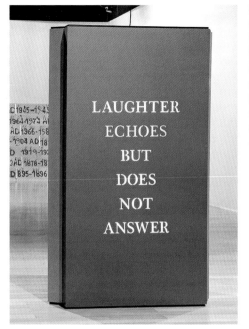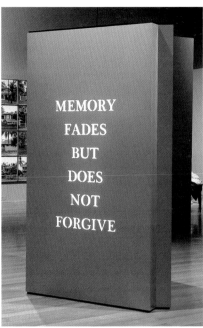

2011/ 1. *Money Talks But Does Not Remember*; 2. *Time Stops But Does Not Die*; 3. *Power Surges But Does Not Endure.* Cured MDF, LED lights, wooden frame, lighting sequencer. 244 x 122 x 8 cm each; 4. *Memory Fades But Does Not Forgive*; 5. *Laughter Echoes But Does Not Answer.* Aluminum composite panel, LED lights, metal frame, lighting sequencer. 183 x 92 x 8 cm each; 6. *Emotions Surge But Do Not Count.* Acrylic, LED lights, metal frame, lighting sequencer. 183 x 122 x 8 cm

*Surjection*, Art Gallery of York University, Toronto (2011). *Lado A Lado (India – Side by Side)*, Rio de Janeiro and São Paulo (2012).

*Proverbs* is a series of textual sculptures that express a set of ambiguities about transactions and relationships. Money, Power, Laughter, and Memory, amongst other terms, are the scaffolding on which a set of concrete thoughts is built which, like proverbs, can act as the currency of conversation. Each "proverb" is a frieze made out of text incised onto a horizontal plane. The proverbs are activated by fluctuations of an electrical signal that illuminates different configurations of the words in each text. Each configuration yields a terse new sense, sometimes contrarian, sometimes tangential, always precise. Light dances across the words, the proverbs change, meaning multiplies.

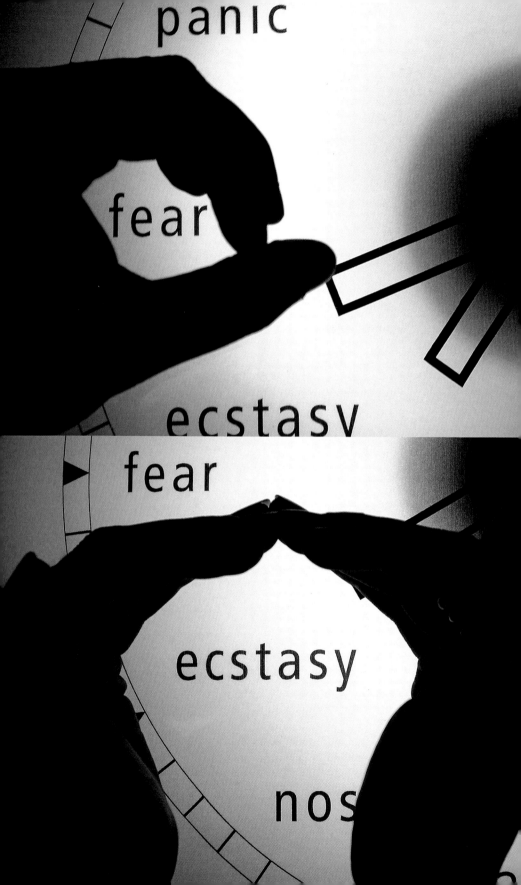

## ON THE OTHER HAND

2009/ Wall-mounted LED, acrylic lightbox. 71 x 10 x 4 cm

----

*Escapement*, Frith Street Gallery, London (2009).

----

The clock's hands measure the stations of the hours, while human hands play their own game of silhouettes, closing in on the hour of fear only to then open out on the moment of ecstasy, as if protecting Time from its own devices. A sense of time, alterity and the parenthetical presence of the human body constitute a vocabulary for states of being.

# THE PERPETUAL RECALL OF THE PENULTIMATE AFTERNOON

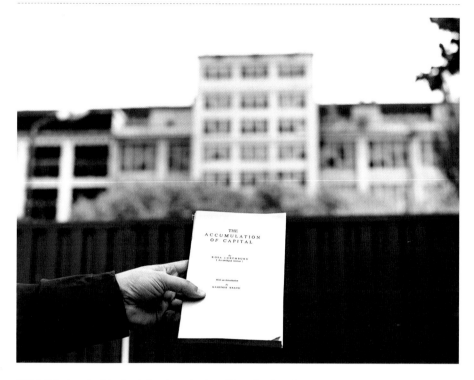

2010/ Black and white lambda prints. Series of 5, each 76 x 76 cm

*The Capital of Accumulation*, Project 88, Mumbai (2010).

*The Perpetual Recall of the Penultimate Afternoon* constructs an itinerary in the footsteps of Rosa Luxemburg's last days in Berlin, with a detour into the yard of the former Rosa Luxemburg Electric Light Bulb Factory in Warsaw. A record of the different addresses where Rosa Luxemburg lived in the days before she was assassinated, these photographs are studies and scenarios for sudden departures and fugitive entries — traces of places to pause and consider the accumulation of restless afternoons.

The camera hesitates, until a hand appears bearing Luxemburg's book, *The Accumulation of Capital*, in front of the factory gates.

Staircases wait, as if they are going to be summoned to offer a testimony at a photographic witness stand. A landing anticipates a darkening.

# DISORIENT

2008/ Print on bond paper. 30 x 21 cm

----------------------------------------------------------------

Part of Markus Meissen's *The Violence of Participation*, 2007 Lyon Biennale, Lyon (2007). Markus Meissen, *The Violence of Participation* (Berlin: Sternberg Press, 2007).

----------------------------------------------------------------

A fragment of faux classical Greek statuary, an extended arm, stretches across the plane of a poster, traversing a laterally inverted map of Europe, pointing away, below a band of flat colours, an array of would-be flags. The orient disturbs the cardinal directions.

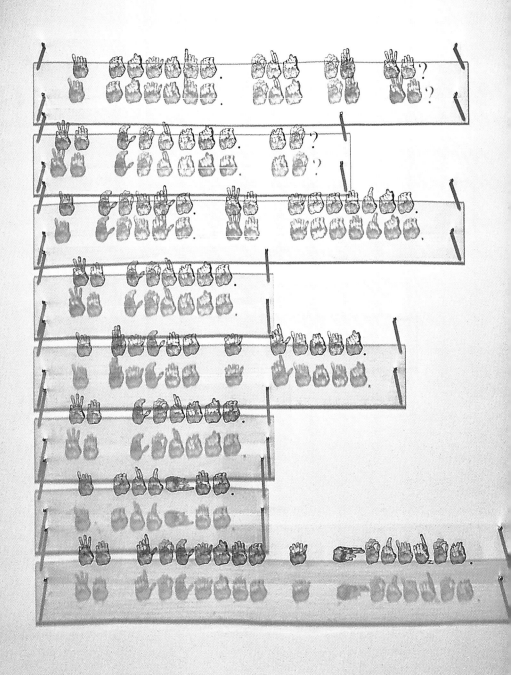

I stands. Out of We?
We counts. No?
I coils. We asserts.
We counts.
I faces a limit.
We counts.
I surges.
We locates a horizon.

2011 / Laser-cut metal on acrylic, vinyl text. 222 x 204 x 10 cm

*Surjection*, Art Gallery of York University, Toronto (2011). *Guesswork*, Frith Street Gallery, London (2012).

In *Rewriting On the Wall*, hand-prints are reconfigured to produce an alphabet of gestures—each a gloss of the letters in standard American Sign Language as used by deaf and mute people. The letters add up to a text (which accompanies the work): a stammering, hesitant, syntactically unsure consideration (written by a hand that appears on the wall like the hand that wrote on the wall in the episode of Belshazzar's feast in the Old Testament) of the relationship between 'I' and 'We' and the horizon that encompasses singular and plural modes of being.

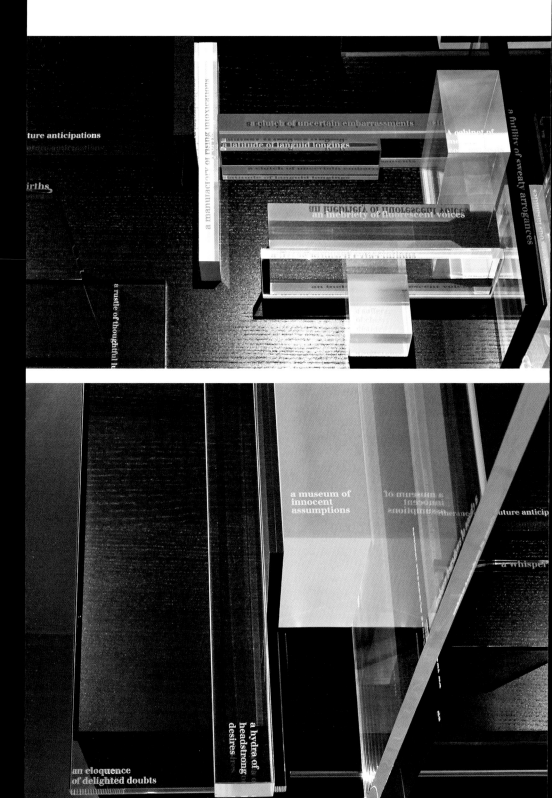

ture anticipations

irths

a rustle of thoughtful l

a clutch of uncertain embarrassments

a latitude of languid longings

an inebriety of fluorescent voices

A cabinet of

a futility of sweaty arrogances

a museum of
innocent
assumptions

ture antici

a whisper

an eloquence
of delighted doubts

a hydra of
headstrong
desires

# 36 PLANES OF EMOTIONS

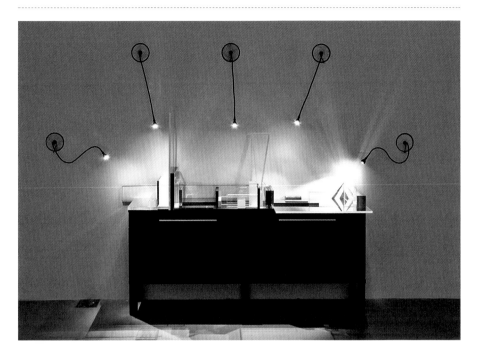

2011 / Laser-engraved acrylic glass, furniture, lighting. 180 x 150 x 60 cm

*Surjection*, Art Gallery of York University, Toronto (2011). *Raqs Media Collective*, The Photographers' Gallery, London (2012).

*36 Planes of Emotions* extends the palette of emotions to include states of collective potential. These are embodied in an assemblage of phrases, surfaces, and transparencies that enlist a cluster of invented collective nouns. The nouns etch enigmatic, invented states of being and emotions on to transparent acrylic surfaces. Light, words, perspex hues, and refractions produce their own whimsical annotations.

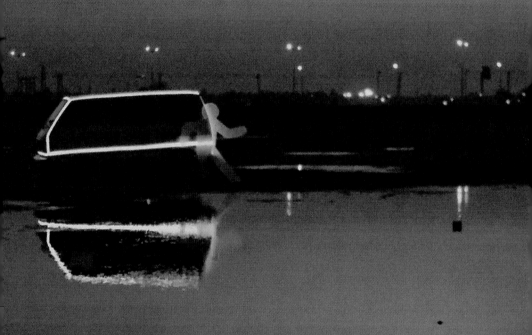

# HOW TO GET FROM HERE TO THERE

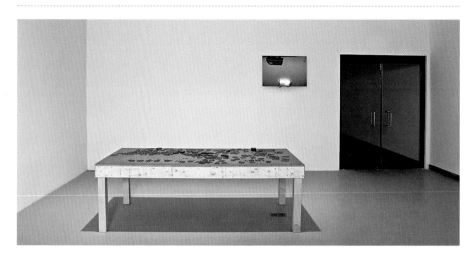

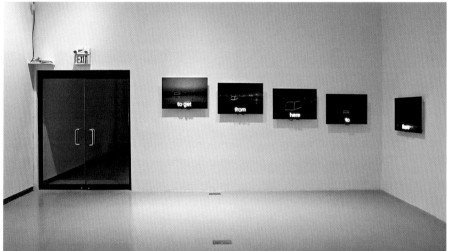

2011 / Photographs mounted on acrylic glass, neon. Series of 6, each 64 x 94 x 10 cm

*Surjection*, Art Gallery of York University, Toronto (2011).

Seven photographic prints trace the journey of an illu-
minated vehicle across a liminal landscape. Neon letters,
gesturing towards a terse but optimistic instruction,
annotate each step of the way.

# IMPOSSIBLY RARE, INFINITELY VALUABLE, ETERNALLY FREE

2010/ Photograph. 21 x 15 cm

---

*Hard to Sell, Good to Have*, Palais Sturany, Vienna (2010).

---

To survive on love and fresh air is to thrive
on next to nothing. Accordingly, this image
bottles the two things that are precious but
impossible to sell — love and fresh air.

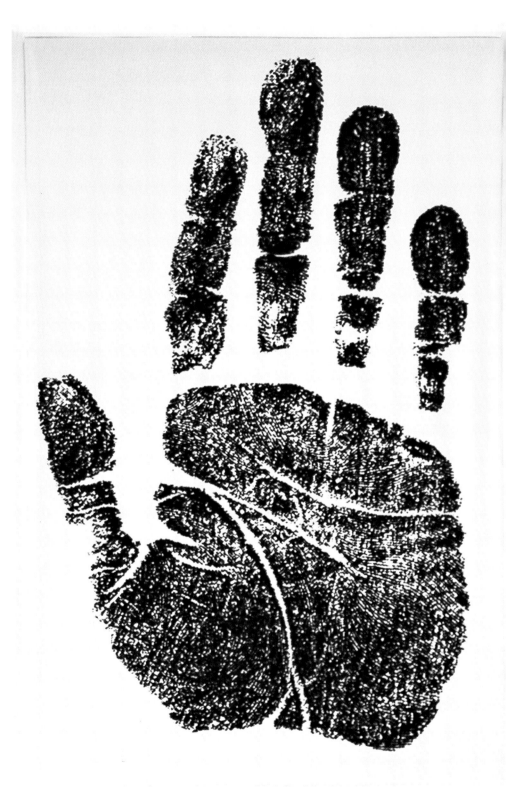

# THE UNTOLD INTIMACY OF DIGITS

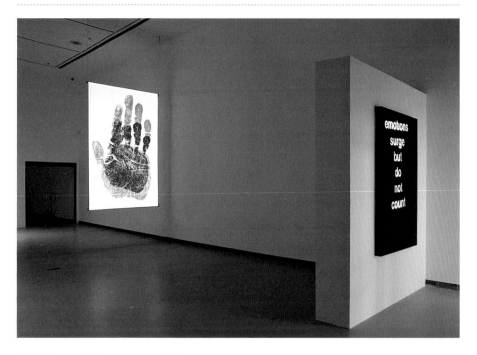

2011/ Looped video projection. 1:00

*Surjection*, Art Gallery of York University, Toronto (2011). *Against All Odds*, Lalit Kala Akademi, New Delhi (2011).

In every sum figured by power, a remainder haunts the calculation. Not everything adds up. A people are never equal to a listing of their bodies. They are something more and something less than a population. Counting counter to the reasons of state, Raj Konai, a peasant from nineteenth-century Bengal, the owner of the floating trace of a disembodied hand indexed in a distant archive, persists in his arithmetic.

The handprint of Raj Konai was taken in 1858 under the orders of William Herschel — scientist, statistician, and, at the time, a revenue official with the Bengal government. It was sent by Herschel to Francis Galton, a London eugenicist and pioneer of identification technologies. It is currently in the custody of the Francis Galton Collection of the University College of London. This is where the Raqs collective first encountered the image of Raj Konai's hand. Fingerprinting experiments, and later technologies, all began with this handprint.

India has now embarked on a nationwide Unique Identification Database (UID) and plans to have its billion soon counted and indexed.

# TIME CAPSULE FROM 2011 (TO BE OPENED IN 2061)

2011/ Aluminum box with contents. 39 x 29 x 32 cm

*Imagine Being Here Now*, 6th Momentum Biennial, Moss, Norway (2011).

*Time Capsule*, from 2011, is a time travel device which makes it possible for Raqs to claim its contemporaneity with the future. At the same time, the contents of the container constitute an encryption of the state of play between the ways in which the Raqs collective inhabits the present, interprets the past, and faces the future.

The container, interred into the earth on the 18th of June on the Alby Estate in the city of Moss in the county of Østfold in Norway as part of the *Momentum Biennale 2011: Imagine Being Here Now*, will be opened at an appropriate date in 2061. The work is annotated by a text by Raqs Media Collective, "A Letter to Amália Jyran who will be Fifty Four in 2061 CE," published in the reader accompanying the Biennale.

## PRODUCTION & PHOTOGRAPHY

Unless indicated, all images are courtesy of Raqs Media Collective

*Co-ordinates 28.8N 77.15E*, 2002
Video Editing: Parvati Sharma
Sound Design: Vipin Bhati
Print Design: Pradip Saha
Research Assistance: Diya Mehra
Produced at the Sarai Media Lab, Sarai CSDS

*5 Pieces of Evidence*, 2003
Video and Sound Editing: Parvati Sharma
Coding: T. Meyarivan
Produced at the Sarai Media Lab, Sarai CSDS

*The Wherehouse*, 2004
Print Design: Mrityunjay Chatterjee
Coding: T. Meyarivan
Object Gathering: Bruno
Facilitation: Petit Chateau, Brussels

*Escapement*, 2009
Documentation courtesy Frith Street Gallery,
London.

*Global Village Health Manual, Ver 1.0* (with
Mrityunjay Chatterjee), 2000
Produced at the Sarai Media Lab, Sarai CSDS

*Sightings*, 2007
Print Design: Mrityunjay Chatterjee
Documentation courtesy San Francisco Art Institute.

*Erosion by Whispers*, 2005
Print Design: Pradip Saha

*With Respect to Residue (Table Maps for
Liverpool)*, 2004
Print Design: Mrityunjay Chatterjee
Documentation courtesy Liverpool Biennial.

*With Respect to Residue: 4 Illuminated Maps
for the Pearl River Delta*, 2005
Print Design: Mrityunjay Chatterjee

*A/S/L (Age/Sex/Location)*, 2003
Video Editing: Parvati Sharma
Sound Design: Vipin Bhati
In chatroom: Amanda McDonald Crowley; Shveta
Sarda; Tripta Chandola; Rachel Magnusson
Produced at the Sarai Media Lab, Sarai CSDS

*soDA Magazine Story*, 2002
Print Design: Pradip Saha

*A Measure of Anacoustic Reason*, 2005
Sound Editing: Iram Ghufran
Produced at the Montalvo Artists Residency, Lucas
Artists Residency Program

*Can you say that again? (5 Uneasy Pieces)*,
2010
Audio Direction: Sujin Oh
Production Co-ordination: Jihyun Kim
Documentation by Danam Kim, courtesy Anyang
Public Art Project.

*Over Time*, 2010
Documentation courtesy Project 88 Gallery, Mumbai.

*The Impostor in the Waiting Room*, 2004
Performance: Arjun Raina
Video Editing: Iram Ghufran
Masks: Nataraj Sharma
Produced at the Sarai Media Lab, Sarai CSDS

*They Called it the XXth Century*, 2005
Print Design: Pradip Saha
Documentation courtesy Künstlerhaus, Stuttgart.

*Insurance % Investment*, 2007
Documentation courtesy by Terje Östling,
courtesy Lunds Konsthall.

*The KD Vyas Correspondence, Vol. 1*, 2006
Video & Sound Editing: Iram Ghufran
Produced at the Sarai Media Lab, Sarai CSDS
Documentation courtesy by Norbert Thigulety,
courtesy Museum of Communication, Frankfurt.

*Anonymous Steel Worker*, 2007
Print Studio support: Artists Image Resource,
Pittsburgh; Bill Rodgers

*Love is Engineering*, 2009
Design: Amitabh Kumar

*However Incongruous*, 2011
Production Co-ordination: Miguel Magalhães

*Skirmish*, 2010
Design: Amitabh Kumar

*Shore Leave*, 2010-11
Design: Amitabh Kumar

*The Knots that Bind are the Knots that Fray*,
2010
Animation: Ikroop Sandhu

*Surface Tension Studies*, 2010
Production co-ordination: Denise Kwan
Photo printing: Jack Lowe Digital.

*Time is Money*, 2010
Design: Amitabh Kumar

*Unfamiliar Tales*, 2008
Design: Amitabh Kumar
Lenticular: Atul Swami

*A Dying Man Sings of That Which Felled Him*,
2006
Video Image: Mansour Aziz
Video Editing: Iram Ghufran

*Rules to be Invented*, 2010
Documentation courtesy Project 88.

*Revoltage*, 2010
Documentation by Martin Arygolo, courtesy
Festival d'Automne, Paris.

*Please Do Not Touch The Work Of Art*,
2000/2006
Print Design: Mrityunjay Chatterjee
Documentation of Version 2 courtesy Lunds
Konsthall.

*Forthcoming Titles*, 2010/2012
Print Design: Amitabh Kumar

*Strikes at Time*, 2011
Performers: Bhagwati Prasad; Shamsher Ali; Azra
Tabassum; Manish Chaudhari
Video Editing: Pallavi Paul
Sound Design: Ish Shehrawat
Text: Cybermohalla Ensemble
Translation: Shveta Sarda
Animation: Ikroop Sandhu
Production Manager: Ashish Mahajan

*The Capital of Accumulation*, 2010
Video & Sound Editing: Priya Sen
Research: Prasad Shetty; Stefanie Peters; Katarzyna Bialousz
Voices: Shveta Sarda; Rana Dasgupta; Jyotsna Uppal

*Utopia is a Hearing Aid*, 2003
Design: Pradip Saha

**Manifesta 7: Scenarios & Manifesta 7: The Rest of Now**
Documentation courtesy Manifesta7 / Manifesta Foundation.

*Unusually Adrift From the Shoreline*, 2008
Architectural Design: k l o r o f y l l/Alice Sturt/Imke Wojanowski Schöberle
Documentation by Weng Ying, courtesy Neighbourhood Secrets Project.

*Reverse Engineering the Euphoria Machine*, 2008
Print Design: Amitabh Kumar

*One Four Four Zero*, 2009
Documentation courtesy Frith Street Gallery, London.

*Sleepwalkers' Caravan*, 2008
Video & Sound Editing: Iram Ghufran

*We the Fuel*, 2011
Print Design: Amitabh Kumar

*Seen at Secunderabagh* (with Zuleikha Chaudhari), 2011
Performers: Manish Chaudhari; Bhagwati Prasad; Kavya Murthy
Animation: Ikroop Sandhu
Sound: Priya Sen

*The Surface of Each Day is a Different Planet*, 2009
Video/Sound Editing: Priya Sen
Animation: Ikroop Sandhu

*More Salt in Your Tears*, 2011
Documentation by Lotta Petronella, courtesy Contemporary Art Archipelago, Turku.

*An Afternoon Unregistered on the Richter Scale*, 2011
Animation: Ikroop Sandhu

*Proverbs (1-6)*, 2011
Graphic Design: Amitabh Kumar
Documentation of *Emotion Surge...* by Cheryl O'Brien, courtesy Art Gallery of York University.

*Rewriting on the wall*, 2011
Graphic Design: Amitabh Kumar
Documentation by Cheryl O'Brien, courtesy Art Gallery of York University.

*36 Planes of Emotions*, 2011
Graphic Design: Amitabh Kumar
Documentation by Cheryl O'Brien, courtesy Art Gallery of York University.

*How to get from here to there*, 2011
Documentation by Cheryl O'Brien, courtesy Art Gallery of York University.

*The Untold Intimacy of Digits*, 2011
Animation: Ikroop Sandhu
Documentation by Cheryl O'Brien, courtesy Art Gallery of York University.

# PUBLICATION

Art Gallery of York University
4700 Keele Street, Toronto ON
Canada M3J 1P3
www.theAGYUisOutThere.org

Editor: Michael Maranda
Design: Lisa Kiss Design, Toronto
Printed in Canada by
   Warren's Waterless Printing
Distributed by D.A.P. / Distributed Art
Publishers

**Library and Archives Canada Cataloguing
in Publication**

Raqs Media Collective (Organization)
[Works.  Selections]
   Raqs Media Collective : casebook.

Published in conjunction with the exhibition
Surjection by Raqs Media Collective of New
Delhi, held at the Art Gallery of York University
from 22 September through 4 December, 2011,
and curated by Philip Monk.

Includes bibliographical references.
ISBN 978-0-921972-68-6 (pbk.)

1. Art, Indic--21st century--Exhibitions.  2. Raqs
Media Collective (Organization)--Exhibitions.
I. Monk, Philip, 1950- , writer of added
commentary  II. York University (Toronto, Ont.).
Art Gallery, host institution, issuing body
III. Title.

N7305.R37 2014    709.54'56074713541
C2014-901789-8

*The Art Gallery of York University is supported by
York University, the Canada Council for the Arts,
the Ontario Arts Council, and the City of Toronto
through the Toronto Arts Council.*

Publication of this book was made possible through the generous financial support of Laura Rapp.

**Cover**
*Marks*
2011/ Acrylic, MDF, red LEDs, electrical wires, gold mylar sheets. 185 x 258 cm

**Inside Covers (front & back)**
*The Namak Haraam's Philosophy Revised*
2012/ Digital prints. Series of 2, each 422 x 60 cm

How to break and betray, if and when necessary, the covenants of salt, the obligations of servitude and loyalty, the namak halaali of nativity and nations? How to be a namak haraam? Why spill the salt of the master?

Treason too can be a commitment.

In order to make peace with the alien, first one must become a stranger to oneself. Reciprocally, the alien too must turn against herself. At the intersection of these two turns lies the fulcrum of possibility. Salt, not blood, must be spilt on both sides. It takes two traitors, two namak haraams from two hostile sides, to act with all the courage of treason that they can muster in their bones.

Somewhere, there might exist a library dedicated to the philosophy of the namak haraam, stacked high with books filled with the unwritten word. What titles would one browse if one came across its stacks, folded into the course of a tiring day like a mirage in a desert? Can books be desired into existence by reciting the spells that are waiting to be read off the surfaces of their wished-for spines? Can the namak haraam ever repay his debts, with interest.

Every book demands another, but not all of them get written. Every debt demands to be paid, but not all are redeemed. Then there are the debts that we owe to the all that we read, which we can never really repay. In that sense we are all "namak haraams," defaulters to the debt of purloined knowledge. Someday, a Hamlet will issue a stern reprimand, saying, "There are more things on heaven and earth, namak haraam, than are dreamt of in your philosophy." He will be reminding us of the things we owe, with interest.

**Back Cover**
*However Incongruous*
2011/ Fibreglass. 106 x 92 x 320 cm